1987

America & Lewis Hine

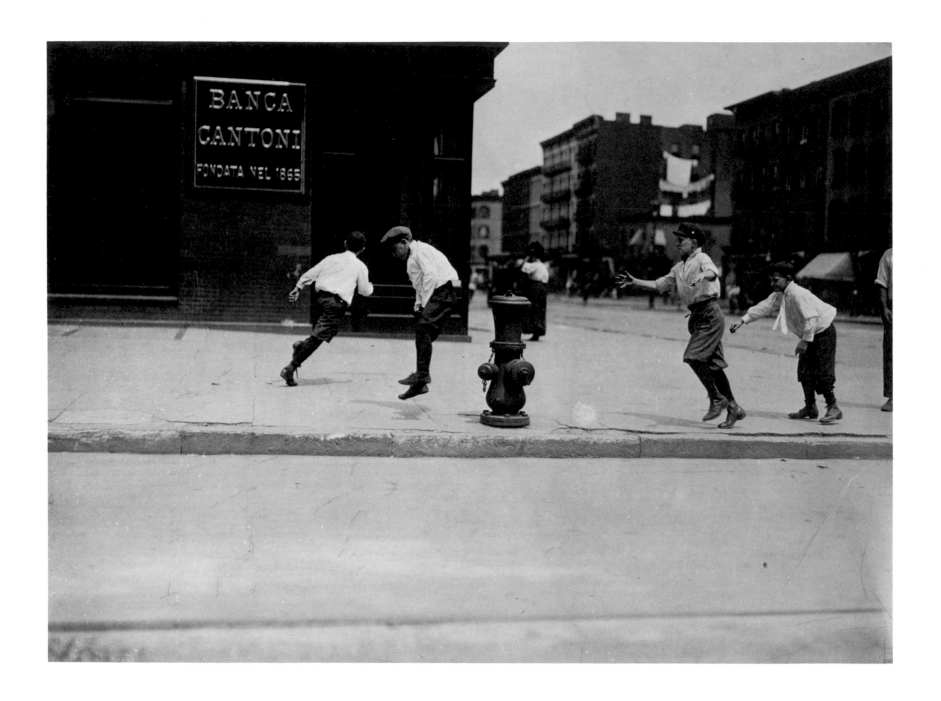

Leapfrog, New York City, 1911.

America & Lewis Hine

Photographs 1904-1940

Foreword by Walter Rosenblum
Biographical Notes by Naomi Rosenblum
Essay by Alan Trachtenberg
Design by Marvin Israel

An Aperture Monograph

Aperture, Inc., publishes a periodical, portfolios, and books to communicate with serious photographers and creative people everywhere. A complete catalogue will be mailed upon request. Address: Millerton, New York 12546.

Library of Congress Catalogue Card No. 77-70068

ISBN: 0-89381-008-8 Cloth ISBN: 0-89381-017-7 Paper
ISBN: 0-89381-016-9 Museum Edition

Composition by David E. Seham Associates, Metuchen, New Jersey
Printed by Rapaport Printing Corporation, New York City
Bound by Sendor Bindery, New York City

Manufactured in the United States of America

Published in conjunction with the exhibition
A Retrospective of the Photographer Lewis W. Hine, 1874–1940
The Brooklyn Museum, March 12–May 15, 1977
University Art Museum, Berkeley
The Denver Art Museum
Chicago Historical Society
Museum of Art, Carnegie Institute, Pittsburgh
Yale University Art Gallery, New Haven.

Publication of *America & Lewis Hine* is made possible by a contribution from Paul and Hazel Strand.

ACKNOWLEDGMENTS We wish to thank the following persons and organizations for making available photographs by Lewis W. Hine: Herbert Mitchell and Prof. Adolf K. Placzek (Avery Library, Columbia University), John Tris (Chicago Historical Society), Robert J. Doherty (International Museum of Photography—George Eastman House), Helios Gallery, Alan Fern and Jerry Kearns (Library of Congress), Lunn Gallery/Graphics International, Ltd., Jeffrey Newman and Margaret Toner (National Child Labor Committee), and Tom Beck (University of Maryland Baltimore County, Library). Our special thanks to Alvin Balinsky for his technical assistance, delivered in unfailing good spirits and with reverence for Hine's vision.

For reading the manuscript and providing generous criticism, Alan Trachtenberg wishes to thank Nancy Cott, Robert Herbert, Irving Howe, Ian Jeffrey, Jerome Liebling, Daniel Lindley, Betty Trachtenberg, and Zev Trachtenberg. In preparing the text, Naomi Rosenblum kindly shared her research, and Harris Dienstfrey provided editorial guidance.

Although gathering chronological information may seem to be a relatively simple matter, in the case of Lewis W. Hine it required the help of many individuals. The following persons all contributed in some measure to the reconstruction of Hine's career: Berenice Abbott, James C. Anderson (Director of Archives, University of Louisville), Lura Beam, John DeSha Davies, Robert M. Doty (Director, Akron Art Institute), William Ewen, Louise and Maurice Freedman, Phyllis Harnack (Hastings Historical Society), Paul S. Harris, Andrea Hinding (Curator, Social Welfare History Archives, University of Minnesota), Corydon Hine, Kitty Hobson (Archivist, Oshkosh Public Museum), Martha E. Jenks (Director of Archives, International Museum of Photography), Geri Lanza (Hastings-on-Hudson Public Library), James Marshall, James R. Mund (Chief, Graphics Division, Tennessee Valley Authority), Helen E. Simpson (Oshkosh Public Library), and William E. Woolfenden (Director, Archives of American Art).

The bibliography has been expanded and reorganized from the excellent one provided by Judith Mara Gutman in *Lewis Wickes Hine and The American Social Conscience* (1967). The following persons provided material for the expanded bibliography: Marynn Ausubel, Seymour Lesh (National Child Labor Committee), Meyer Mathis (American Red Cross), Gunter Pohl (Local History and Genealogy Division, New York Public Library), Young Hi Quick (Western Electric Co.), and Dorothy Swanson (Tamiment Library, New York University).

This publication accompanies an exhibition organized by The Brooklyn Museum for the Spring of 1977. The exhibition will travel to the University Art Museum, Berkeley, The Denver Art Museum, Denver, Chicago Historical Society, Chicago, Museum of Art, Carnegie Institute, Pittsburgh, and Yale University Art Gallery, New Haven.

Contents

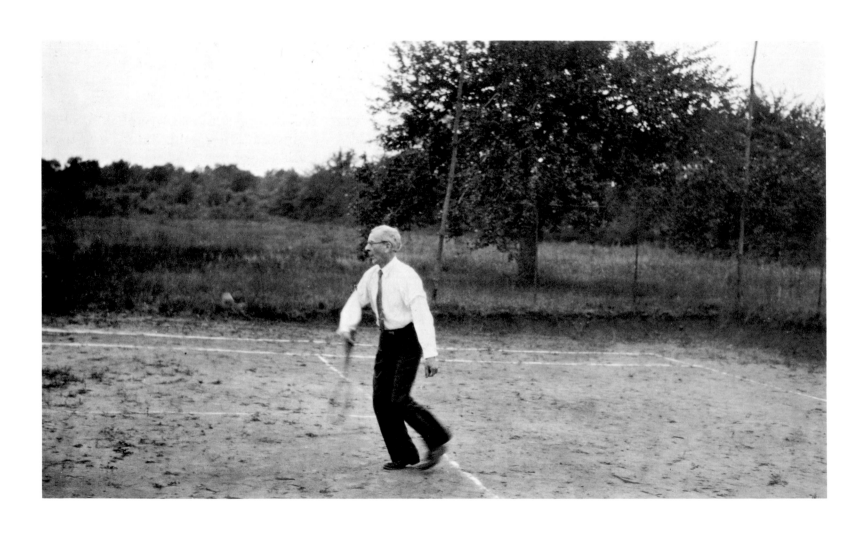

Lewis Hine playing tennis, c. 1927

(1)

Foreword

My first memory of Lewis Wickes Hine goes back almost forty years, to my days as secretary, janitor, darkroom attendant, and general helper at the Photo League in New York. It was late afternoon of a lovely spring day. An elderly man slowly climbed the two steep flights of stairs leading to the loft floor of the building on East 21st Street that housed the League, crossed the room to the front window, and quietly sat down. He seemed oblivious to the street noises, to the trucks loading textiles, and even to my presence. He sat for about an hour and left as quietly as he had arrived.

He came again the next day, but this time I joined him at the window. He returned often during the next few months, and I always sought his company. I knew him as "Lewhine," and I was soon completely under his spell. We spent many hours in quiet conversation. I felt embraced by his presence. There were no formalities with him, no status games—just honesty and simple dignity. I had never met anyone like him.

Hine was not the popular image of a glamorous photographer. He was slender and small, with thinning hair parted in the middle. He looked like an old schoolteacher in a Victorian film. But his eyes had an impish gleam and his evident relish at his own puns wreathed his face in a wonderful smile.

Although he rarely spoke about his own affairs, he was quite willing to help me with mine. He spent endless time on my photographs, which must have seemed to him feeble imitations of what he had accomplished years before. His suggestions were always within my reach, for he was a born teacher. When I complained about the difficulty of living in New York on my ten-dollar-a-week salary, he recommended me to SURVEY GRAPHIC for free-lance work. His letter of introduction said, "Here is a new and better Hine." Can one ever forget such generosity?

Despite his reluctance to speak about himself, there were some things I did discover. His afternoon visit to the League was a brief respite in what was for him an otherwise dismaying day. Corydon, his son, had had an accident and was in the hospital, hovering between life and death. His wife, Sara, suffered from asthma and was subject to attacks from which there was no relief. With the help of neighbors, Hine was trying to function as father, nurse, and provider.

Provider was the most difficult of his roles. Daily, he would scour the city searching desperately for work, but nearly every effort to find a job or sell his photographs was unsuccessful. In that year, 1938, Hine was totally without funds. SURVEY GRAPHIC gave him fifty dollars against future work; unfortunately, this organization, for which he had worked for thirty years, was itself in difficult circumstances. Libraries, collections, and museums wanted his photographs, but only as free gifts. Yet even here, Hine was obliging, torn as he was between his need and a deep-rooted desire to make his work available to those who wanted it.

For more than two years, Hine had corresponded with Roy Stryker in an effort to find employment with the Farm Security Administration. Considering his previous experience, it was the most natural outlet for his talent. In final despair, Hine explained that he was without money, that his wife was ill and his home in Hastings-on-Hudson in danger of foreclosure, and that he was prepared to work for a very small salary. Stryker, less than honest, pleaded poverty and kept him hanging for those two years. Actually, Stryker's budget had been increased during that time and ample money was available. To others, Stryker claimed that Hine, this most gentle of men, was too difficult to work with and that his best days were behind him.

Still hopeful, Hine applied for a Guggenheim Foundation grant with strong support from Elizabeth McCausland, Berenice Abbott, Beaumont Newhall, Willard Morgan, and others. He reaffirmed his life-long credo with his proposed topic, "Our Strength Is Our People." "This project should give us light on the kinds of strength we have to build upon as a nation. Much emphasis is being put upon the dangers inherent in our alien groups, our unassimilated or even partly Americanized citizens—criticism based upon insufficient knowledge. A corrective for this would be better facilities for seeing, and so understanding, what the facts are. . . ." The Guggenheim Foundation, after what seemed like a virtual promise to accept the project, turned it down. The Carnegie Foundation expressed interest in a Hine project on American craftsmen, but they too ultimately rejected the proposal.

Utterly frustrated, Hine turned to welfare. How finally ironic that this photographer, who had documented relief activity so vividly, was now himself relegated to the relief line. After several visits, he was given five dollars for food and an invitation to return at a later date. Unable to pay off his mortgage, he was forced to submit to foreclosure yet allowed to remain in his house on a monthly basis. He was visited there by a reporter and a photographer from the New York HERALD TRIBUNE who hoped to document his plight, but he turned them back—suggesting they use the space to publicize his work instead.

And then the final blow. Sara Rich Hine died on Christmas morning, 1938. She had been waging a losing fight, with decreasing resistance, and grippe had turned into pneumonia. Rushed to the hospital, she was put in an oxygen tent and given blood transfusions, to no avail. She was buried on her birthday. As Hine said, "There were so many things she needed to do and to find out—there must be some way such a soul can carry on under better conditions,—there's no use in anything else."

Hine's personal tragedy came at a time when he was just beginning to regain a measure of public recognition. Elizabeth McCausland rediscovered Hine for the public through articles in the Springfield REPUBLICAN, SURVEY GRAPHIC, and U.S. CAMERA QUARTERLY. Beaumont Newhall wrote about him for the MAGAZINE OF ART and about

"Documentary Photography" for PARNASSUS. CORONET published an article on him by Robert Marks. McCausland and Abbott organized a retrospective exhibition of Hine's work for the Riverside Museum in New York. The list of sponsors read like a WHO'S WHO in photography, government, and social work. Stryker lent his name, as did Alfred Stieglitz, who had totally ignored Hine until that time. The Photo League, where Hine had been participating in a project called "Men at Work," pitched in with enthusiasm. Membership meetings were devoted to Hine and his work. PHOTO NOTES, the League publication, published articles by McCausland and others. Hine was proclaimed an inspiration to what we, as "concerned" photographers, were trying to accomplish. Members helped to mount and hang the exhibition at the Riverside Museum.

But it was all too late. Hine died in November, 1940, impoverished, dispirited, worn out. One of America's great artists, a man who documented the essence of an age as no other had, died destitute and acknowledged too late. Perhaps that is the appointed fate of photographers who lay bare the poignancies of modern life. Atget was found dead in his apartment, malnourished to the point of starvation; Mathew Brady, whose Civil War document could find no home, ended his days in penury; Alice Austin was rescued from the poor farm at the end of her life.

Who was Lewis Hine? Why is he in a pantheon reserved for a rare few photographers? Frank Manny found him, possibly as an obscure teacher in a normal school in Oshkosh, Wisconsin, and brought him to New York to teach at the Ethical Culture School. Hine was completely without experience, but Manny urged him to become the school photographer and in this way he gained technical expertise.

The compassionate vision which Hine maintained throughout his life had other roots. His revulsion against the use of children in the early twentieth-century American industrial labor force and his empathy with all those who toil were not based on hearsay evidence garnered from books or newspapers. His own experience—in a furniture factory, a bank, a retail store, thirteen hours a day, six days a week, for a miserable four dollars in wages—colored his entire existence and filled him with a passion from which he could never escape.

Ellis Island became the crucible that formed Hine, gave him direction, and schooled him for what was to follow. Millions of men, women, and children from Middle and Southern Europe churned through the port of New York between 1903 and 1913, laden with newly acquired names and Old World baggage. Waiting to be told whether they were to stay or be sent back, these bewildered souls, herded in pens, clutched their tickets, name badges, and children's hands as they hung on to their visions of a new life. And into this polyglot, straining mass came Hine, sometimes with Manny trailing along as assistant.

Today's young photographer, with 35 mm camera and

Tri-X film, must marvel at Hine's skill and tenacity. Amidst crowds of anxious immigrants milling about, Hine had to locate his subject, isolate him from the crowd, and set the pose—almost always, because of the language barrier, without words. He had to set up his simple 5 x 7 view camera on its rickety tripod, focus the camera, pull the slide, dust his flash pan with powder, and through his own look and gesture try to extract the desired pose and expression. With a roar of flame and sparks, the flash pan exploded, an exposure was made, and beneath the protective cloud of smoke which blinded everyone in the room Hine would pack up and leave. A second exposure was out of the question; one shot was all he had.

Hine's Ellis Island photographs pay homage to people who had left their homes and traveled across the ocean under near slaveship conditions to seek a new beginning in a strange land. Whether it is the young Czech woman in native costume, or the proud and sorrowful old Jew, we gain fresh insight through his vision. Each individual's stance and gesture allow us to grasp the essence of a particular time, to look at the portrait of an age. Although the immigrant's dream was seldom to be matched by reality, the beauty Hine saw in his subjects was a distillation of the known terror of the past and the uncertain hope of the future. His Ellis Island photographs are among the finest in all of photography. They constitute the New World's twentieth-century epic poem, a paean in honor of those who came to our shores for sustenance and, in turn, sustained us.

As do all serious artists, Lewis Hine regarded his work as a moral responsibility. It quickly became evident that his Ellis Island "Madonna," the proud Jew, and the beaming German family were all to become cheap labor, exploited by an unfeeling and greedy system. They would be tested in ugly tenements, suffocatingly hot in summer and freezing cold in winter, boxes without heat, hot water, or toilet facilities. The dream would expire in sweatshops at starvation wages or in dreary, endless toil in tenement homes. And the greatest of all crimes, the exploitation of children as laborers, would wither the hope and grace of the young.

This degradation was to become his obsession; it would give him no rest. No matter the weather or his state of health, Hine was in the field documenting the misery of exploited children. In the Child Labor Bulletin of 1914 he wrote: "For many years I have followed the procession of child workers winding through a thousand industrial communities from the canneries of Maine to the fields of Texas. I have heard their tragic stories, watched their cramped lives and seen their fruitless struggles in the industrial game where the odds are all against them. I wish I could give you a bird's-eye view of my varied experience." His photographs did much more than that.

The photograph of the breaker boys working in a coal mine is the finest example of Hine's genius. The scene, the breaker room in the mine, reaches beyond reality into a world we inhabit only in a terrifying nightmare. Breaker

boys are huddled over their work, their faces black with soot, their eyes the only sign of life in bodies that seem already old. They are bent over, twelve to fourteen hours a day, six days a week, separating coal from slag for the pitiful wage of seventy-five cents a day. Other miners learn of the photographer's presence and come flooding into the room, filling every inch of space. Gas jets mounted in the ceiling reinforce the illumination of two small windows. Hine, standing in the corner with his camera, has attracted everyone's attention. Each child assumes a position peculiarly his own; no one play-acts or mimics. The faces are full of trust and dignity. Each fragile personality seems strangled by the environment: young dreams suffocating in coal dust. "Breaker Boys" makes clear why Hine's photographs were the single most important influence in this country's passage of child labor legislation.

Certainly, Hine was conscious also of the aesthetics of photography. He worked so hard and traveled such distances that the time spent on each print must have been minimal. His files contain beautiful prints as well as mediocre ones. But when he organized a photograph, the effect was right. Considering the range of subject matter, the difficulties of site and execution, his vision is always fine and often superb.

Hine's work for the National Child Labor Committee was frequently dangerous. He was often exposed to physical harm, even death, for the immorality of child labor was meant to be hidden from the public. Irate foremen and factory police were not prepared to accept his presence. To most employers, the exploitation of children was so profitable that nothing could be permitted to end it; upon exposure, it was treated as a part of normal human existence. "Why shouldn't the child work alongside his mother?" was the plaintive cry of the factory owner. "The child will then be safe."

To gain entry into mines, mills, and factories, Hine was forced to assume many guises. His students at the Ethical Culture School had known him to be a marvelous actor who would amuse them on nature walks by becoming a wayward tramp or an itinerant peddler. When he photographed for the NCLC, his repertory ranged from fire inspector, post card vendor, and Bible salesman to broken-down schoolteacher selling insurance. Sometimes he was an industrial photographer making a record of factory machinery. He would set up to photograph a loom, then ask a child to step into the picture so that he could get a sense of scale. Hine knew the height from the floor of each button on his vest so that he could measure the child standing alongside him. Hidden in his pocket was a little notebook in which he wrote vital statistics such as age, working conditions, years of service, and schooling. When he failed to gain admittance to a factory, he would often visit homes in the early morning and wait outside to photograph the children on their way to a long day's work.

It is indeed ironic that Hine was accused of being dishonest and his results judged suspect because he was

forced to use deception to document the facts or conditions of child workers. The NCLC reassured the public that his results were always checked, and Hine made certain to document his photographs with specific proof. He was a skilled writer, too, and for many years his notes were used as field reports for the NCLC.

In the last forty years, documentary photography has expanded enormously. But in 1903, when Hine began to work, there were few photographic precedents. Others had used photography as a weapon against oppression and wrong, or as a way of helping people to build a better world, but Hine most probably did not know of them. In Scotland, David Octavius Hill had photographed New-haven fisherfolk in 1843, intending to sell albums to raise funds to deck their boats for greater safety. Thomas Annan had photographed the slums of Glasgow, and John Thomson had documented the street life of the London poor.

Of Hine's contact with his elder contemporary Jacob Riis, we know nothing at all. Riis wrote for CHARITIES AND THE COMMONS and Hine photographed for them, so he may have been familiar with the earlier Riis work HOW THE OTHER HALF LIVES. And there were others who were photo-graphing the slums and working conditions of the urban centers in the century's first decades. But whether or not he knew of their work, Hine found his own way. His touchstone was always real people in a real world of which he and they were a part. He was a humanist, and the essence of his art was his belief that to be happy and beautiful, to be a child, to flower and grow, the world needed changing. And it was his duty to try to change it.

So from the battlefield of child labor he went to the war zones of World War I in Europe. Rejected at first for physical disability by the Red Cross, he somehow managed to get overseas in 1919. Touring the ruined lands of Serbia, Greece, and France, he sought out individual misery or bewilderment. The best of these pictures often suggest the steamy togetherness of Balkan peasant life or display the aching beauty of a homeless youngster.

In the 1920's and early 1930's, Hine turned to the American working class, seeking in their faces, their hands, and their activity his paean of praise for the dignity of labor. He produced more than a thousand pictures of the Empire State Building in construction and used several of these, along with other work portraits made during the Twenties, for MEN AT WORK (1932). During these years, he became involved with many other projects, some naturally less interesting and moving than others as he sought economic and pictorial sustenance.

Lewis Hine was no mere itinerant photographer, acci-dentally happening upon a significant moment in Ameri-can history. One has only to compare his images with others made at the same time and of the same event. Most settle for the facts of the situation: the broken floor and fetid wall, the garbage-strewn alley and the bleak frame dwelling. Hine's vision is rare because it is essential. He realized that the cracks in the wall, the poor light, the

unending toil had to do with hopes and dreams and strengths. It was on these that his camera focused.

Hine was a cultured man with a wide range of interests. He was versed in the natural sciences and had earned a Master's Degree in education. He had studied the arts, even wrote on photographic aesthetics, and followed the Photo-Secessionist movement in photography with interest if not in agreement. He read widely in economics and was involved in political ideas. Among his friends were important activists of the time such as Paul Kellogg and John Spargo, and he wrote for the publications of both the reform and socialist movements; his photographs also appeared in such publications.

His contemporaries in the field of social work respected his accomplishments, realizing that his photographs were pivotal in the legislative battle against child labor. Aesthetically, however, these men and women had little appreciation of his photography. Nor was there any rapport between Stieglitz and Hine, although Hine brought his photography class at the Ethical Culture School to "291" and later followed Stieglitz's work in his exhibitions. Hine had little time for gum bromoil prints, soft-focus lenses, retouched photographs of nature, or artfully posed nudes. Stieglitz's EQUIVALENTS seemed to have left him amused but untouched. Hine could have opted for the friendly quarters of the New York Camera Club and reveled in ribbons, medals, awards, and prizes, and he might have scaled the "ivory tower" of "291." Instead, he was drawn to the world of the oppressed, the hungry, the disenchanted.

Although it would have been singularly apt, no one until now thought of titling a book of his photographs AMERICA & LEWIS HINE. Yet America and Lewis Hine are inseparable. Hine could not have made his photographs in a different place or at a different time, for the social turmoil of the Progressive period of American history was the fabric of his vision. Nor are those times more powerfully depicted than in his work. Hine's photographs fused the data of time and place with the intimations of human aspirations. An explorer of body and spirit, he sought to illuminate the dark recesses of the American experience, and to make that experience accord with man's hope.

"Light is required," he said. "Light in floods." For the light he sought, for the light we needed, and still need, for the light he shed, we will be forever in his debt.

—Walter Rosenblum

Arts and Sciences, Columbia University, to study sociology. In the fall, he is assigned by Paul U. Kellogg to photograph for the Pittsburgh Survey, a pioneering sociological study.

1908 Hine continues at ECS through the spring term. By this time, he has made "at least 1,000 plates" for the school, but during World War I he will sell the glass for scrap.[6] In Washington, D.C., he photographs slum conditions to provide additional photographs for the Charles Weller publication, *Neglected Neighbors in the National Capital.* The National Child Labor Committee hires him in August, at $100 per month plus expenses, because Owen Lovejoy and others at the NCLC are convinced that "an expert photographer would render valuable service" in their effort to awaken public interest in the passage of regulatory legislation. His first assignment is to accompany Edward Clopper, Secretary of the Ohio Valley States Committee, to Indianapolis, Cincinnati, and West Virginia, with the purpose of photographing child labor conditions in mines and factories. Clopper writes to the committee that Hine "displayed both tact and resourcefulness . . . and gathered a large amount of valuable material, not only photographic."[7] Hine's photographs appear in newspapers, in NCLC publications, on posters, and for publicity; his stereopticon slides are used for illustrated lectures. In November, Hine visits glassworks in West Virginia and textile mills in North Carolina, making 230 photographs

along the way. His first advertisement for "Social Photography by Lewis W. Hine" runs in *Charities and the Commons.*

1909 In January, Hine attends the NCLC Annual Conference in Chicago. The publicity for the conference states: *arrangements have been made to have a large number of photographs and charts collected by the committee's investigators exhibited. . . . This silent method of bringing before the eye the actual conditions . . . is believed one of the most valuable features of the Conference.*[8]
While in Chicago, Hine photographs at Hull-House. He continues doing field work for the NCLC, conducting investigations in the Georgia towns of Augusta, Macon, Valdosta, and Tifton, during which he experiences legal difficulties. In March, he investigates street trades in Hartford and Bridgeport, Connecticut; in July, he submits reports on the conditions in textile mills in New England and on child labor in Maryland. He photographs the oyster packing and tobacco industries in the Gulf States and glassmaking in New Jersey. Having produced over 800 photographs since January, he hires an assistant, Paul Schumm, to work in the darkroom. His photographs are used for newspaper publicity (an article by McKelway on child labor practices in North Carolina, accompanied by Hine photographs, appears in eleven periodicals) and for exhibits which he prepares himself. Other agencies, such

as the Child Welfare League, use his photographs in a similar manner. As staff photographer for *The Survey*, Hine arranges for the magazine to use NCLC publicity. He also prepares stereopticon slides, to be loaned out in sets of fifty to seventy-five, keyed to a lecture prepared by E. V. Lord, Secretary of the New England Committee. His salary is raised to $150 per month, and new photographic supplies are purchased. The plates made for the NCLC are retained until 1974.[9] In November, Hine photographs for the newly formed New York State Immigration Commission, Louis Marshall, Chairman. He takes a two-week, 1,200-mile automobile trip through upper New York State with commission members Lillian Wald, Mary Drier, and Frances Kellor, who point out subjects to be photographed in Barge Canal housing facilities.

1910 Hine investigates Buffalo, New York, school children in canneries, Delaware street trades and cannery operations, Illinois factories, and Alabama cotton mills and mining operations. In April, he is engaged for six months at a yearly salary of $3,000 plus expenses. He and the NCLC are convinced of the effectiveness of photography in arousing public opinion as the NCLC begins to realize a small income from slide rentals and provides other investigators with photographic equipment. Hine writes:

> *I am sure I am right in my choice of work. My child labor photos have already set the authorities to work to see if such things can be possible.*[10]

1911 Traveling almost continuously for the NCLC, Hine makes winter trips to Missouri, Alabama, Georgia, and Tennessee, then Indiana and Pennsylvania. Of his subsequent investigation of the oyster-packing industry, he writes:

> *A line of canning factories stretches along the Gulf coast from Florida to Louisiana. I have witnessed many varieties of child labor horrors . . . but the climax, the logical conclusion of the "laissez-faire" policy regarding the exploitation of children is to be seen in the oyster-shuckers and shrimp-pickers in that locality.*[11]

In the spring, he photographs the textile mills of Mississippi and Virginia, and collaborates with his wife on a report of the thirteen cotton mills, ten knitting mills, five silk mills, three woolen mills, and the glass and shoe factories visited in Virginia. Following a two-week investigation of Maine sardine canneries, he tours cranberry bogs in Massachusetts with Richard Conant and Owen Lovejoy, after which Conant accompanies him through the New England mills. Hine also attends board meetings of the NCLC to explain the background and use of photographs. By now, the NCLC is firmly committed:

> *No anonymous or signed denials can contradict proof given with photographic fidelity. These pictures speak for themselves, and prove that the law is being violated. . . .*[12]

1912 A son, Corydon, is born to the Hines, who purchase land in Hastings-on-Hudson, New York, for a future home. Hine advertises photographic services comprising stereopticon slides, photographs, and enlargements in various categories: immigrants, labor, and living conditions.

1913-1914 Now considered the most extensive and successful photographer of social welfare work in the country, Hine travels to the South, the Southwest, and the Northeast, and begins to lecture for the NCLC. Concerning his responsibility for exhibits, the NCLC notes:

> *The Exhibit Department has developed under the direction of Mr. Hine. The material has been revised and remodelled, and a number of new exhibits added. Exhibits have put our cause before the people in an impressive way. We hope that under Hine's efficient management it will become self-supporting and will bring in revenue.* [13]

1915-1917 NCLC exhibits are shown at both the San Diego and San Francisco expositions. Hine continues his illustrated lectures and extensive documentation, again investigating Southern mills as well as Colorado beet fields, Texas and California agricultural workers, and New Jersey and Connecticut cranberry pickers and tobacco workers. He also reinvestigates tenement homework in New York City. His documentation reflects the NCLC shift from child mill workers to child agricultural laborers when legislation regulates the former. Between 1916 and 1917, he travels over 50,000 miles.

1917-1918 Hine moves to Edgars Lane, Hastings-on-Hudson, where the top floor of his home is used by a local progressive school. The NCLC votes to reduce his salary from $275 to $200 per month, claiming that the investigatory work which he is now relinquishing merits higher pay than does photography. Despite their statement that this reduction is "no reflection on the ability or faithfulness of Mr. Hine," [14] he terminates his association with the NCLC. At the age of forty-four, he joins the American Red Cross in May, 1918, as assistant to Lt. Col. Homer Folks and is given the rank of captain at a salary of $300 per month. In July, waiting for a special mission to depart from France for the Balkans, Italy, and Greece, he photographs at St. Étienne. During the mission, he makes 400 photographs.

1919-1920 After returning to Paris in January, Hine takes 300 photographs in northern France and Belgium within one week in April. Again, he makes his material available to *The Survey*. Lt. Col. Folks uses Hine's pictures to arouse public interest in the condition of the civilian populace in Europe and projects a book on his experiences, working out the picture selection with Hine. The ARC asks Hine to join a mission in Germany, but he returns to New York in June, 1919. Attached to the Publicity De-

partment of the ARC National Headquarters, he arranges exhibits and photographs domestic projects. Requests for his social photographic work are referred to Hiram Meyers, a New York City commercial photographer. Hine anticipates slack times as he experiences difficulties in straight sociological work. Beginning to stress the artistic and symbolic aspects of the camera, he changes his studio publicity to read: "Lewis Wickes Hine, Interpretive Photography." He arranges exhibitions of his photographs at the Women's Club in Hastings and at the Civic Club and the National Arts Club in New York City. His photograph "The Printer" is bought by the National Arts Club. Continuing in a new direction, with the emphasis that men, not machines, produce industrial wealth, he makes portraits of working people and craftsmen. He calls his new work "the human side of the system" and considers it the "best he's ever done." Despite hopes that industry will recognize the value of the photographs and "pay the freight," he realizes little income, due partly to the national economic slump.

1921 A visit in February to the Stieglitz exhibition at the Anderson Galleries reflects Hine's new attitude toward photography. Of Stieglitz's "fatalism, humanity, affirmation and belief in himself," he says, "I guess he has needed it all . . . who hasn't."[15] *The Survey* provides Hine with his first real income in a year. Throughout most of the decade, he will find strong support in Paul Kellogg, *Survey* editor, who writes:

The more I have thought about your pictures the more enthusiastic I have become about them . . . it seems to me that you are striking a high and far reaching lead.[16]

Kellogg features Hine's work in *The Survey*, suggests other outlets for photographs, sends advances and checks when most needed, and mediates between Hine and other *Survey* staff members. Hine's photographs will be used less frequently toward the end of the decade, when Florence Loeb Kellogg becomes art director. Hine again becomes associated with the NCLC, working on assignments concerned with rural agriculture and education.

1922–1929 Hine returns to Ellis Island for a new series (1926) and works for various agencies: the Milbank Foundation, the National Consumers' League, and the Amalgamated Clothing Workers Union. He takes on assignments for commercial enterprises, including Western Electric, Tung-Sol Lamps, and Sloan's Liniment. In April, 1924, the Art Directors Club of New York awards him their medal for photography at the Exhibition of Advertising Art for his portrait "The Engineer." (Other Hine portraits in the exhibit are "Freight Brakeman," "Mechanic and Air Brake," "The Printer," and "Heart of the Turbine.") His photographs are exhibited at the Advertising Club in 1928 and at the Russell Sage Foundation in 1929, and he is honored at the Twenty-ninth Anniversary Dinner of the NCLC.

Despite this reception of his work, Hine is discouraged by his inability to make a living in photography. He plans to put his house on the market and settle in an upstate rural community (probably Meridale, where the Hines often summer).

1930 In May, Hine is offered a job photographing the Empire State Building in construction. He considers the assignment an aspect of his "interpretation of industry." Often helped by his son, Corydon, and by a Hastings neighbor, he photographs from the top of the structure as it rises. His increased income, praise from Gov. Alfred E. Smith, and additional work notwithstanding, Hine notes that "even skyscrapers have their basements and skyscraping has its rebounds and depressions."[17]

1931 Hine free-lances for several publications and agencies. In February, he is hired by the ARC on special assignment to document drought conditions in Kentucky and Arkansas rural communities. (From 1931 on, he will work with Corydon as his assistant.) Although his photographs no longer appear regularly in *The Survey*, he writes to Paul and Arthur Kellogg:

> I shall always remember what a factor you two and Survey has [sic] been in putting my stuff on the map, to say nothing of what your appreciation and encouragement have meant all through the first quarter of a century of Hineography. . . . I am convinced that had the Paul-Art co-operation failed to synchronize at various critical periods I might still be polishing brains at the Ethical Informary.[18]

The Yonkers Art Museum, Yonkers, New York, exhibits Hine's photographs: "the biggest showing I ever had of my quarter century of work."[19]

1932 Hine's *Men at Work*, a picture book for adolescents, is published in September. Well-received, it is chosen by the Child Study Association as the outstanding children's book of the year. Hine notes that the book's introductory statement is his credo.

1933 Hine restates his credo in an attempt to convince Florence Kellogg, who finds his work unfashionable, of the need for human emphasis in the photography used by *The Survey*:

> I am glad you raised the question of human values in photography beyond mere illustration. . . . it is a very important offset to some misconceptions about industry. . . . one is that our material assets "just happen" as the product of a bunch of impersonal machines, under the direction perhaps, of a few human robots. . . . It is for the sake of emphasis, not exaggeration, that I select the more pictorial personalities . . . for it is the only way that I can illustrate my thesis that

the human spirit is the big thing, after all. . . .[20]
Hine is introduced to manufacturer Sidney Blumenthal of Shelton Looms. He arranges to photograph mill workers and makes a portfolio, *Through the Loom.* The spread of loom photographs, used in *The Survey,* brings requests for additional prints from various sources. Hine has a second portfolio printed and sends it to The Museum of Modern Art, the Brooklyn Museum, and The Metropolitan Museum; to various schools and libraries; and to Ansel Adams and Jane Addams. Kellogg, again supportive, offers suggestions for the use of the loom photographs. He writes about Hine to Dr. Arthur Morgan of the Tennessee Valley Authority and sends him the portfolio. The loom photographs are displayed in the General Exhibits Building at the 1933 World's Fair. Hine submits suggestions for a preliminary photographic survey of TVA projects and in October is hired for a month-long assignment at the Wilson and Muscle Shoals dam sites. He receives $1,000, which includes all darkroom work (done by a local photographer) and travel expenses. Viewing the survey as only a beginning, he writes:

> *Have had a glorious month with TVA. It is a large order they have started and it is all in the first stage. The visual part of it has not been worked out yet and although I have given them a good demonstration, some feel that I could accomplish more.*[21]

He is unable, however, to convince Dr. Morgan and others, who wish to make photographic records of charts, plans, and installations, to continue the survey on his terms. Angered by the use of his TVA photographs without a credit line and finding the TVA remiss in not taking advantage of publicity possibilities for pictorial material, he is finally thankful to end his involvement with an agency he finds too bureaucratic.

1934–1935 Hine's TVA photographs are used in several issues of *The Survey* (1934), but few new assignments follow. Hine does a small job for the ARC in Westchester and Dutchess counties, New York. He travels 2,000 miles through Pennsylvania, Ohio, and New York for the Rural Electrification Administration but experiences difficulty with the REA over the control of negatives. He attempts to interest Roy Stryker, of the Resettlement Administration (later, the Farm Security Administration), in the problem and notes that every time he has waived control over the printing of his work he has regretted it. Stryker asks to see his REA work, advises him to hang on to his negatives, and through 1938 assures him that he is keeping him in mind for a job although, as his correspondence indicates, he finds him too demanding and past his prime.[22] Hine takes on several small assignments for the Montclair Public Library, the New Haven Community Chest, and the New York City Parks Department.

1936–1937 Appointed head photographer for the Na-

tional Research Project of the Work Projects Administration, Hine works with supervisor Lura Beam in Holyoke, Massachusetts, on a program for technological change. He travels to New Jersey and Pennsylvania. Though the project is never completed, his photographs are made available to *Survey Graphic* and published in booklet form with text by project director David Weintraub. He also photographs Civilian Construction Camps, and urban activities, unemployed miners, and rural communities for the WPA.

1938 In reference to the disposition of his negative material, Hine contacts Stryker about the Library of Congress and Romana Javitz about the New York Public Library. He is now in extremely straitened circumstances, with no income from photographic work or government agencies. Paul Kellogg arranges for the Hines to remain on a rental basis in the Edgars Lane house, which is in danger of foreclosure. In November, Corydon has a serious accident. Hine, unable to complete a small assignment for *The Survey*, writes:

> *To Commodore Vic [Victor Weybright] and the Crew of the good ship Survey . . . some extracts from the Log of the Clipper ship Hine. . . . the fog has lifted and the ship, still drifting a little, will soon, we-hope, we-hope . . . operate on her (his) own power to new voyages to more unknown ports.*[23]

Berenice Abbott and Elizabeth McCausland become in-terested in Hine through Beaumont Newhall's article "Documentary Photography." McCausland writes about Hine in the Springfield *Republican, Photo Notes, Survey Graphic,* and the 1939 *U.S. Camera Annual.* She and Abbott urge him to gather his work for a retrospective exhibition arranged for the Riverside Museum with the help of Hudson Walker, and she helps with the selection of photographs and publicity. On reading the McCausland portrait in *Survey Graphic,* Hine writes:

> *As I read it, I had to admit that I never really knew the guy. . . . Really am very grateful to you for all you have done and are doing (and may live to do).*

And later:

> *Every new product from you gives me a catch in my breath and a lump in my throat and an increased wonderment, "how does she do it?"*[24]

He notes, however, that he does not want to be considered a "has-been." Despite the sponsorship of the American Federation of the Arts, he is unsuccessful in an attempt to interest the Carnegie Corporation in underwriting a photographic study of American craftsmen.

1939 Hine, Stryker, and Kellogg arrange stellar sponsorship for the Hine Retrospective, including Stieglitz, Strand, Tugwell, Folks, and New York City Comptroller McGoldrick. The photographs are installed by Hine, aided by Photo League members and WPA project workers. The

exhibition opens in January and travels to The Des Moines Fine Arts Association Gallery in Iowa and The New York State Museum in Albany. Favorable press leads to two assignments: for the *Hartford-Courant* and, in Scranton, for *Fortune* magazine. Sara Rich Hine dies on December 25, after a siege of the grippe and pneumonia. Hine finds it hard to

keep up communication. . . . there is so much to be done, finishing up and continuing lines that have been started, and in which she had a real part.[25]

1940 Hine sells ten enlargements, framed, to the New York School of Social Work for $150. With Stryker's help, he arranges for a small exhibition at a bookshop in Washington, D.C., but is unsuccessful in a second attempt to interest the Guggenheim Foundation in a project on American craftsmen. He makes a gift of one hundred prints to the Russell Sage Foundation and to the Picture Collection of the New York Public Library. On November 4, he dies after an operation at the Dobbs Ferry Hospital; he is buried in Ardsley-on-Hudson. His prints and negatives, and a small number of papers, are given by Corydon to the Photo League. Eventually, these are donated by Walter Rosenblum, in the name of the Photo League, to the George Eastman House, now the International Museum of Photography, Rochester, New York.

—Naomi Rosenblum

NOTES 1. "A Tramp Through the Realm of Historic Rip Van Winkle," Oshkosh *Daily Northwestern*, Oct. 3, 1903, p. 11. 2. Frank Manny to LWH, undated (1938). McCausland Papers, Archives of American Art. 3. A visit by the club to the "291" gallery was recalled by Paul Strand as having occurred in the winter of 1907. The group probably saw the exhibition of the Photo-Secession, Nov. 18–Dec. 30. N. Newhall, *Paul Strand Photographer*, New York, 1945, p. 3. 4. Field note, LWH to Frank Manny, c. 1906. McCausland Papers, Archives of American Art. 5. Hine's written addition, 1938, to above-cited field note. 6. McCausland Papers, Archives of American Art. 7. E. N. Clopper to O. R. Lovejoy, Dec. 31, 1908. NCLC Papers, Library of Congress, Washington, D.C. 8. "Fifth Annual Conference, NCLC," *Charities and the Commons*, Vol. 21, Jan. 16, 1909, pp. 673–75. 9. O. R. Lovejoy, Sept. 30, 1909. NCLC Papers, Library of Congress, Washington D.C. 10. Field note sent by LWH to Frank Manny, c. 1910, returned to LWH, given by him to Elizabeth McCausland in 1938. McCausland Papers, Archives of American Art. 11. Lewis W. Hine, "Child Labor in Gulf Coast Canneries," American Academy Annals, July, 1911, p. 118. 12. O. R. Lovejoy Report. Samuel McCune Lindsay Papers, Rare Book and Manuscript Library, Columbia University, New York City. 13. General Secretary's Report, Sept., 1914. NCLC Papers, Library of Congress, Washington, D.C. 14. O. R. Lovejoy, Report of the General Secretary, Feb. 13, 1918. NCLC Papers, as above. 15. LWH to Frank Manny, Feb. 18, 1921. Manuscript Division, New York Public Library. 16. Paul U. Kellogg to LWH, July 6, 1921. Survey Associates Papers, Social Welfare History Archives Center, University of Minnesota. 17. LWH to Florence Loeb Kellogg, Jan. 1, 1931. Survey Associates Papers, as above. 18. LWH to Paul Underwood and Arthur Kellogg, Feb. 7, 1936. Survey Associates Papers, as above. 19. LWH to AK, April 12, 1931. Survey Associates Papers, as above. 20. LWH to FLK, Feb. 17, 1933. Survey Associates Papers, as above. 21. LWH to PUK, Nov. 25, 1933. Survey Associates Papers, as above. 22. Roy Emerson Stryker to LWH, Nov. 14, 1935. On Dec. 13, 1938, Stryker writes to Rexford Guy Tugwell about Hine, stating, "I fear that he is not again going to do the type of work he did in his younger days." Stryker Archive, University of Louisville. 23. LWH to Victor Weybright, Nov. 26, 1938. Survey Associates Papers, Social Welfare History Archives Center, University of Minnesota. 24. LWH to EMcC, undated, probably Sept., 1938, and Oct. 9, 1938. McCausland Papers, Archives of American Art. 25. LWH to PUK, Jan. 25, 1940. Survey Associates Papers, Social Welfare History Archives Center, University of Minnesota.

(3)

The Photographs

While the new century was being born, baptised and taught to walk with Jane Addams, Jacob Riis and so many preaching the new gospel of "my brother's keeper," Lewis Hine was the visual spokesman for social welfare— the "Social Photographer." He has, for a third of a century, been interpreting Life and Labor to those who need to know that the worker is not a lower form of life. . . . He says "Cities do not build themselves— machines cannot make machines—unless, back of them all, are the brains and toil of Men. In this Machine Age, the more machines we use—the more do we need real men to make and direct them." He shows them following the same urge that has driven all men forward since mankind began. The first item in his credo is that "Work itself has ever been one of the deepest satisfactions that come to the restless human soul."—Looking at Labor: Past and Present," July, 1939

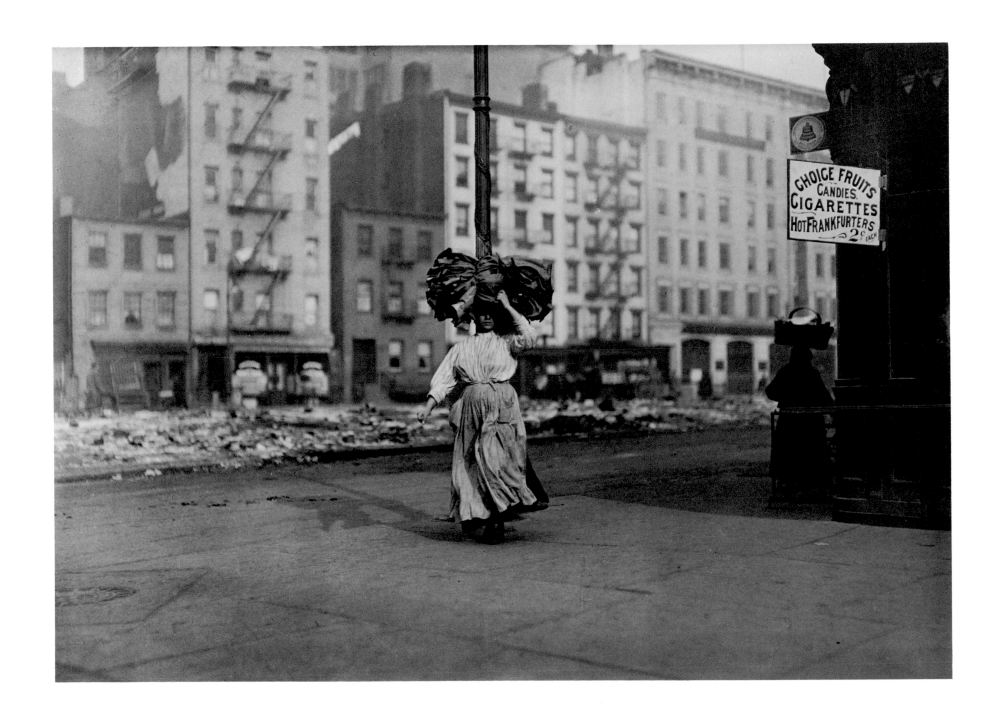

Italian immigrant, East Side, New York City, 1910.

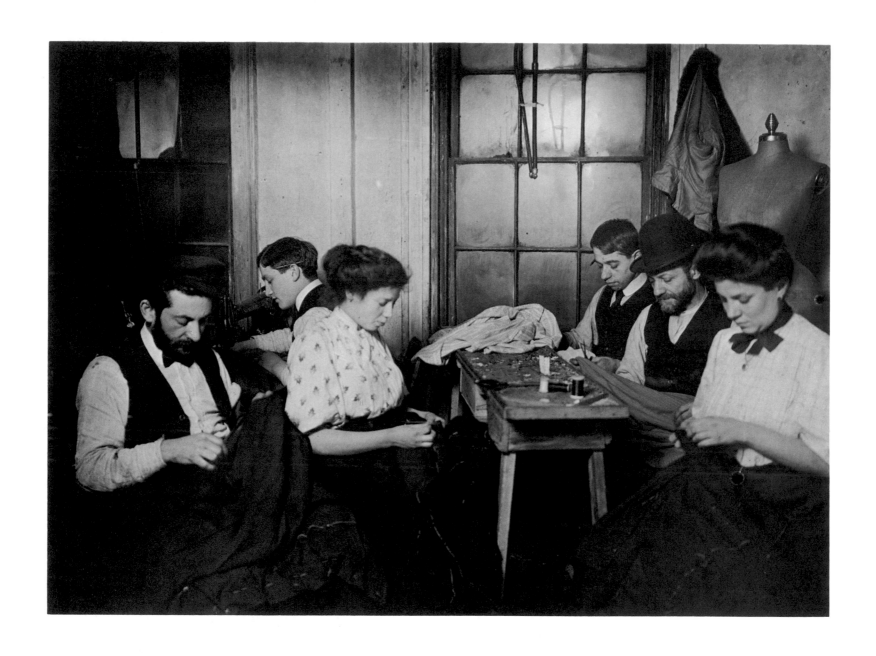

New York City sweatshop, 1908.

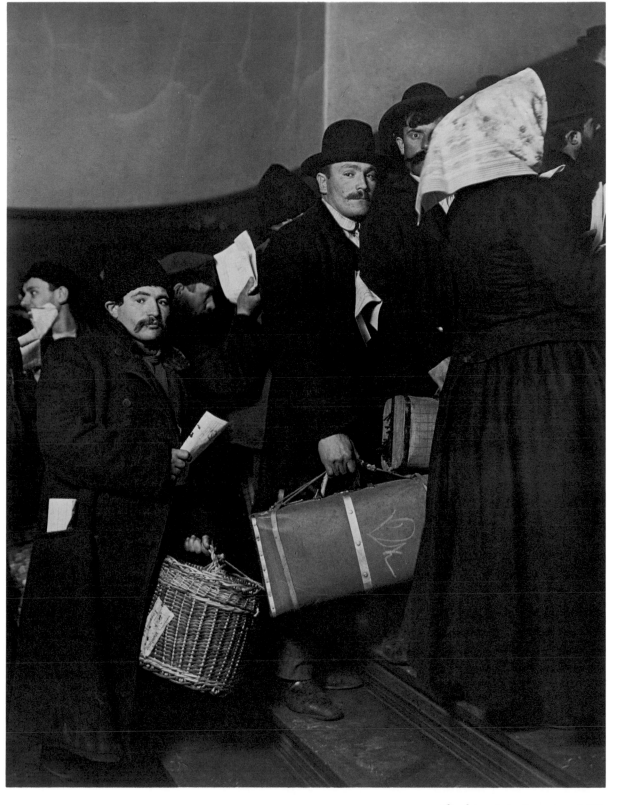

Climbing into America, 1908.

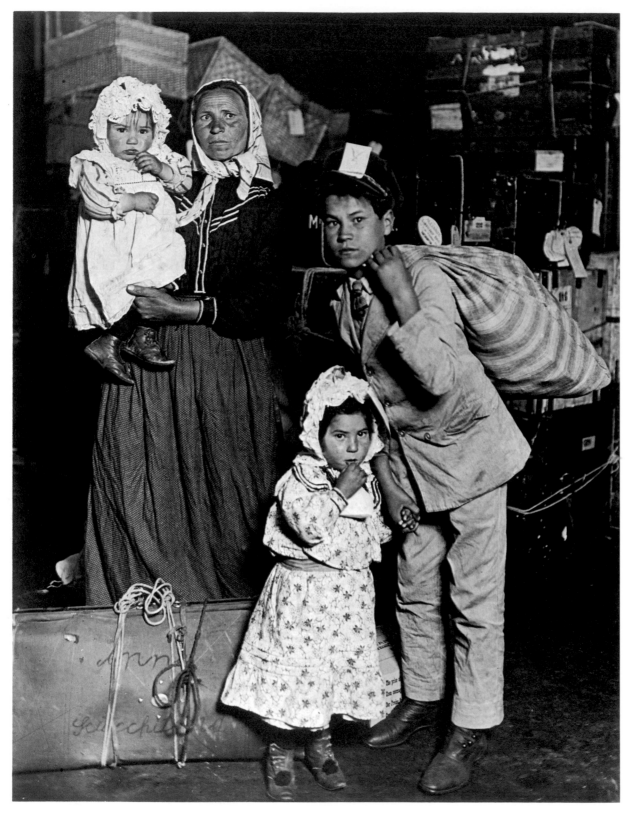

Looking for lost baggage, Ellis Island, 1905.

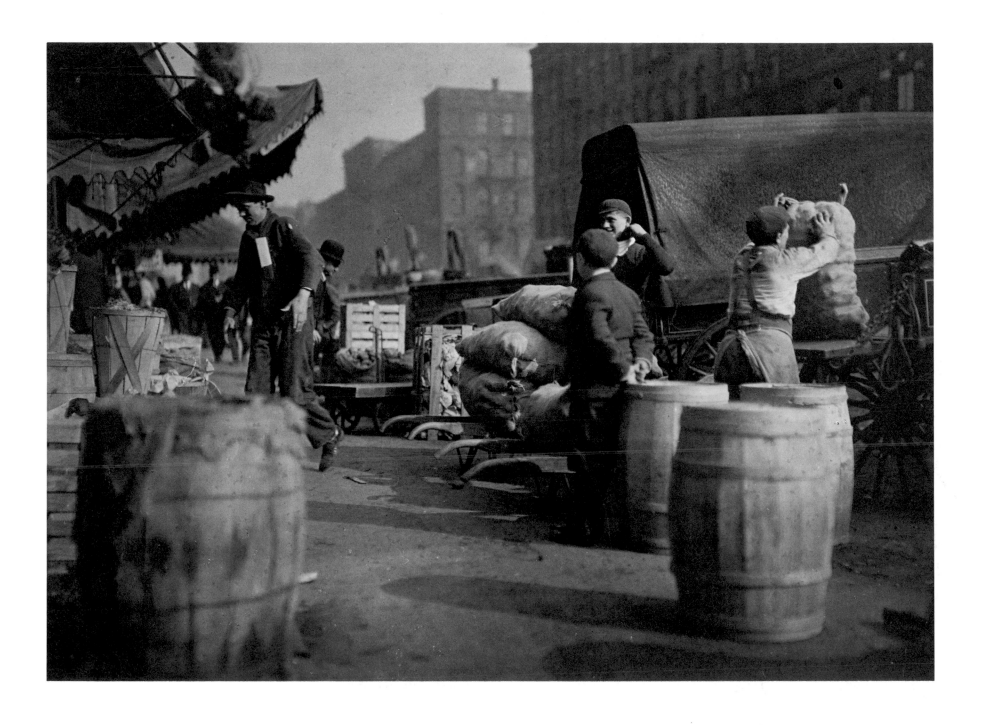

Unloading potatoes on the street, c. 1912.

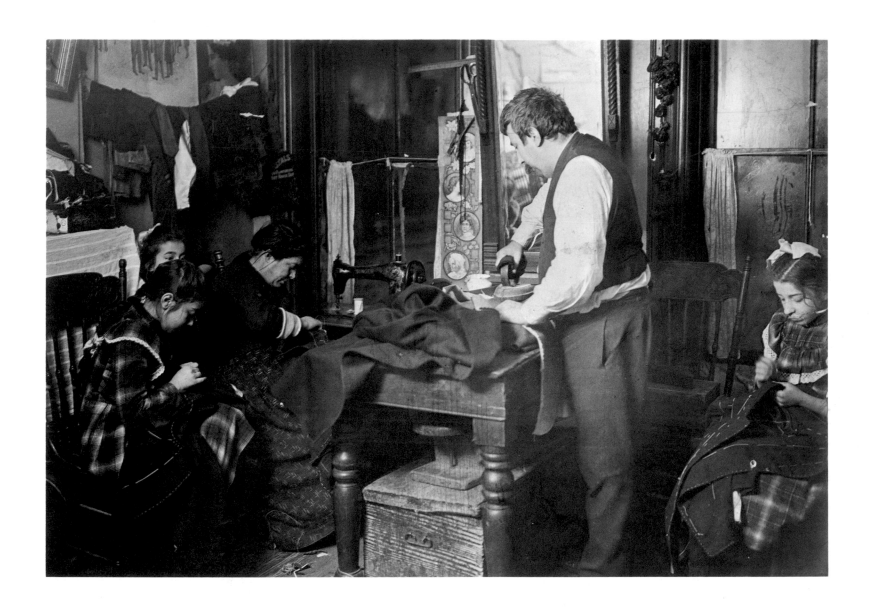

Finishing clothing, tenement homework, New York City, 1906.

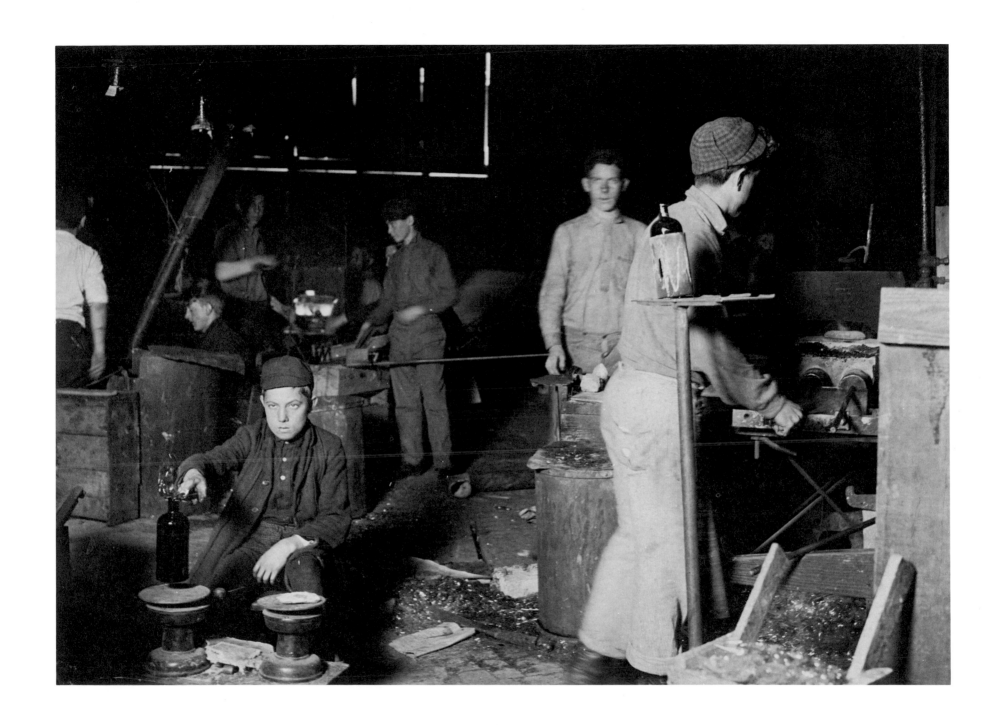

Children in New Jersey glass factory, 1909.

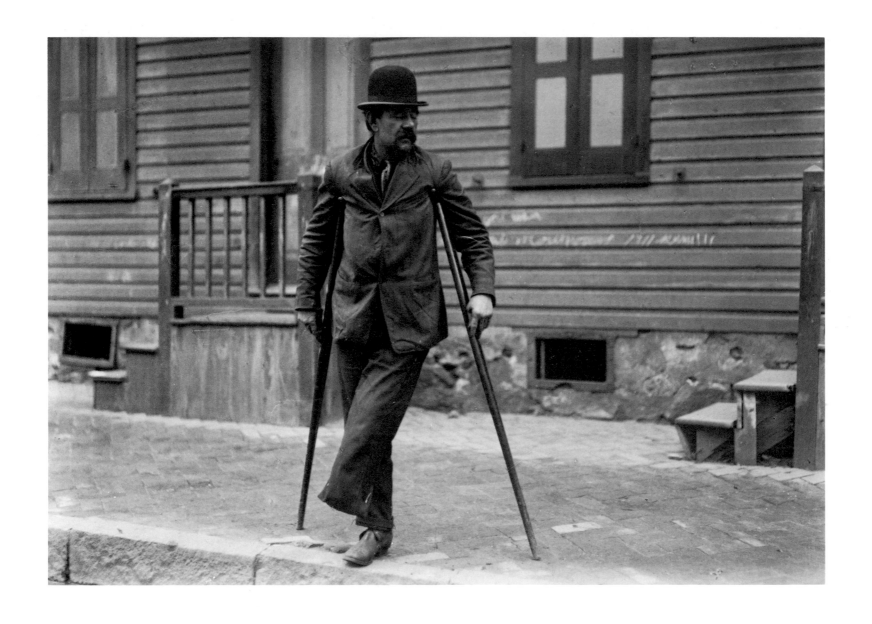

Man on crutches, c. 1910.

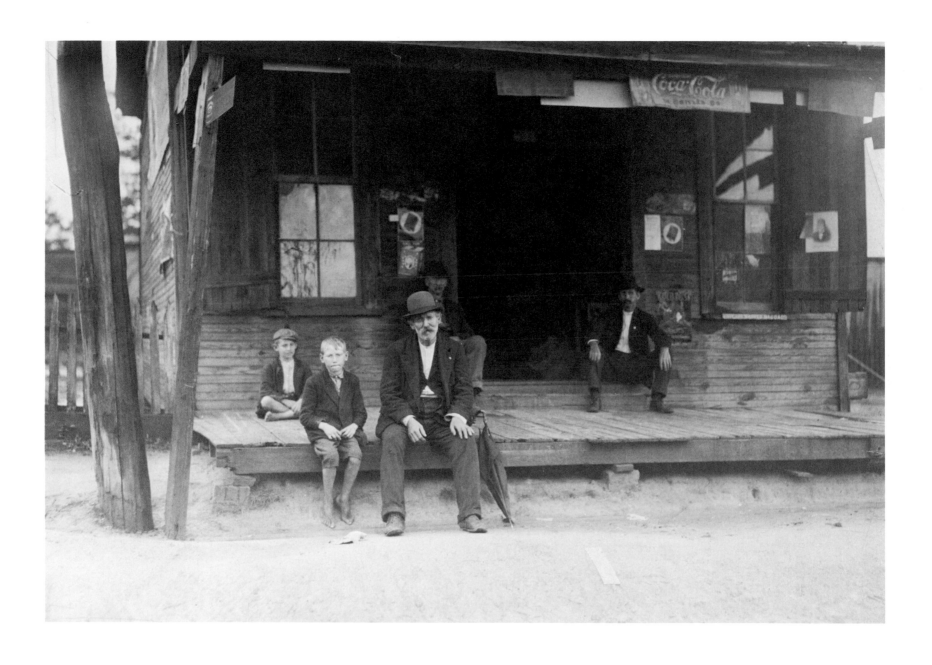

Father and working children, Meridian, Mississippi, April, 1911.

House of ill repute, patronized at noon by factory workers, Chicago, 1910/11.

Newsboys' reading room, Boston, 1909.

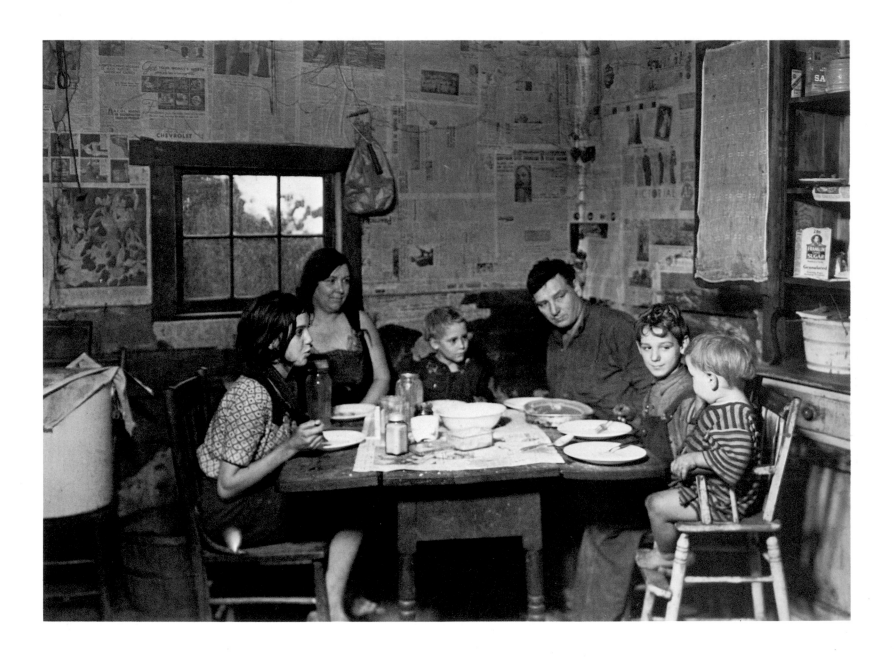

Miner's family, Scott's Run, West Virginia, 1936/37.

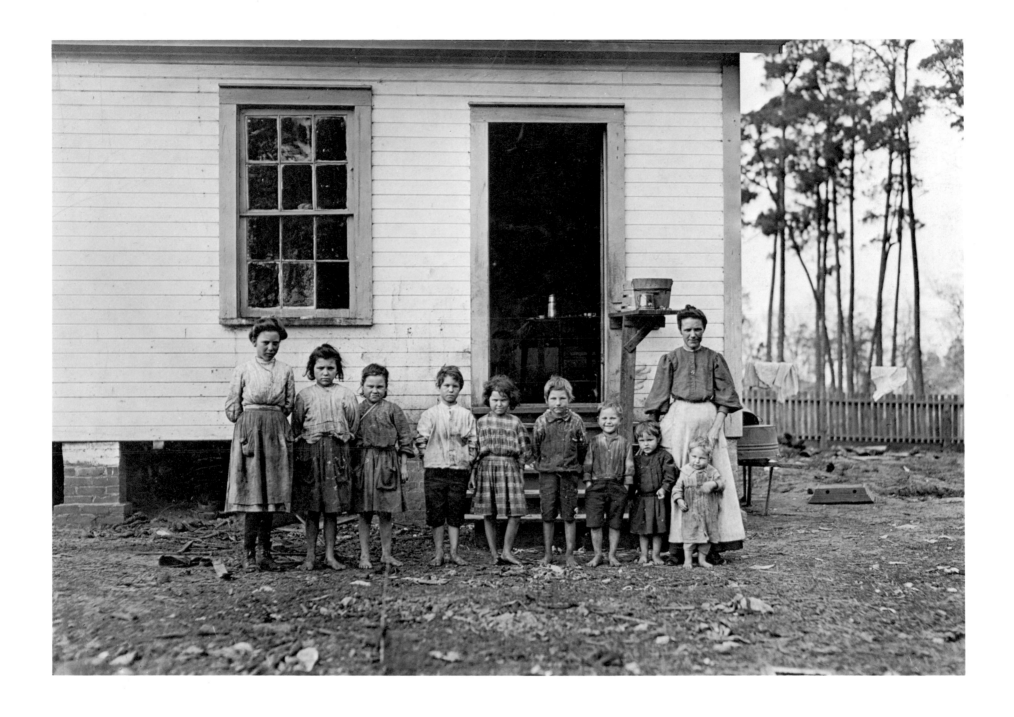

Doffer family, Tifton, Georgia, January, 1909.

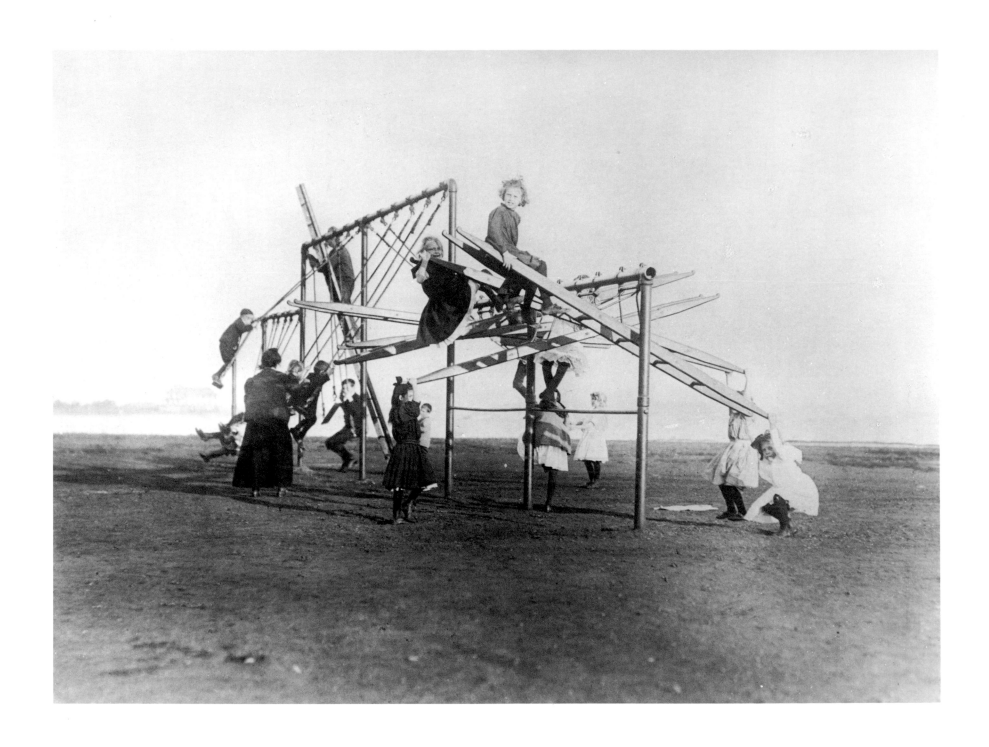

Playground, Boston, c. 1909.

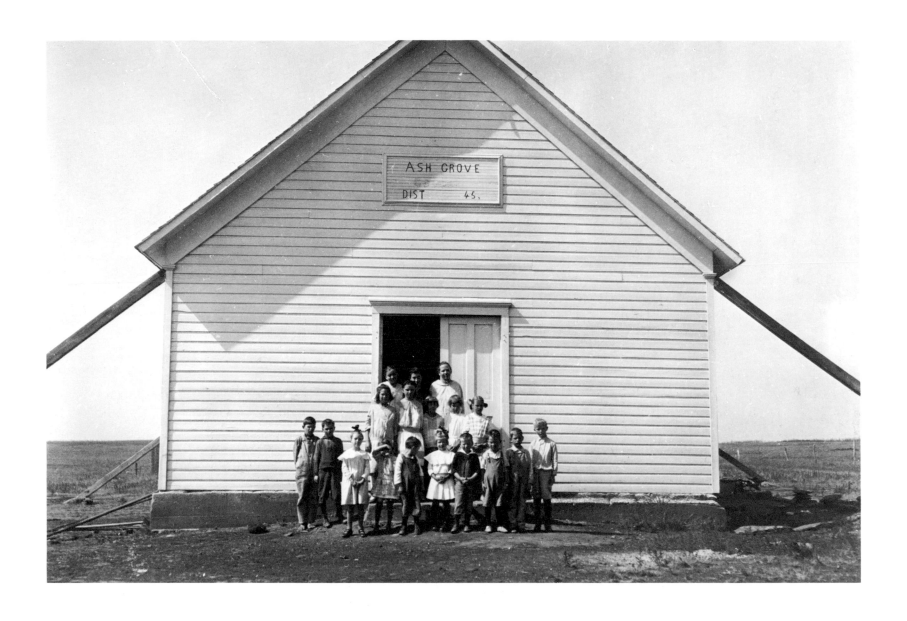

School, Ash Grove, Oklahoma, 1916.

Now, suppose we are elbowing our way thru the mob at Ellis Island trying to stop the surge of bewildered beings oozing through the corridors, up the stairs and all over the place, eager to get it all over and be on their way. Here is a small group that seems to have possibilities so we stop 'em and explain in pantomime that it would be lovely if they would only stick around just a moment. The rest of the human tide swirls around, often not too considerate of either the camera or us. We get the focus, on ground glass of course, then hoping they will stay put, get the flash lamp ready.—Letter from Lewis Hine to Elizabeth McCausland, September 10, 1923.

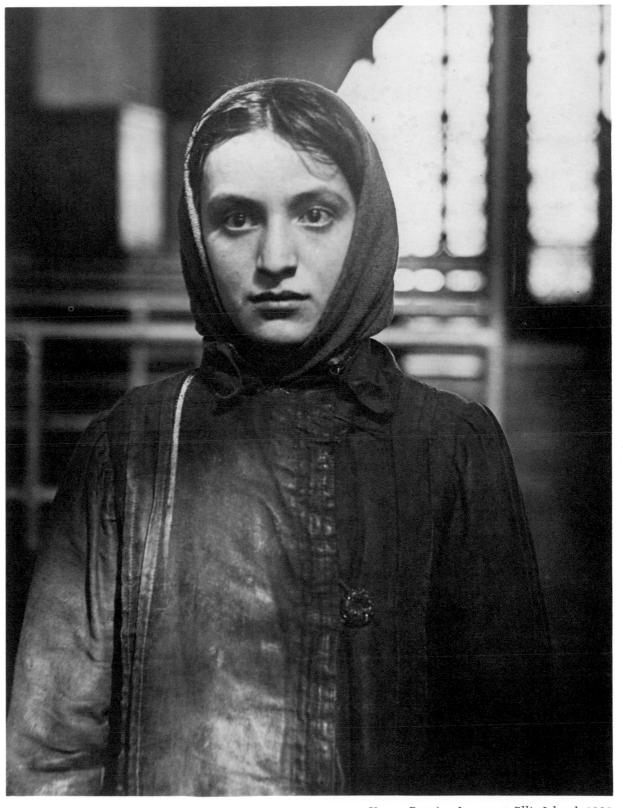

Young Russian Jewess at Ellis Island, 1905.

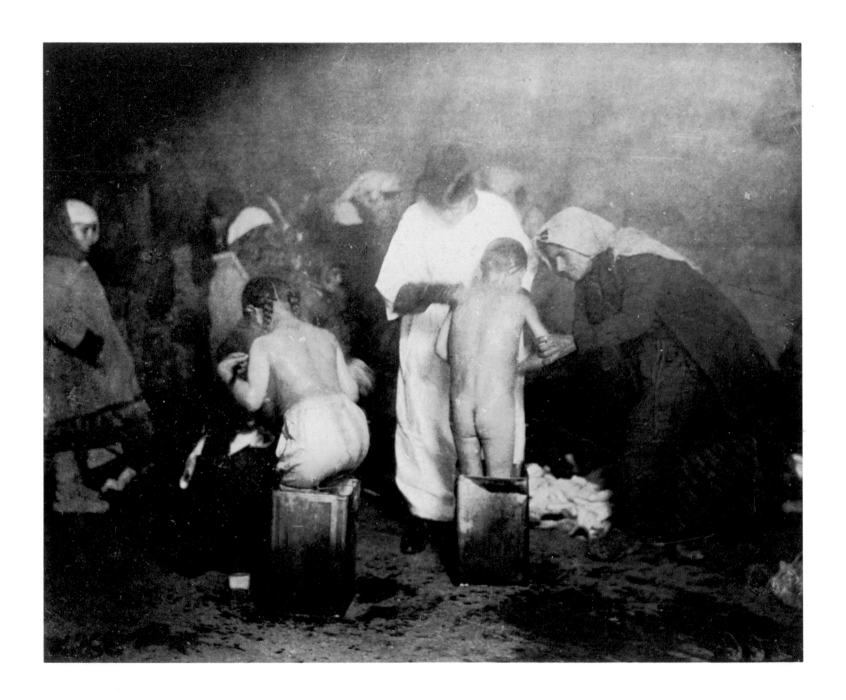

Miss Despit teaching mothers how to care for babies, Skoplie, Turkey, December, 1918.

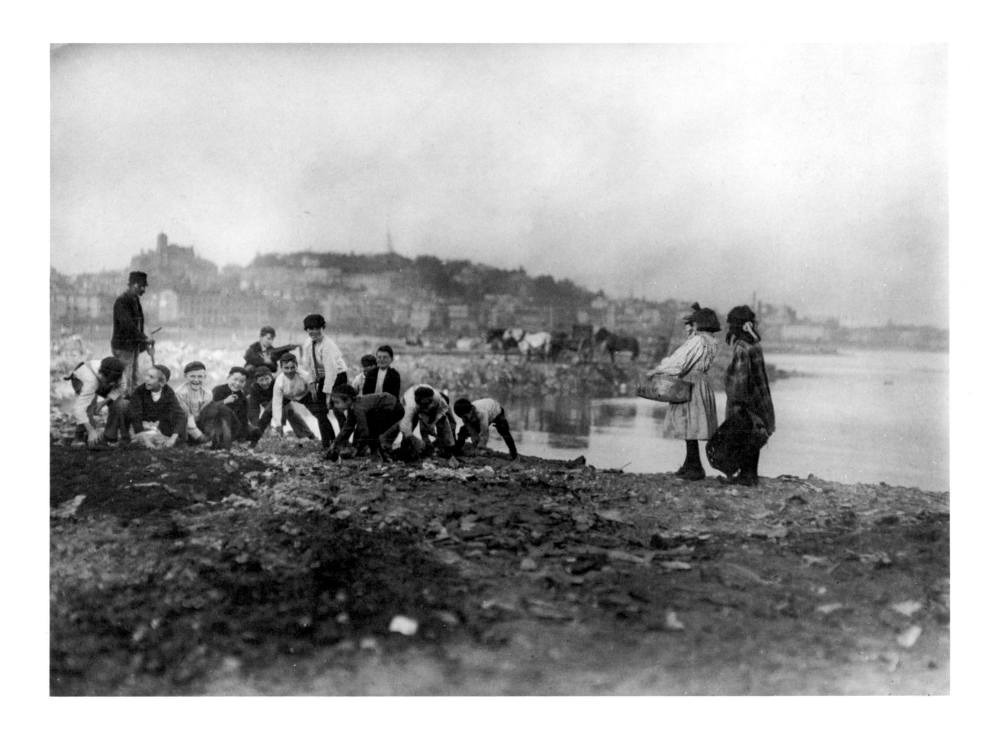

Children at the dump, Boston, c. 1909.

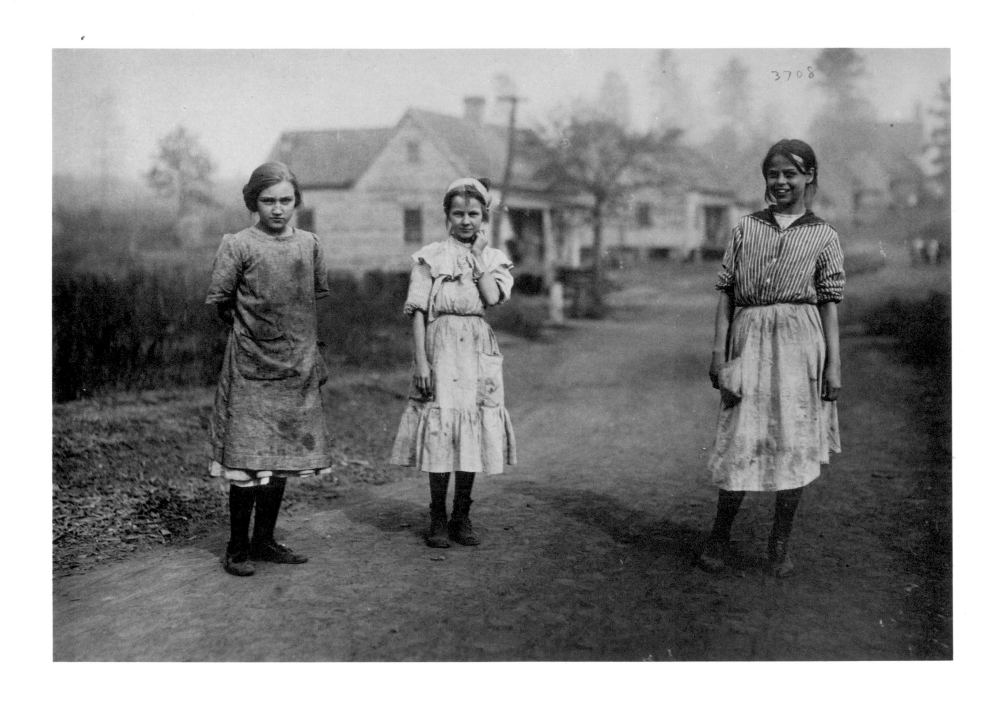

Young workers at cotton mill, Kosciusko, Mississippi, November, 1913.

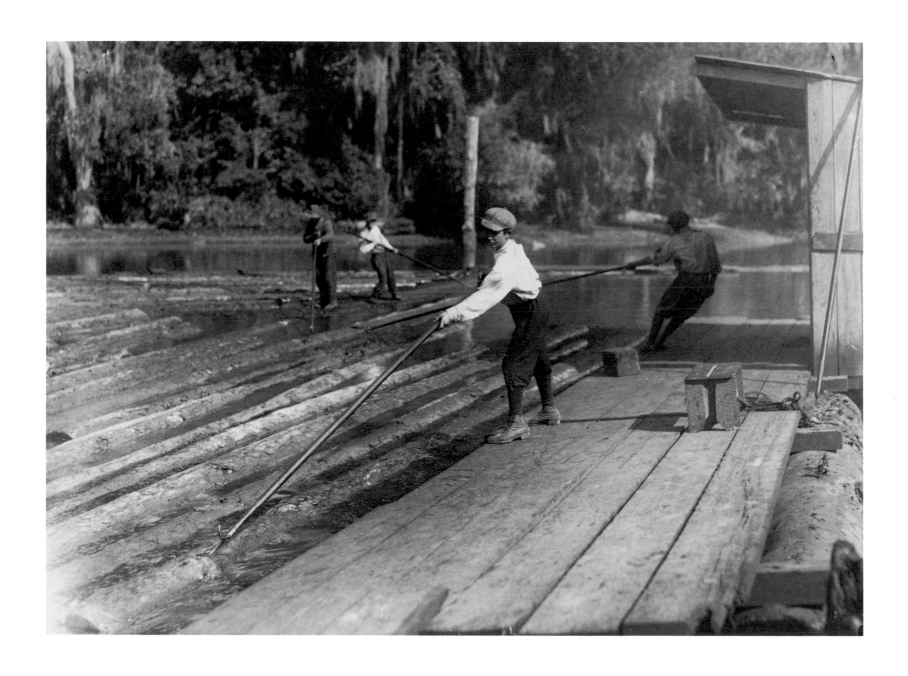

River boy, Beaumont, Texas, November, 1913.

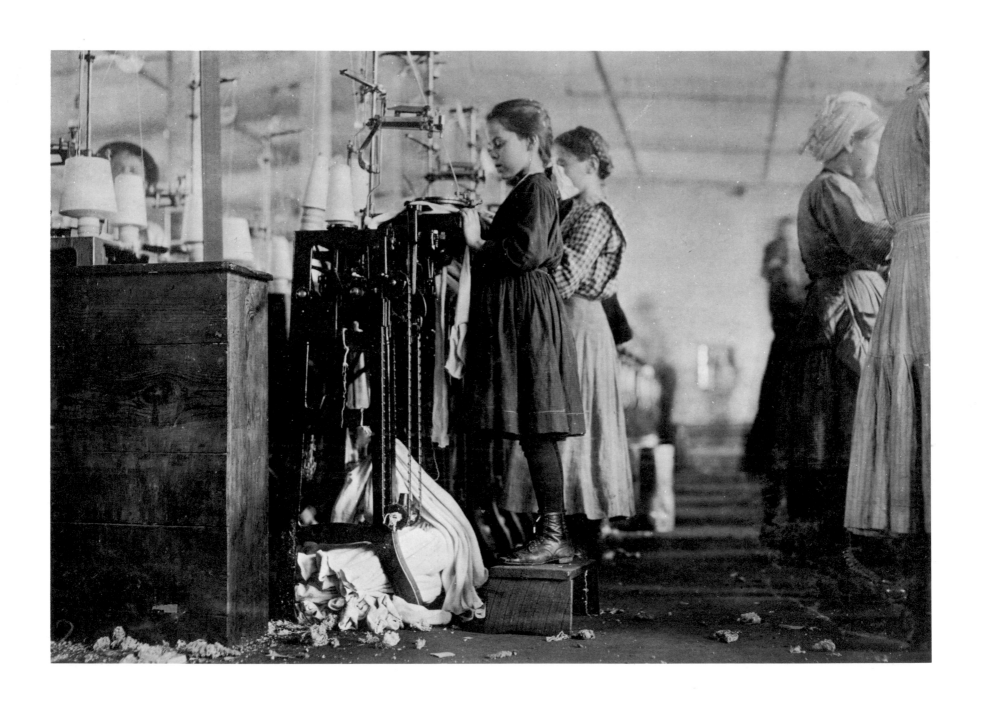

Young girls knitting stockings in Southern hosiery mill, 1910.

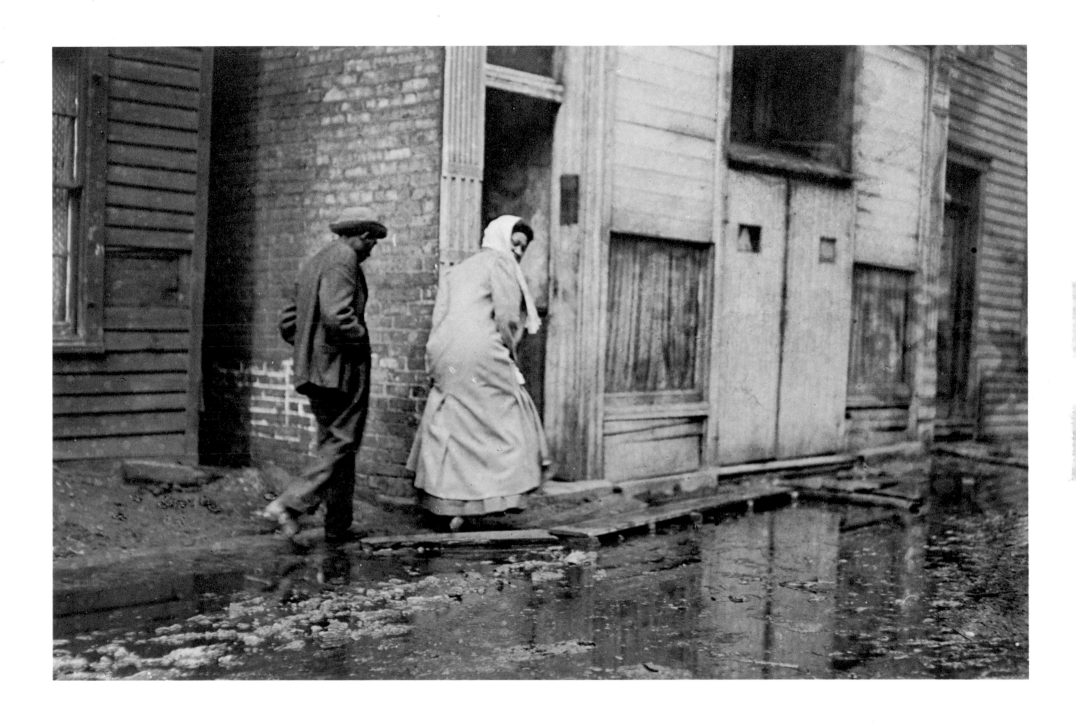

Red-light district at noon, Chicago, 1911.

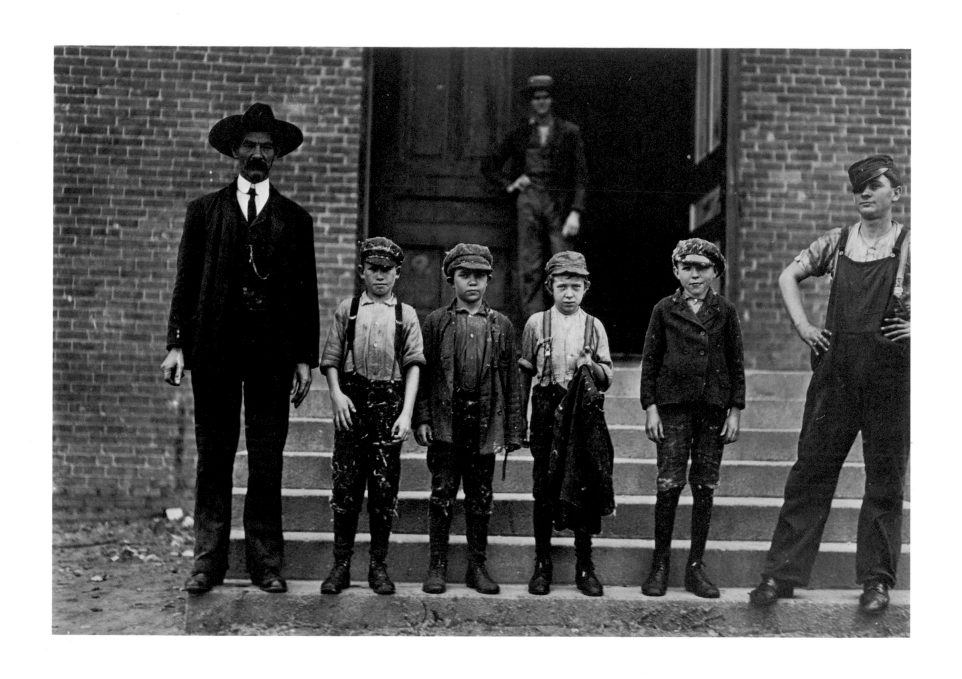

Gastonia, North Carolina, November, 1908.

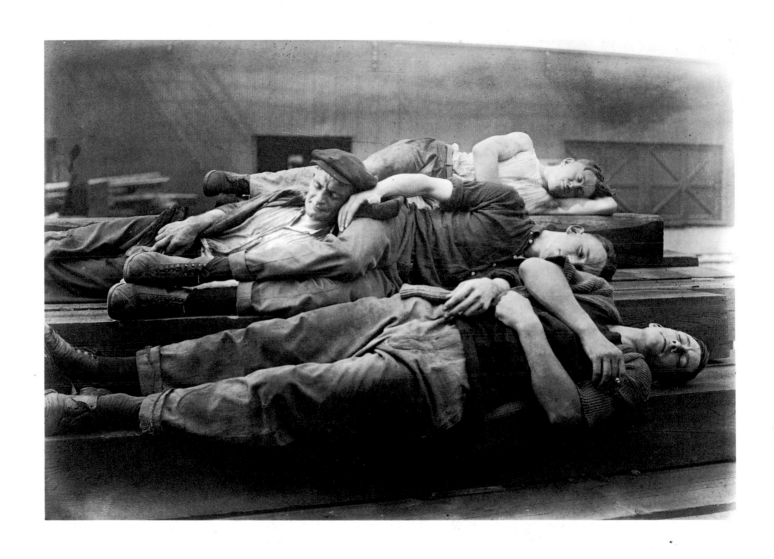

Dock workers enjoying siesta, New York City, c. 1922.

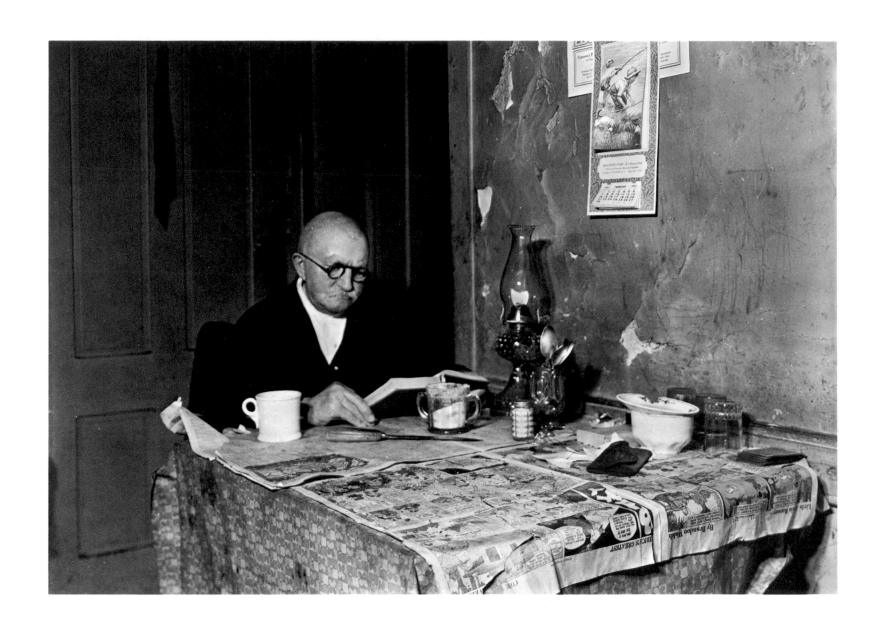

Old man, 1936/37.

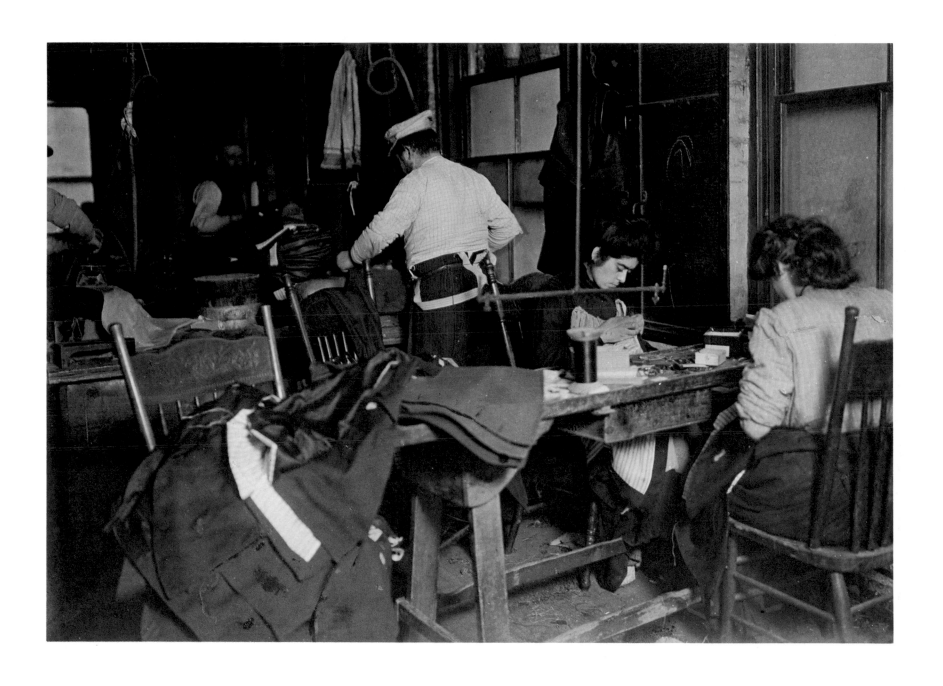

New York City sweatshop, 1908.

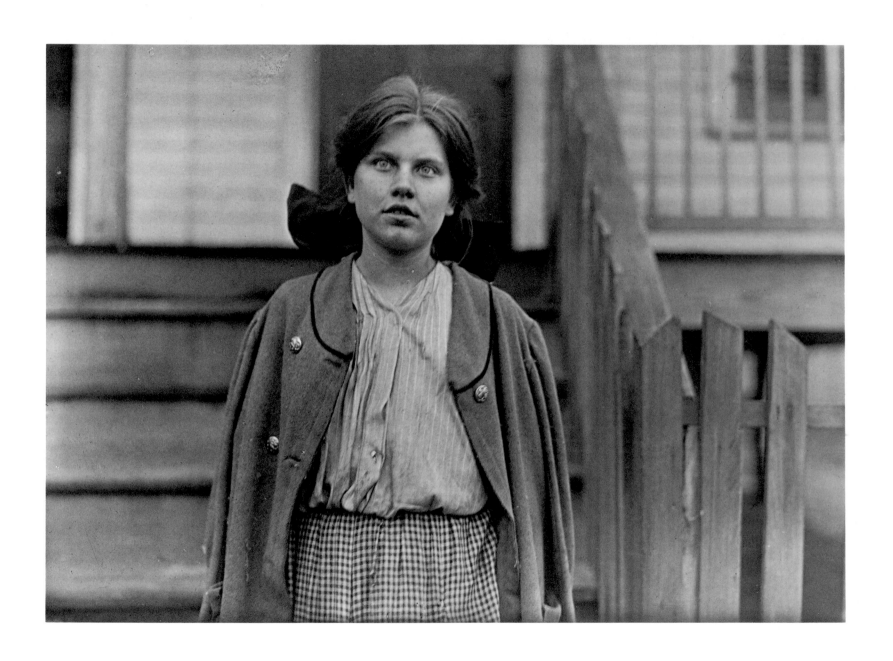

"Joan at the Mill," North Carolina cotton mill, 1909.

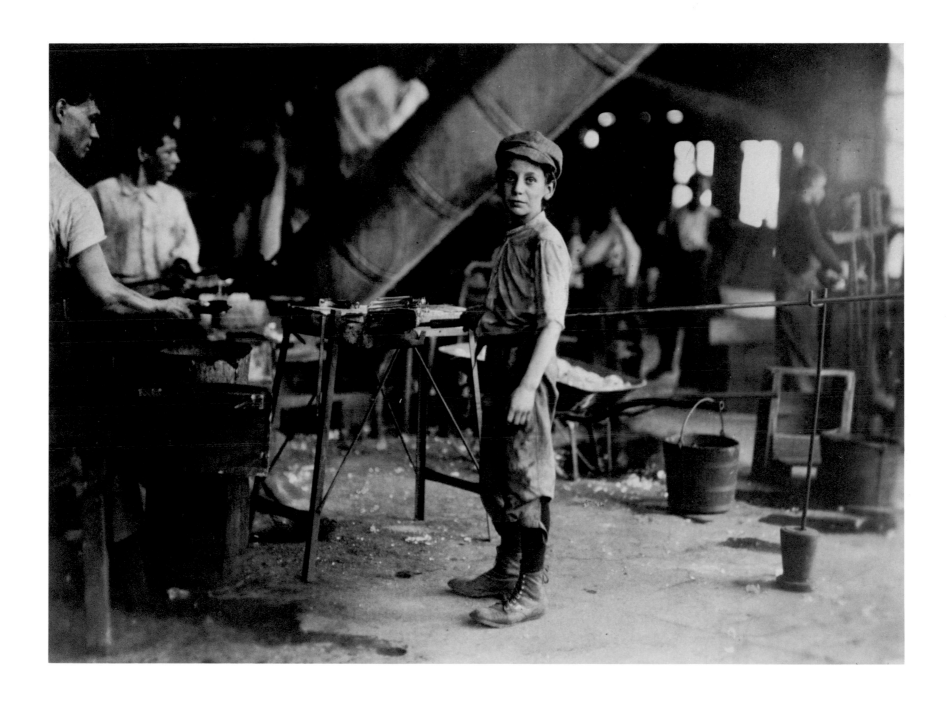

Factory boy, glassworks, 1909.

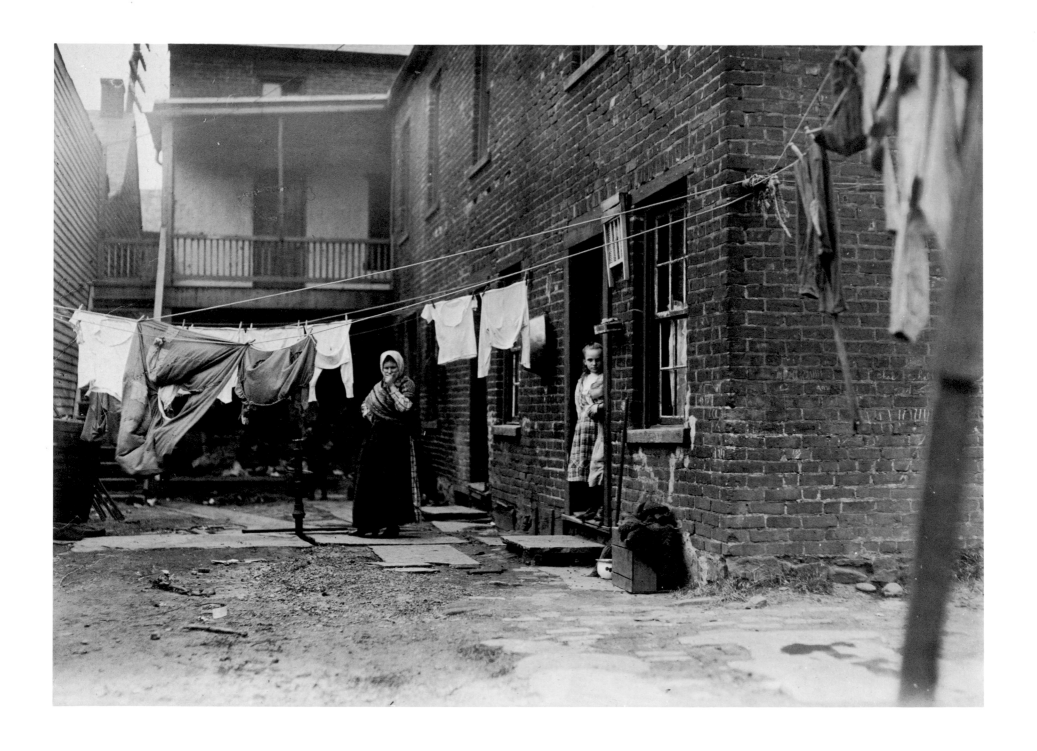

Tenement house and yard, Pittsburgh, 1907/08.

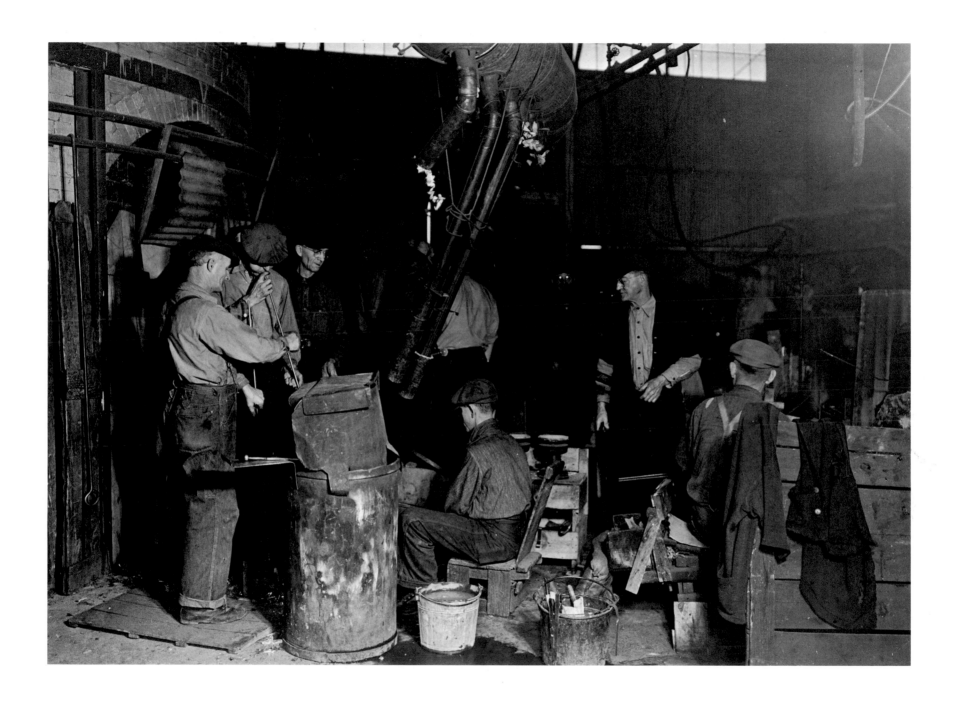

Factory interior, Baldwin Locomotive Works, Eddystone, Pennsylvania, 1936/37.

Then the pieces rattled down through long chutes at which the breaker boys sat. These boys picked out the pieces of slate and stone that cannot burn. It's like sitting in a coal bin all day long, except that the coal is always moving and clattering and cuts their fingers. Sometimes the boys wear lamps in their caps to help them see through the thick dust. They bend over the chutes until their backs ache, and they get tired and sick because they have to breathe coal dust instead of good, pure air.

Hundreds and hundreds of boys work in the mines and in the breakers from early morning until evening, instead of going to school and playing outdoors.—"Mr. Coal's Story," Child Labor Bulletin, *August, 1913*

There is a prevailing impression that in the matter of child labor the emphasis on the labor must be very slight, but let me tell you right here that these processes involve work, hard work, deadening in its monotony, exhausting physically, irregular, the workers' only joy the closing house. We might even say of these children that they are condemned to work.
—"Baltimore to Biloxi and Back," Lewis W. Hine, The Survey, *May 3, 1913*

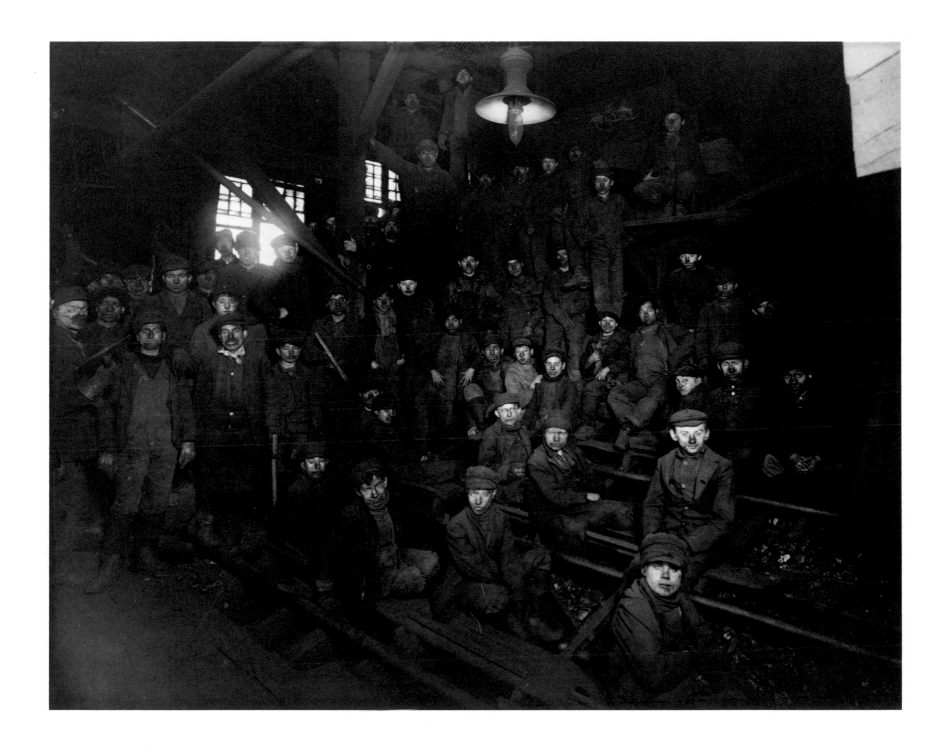

Breaker boys in coal chute, South Pittston, Pennsylvania, January, 1911.

West Virginia coal mine, 1908.

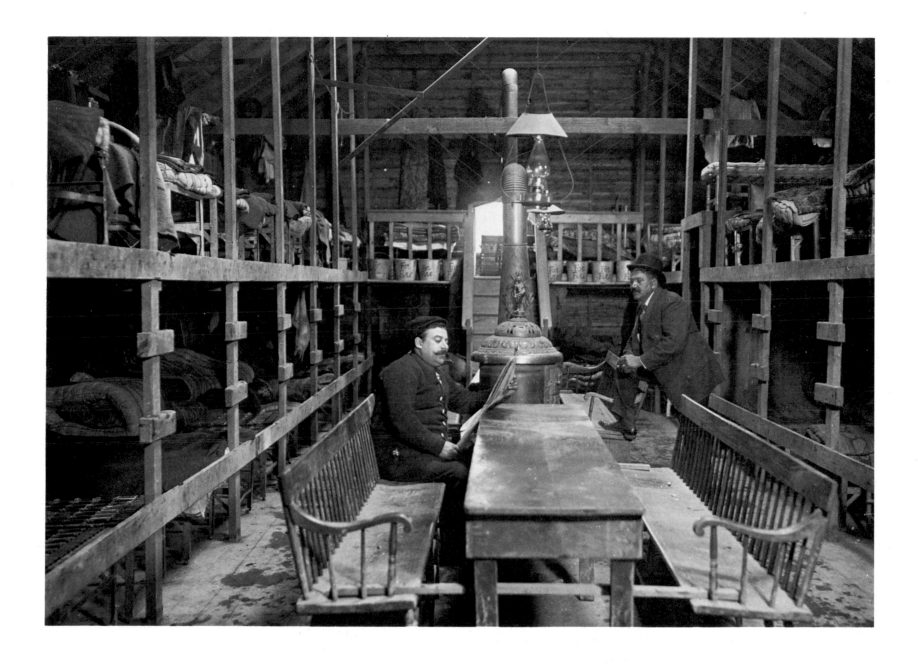

Sleeping quarters of immigrant workers, construction camp, New York State Barge Canal, 1909.

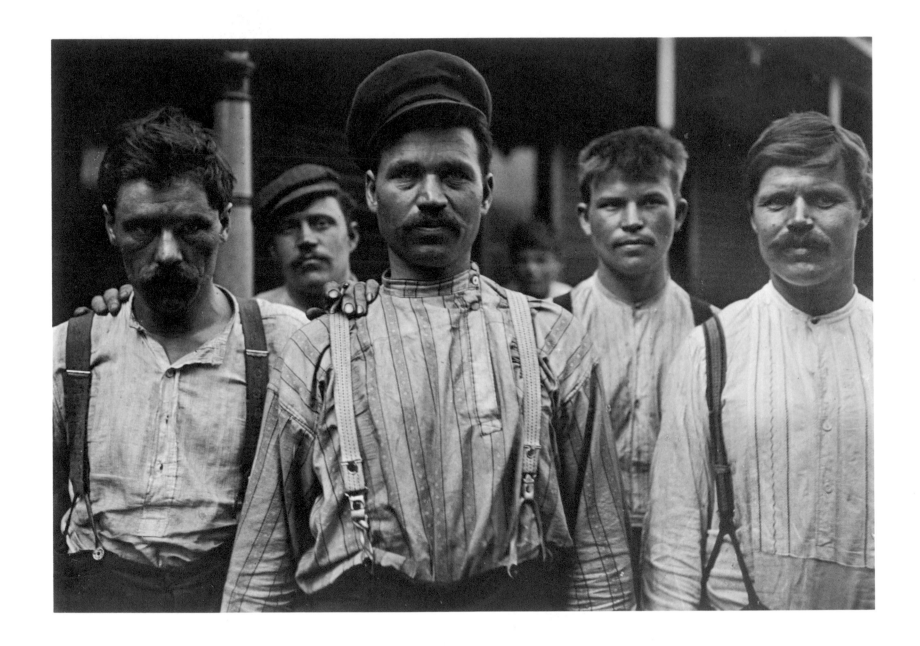

Steelworkers at Russian boarding house, Homestead, Pennsylvania, 1907/08.

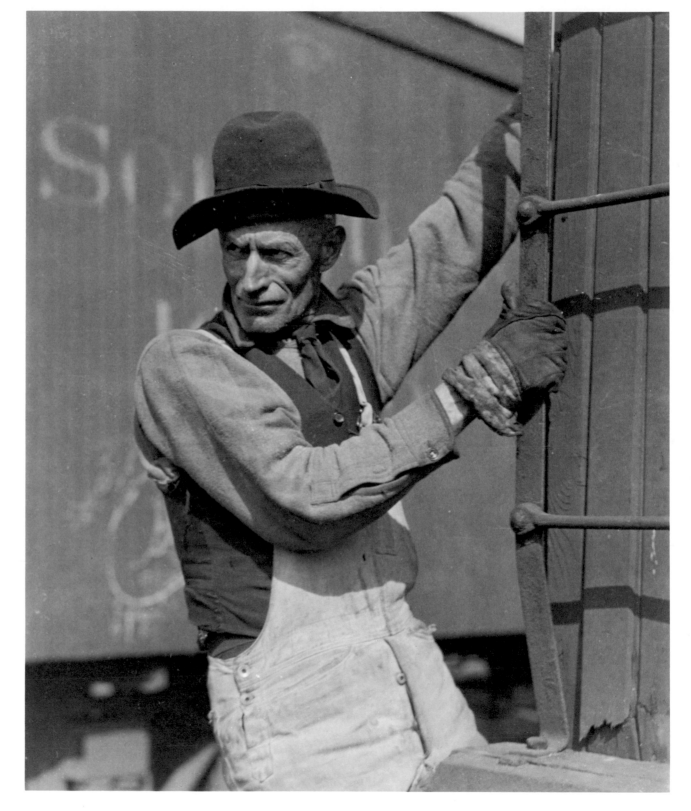

Freight brakeman, New York Central Lines, 1921.

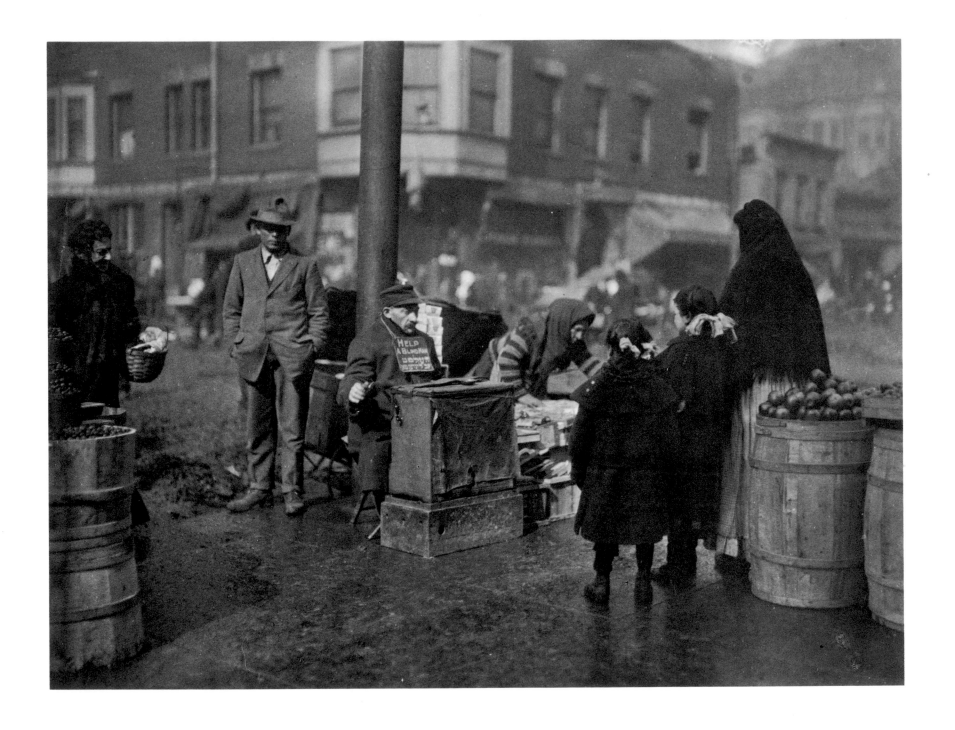

Blind beggar in Italian market district, Chicago, 1911.

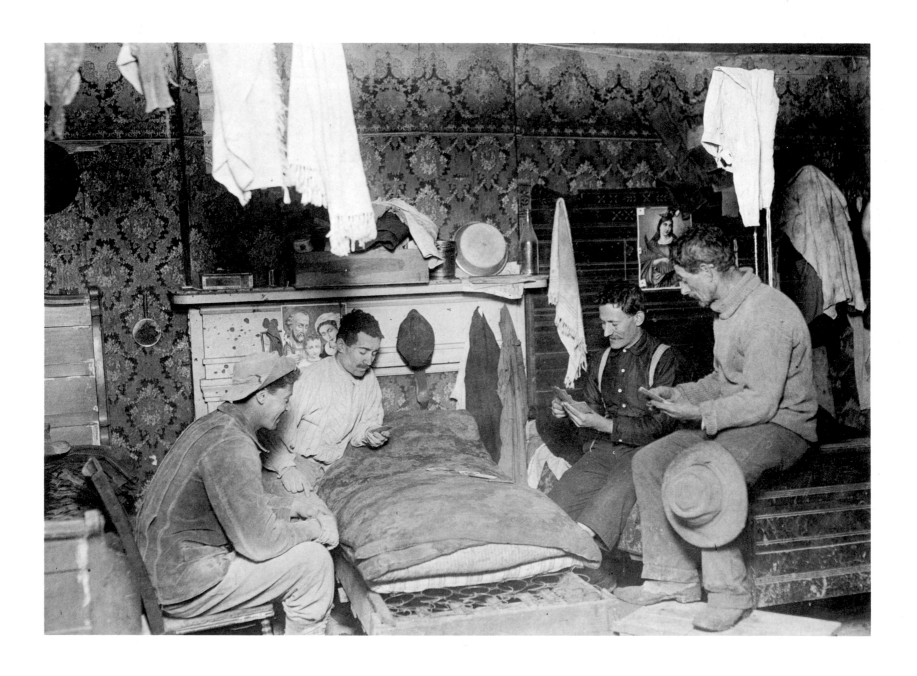

Inside workers' quarters, New York State Barge Canal Construction Camp, 1909.

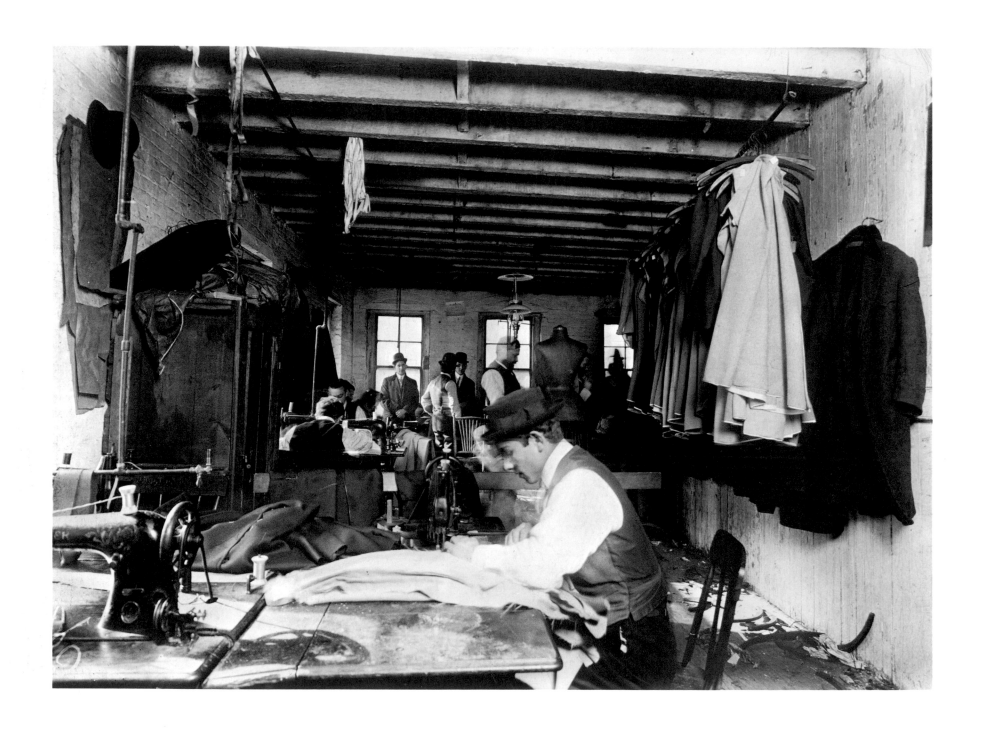

Old-time sweatshop, New York City, 1912.

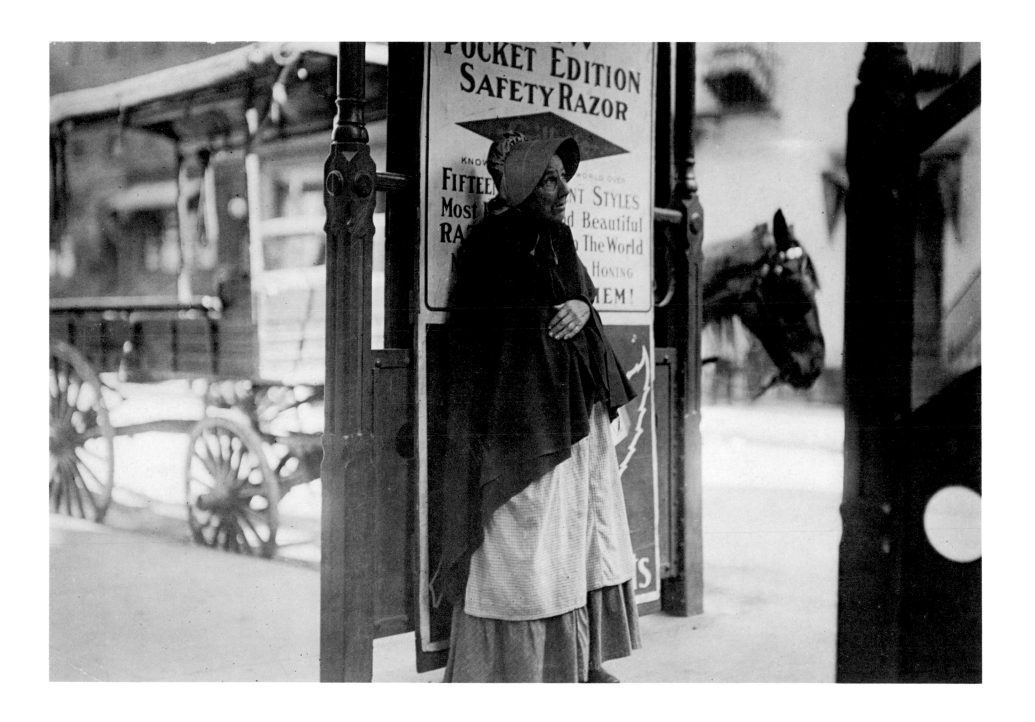

Beggar, New York City, 1910.

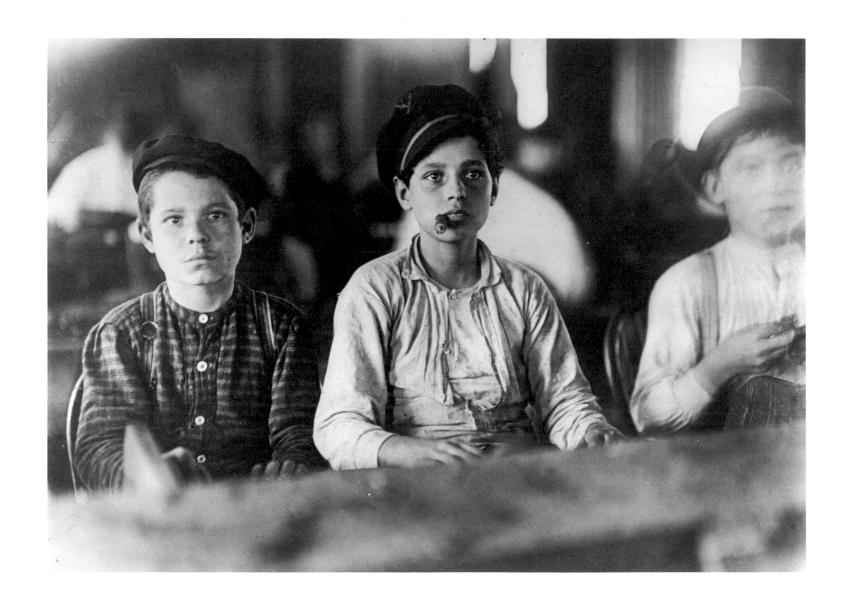

Cigar makers, Tampa, 1909.

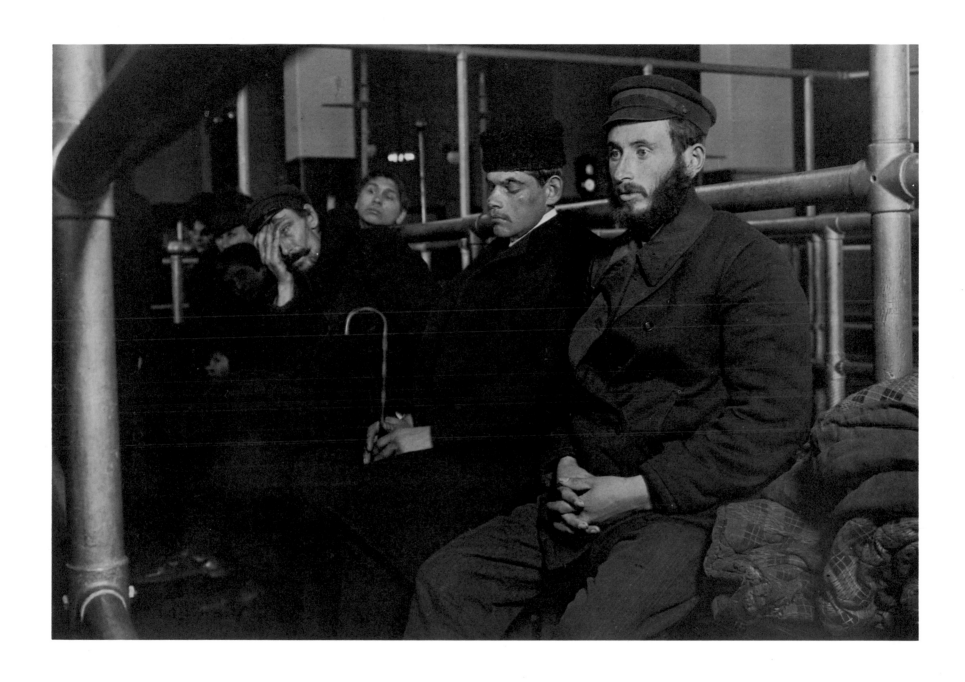

Jews at Ellis Island, 1904.

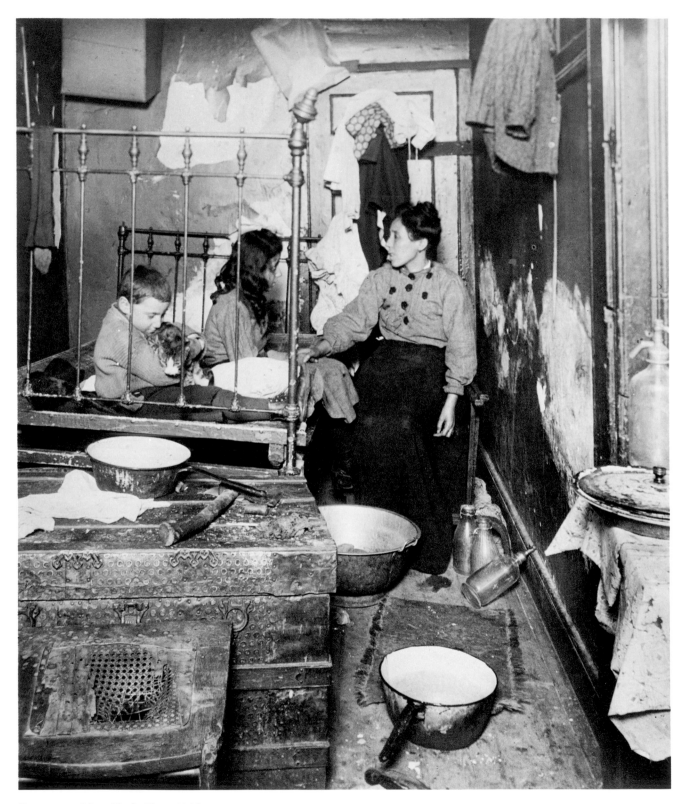

Tenement, New York City, 1910.

Workers outside Pittman Handle Factory, Denison, Texas, September, 1913.

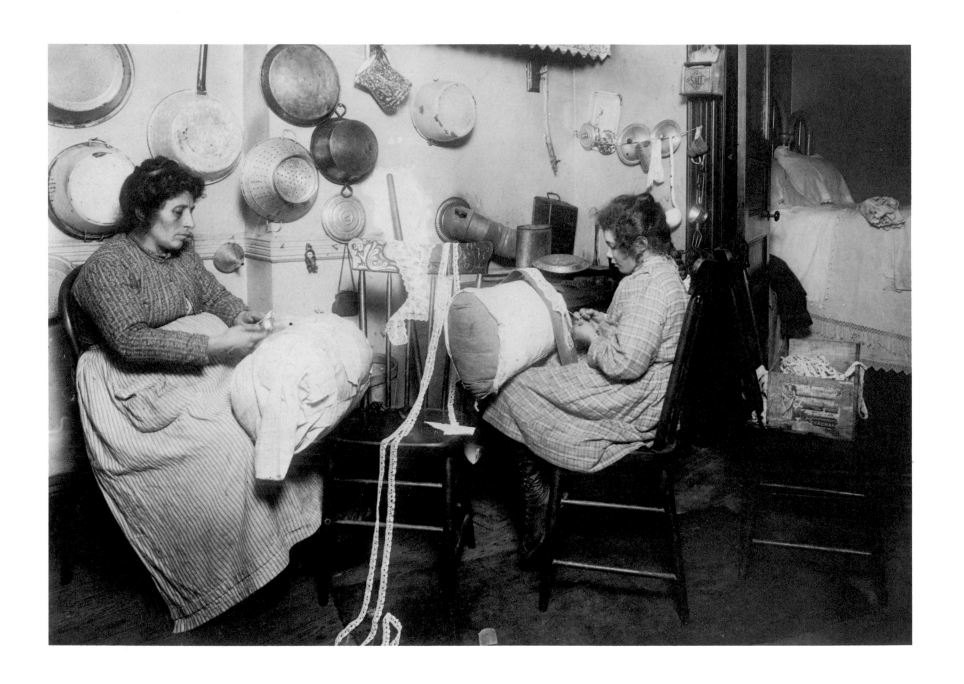

Making pillow lace, New York City, December 22, 1911.

72

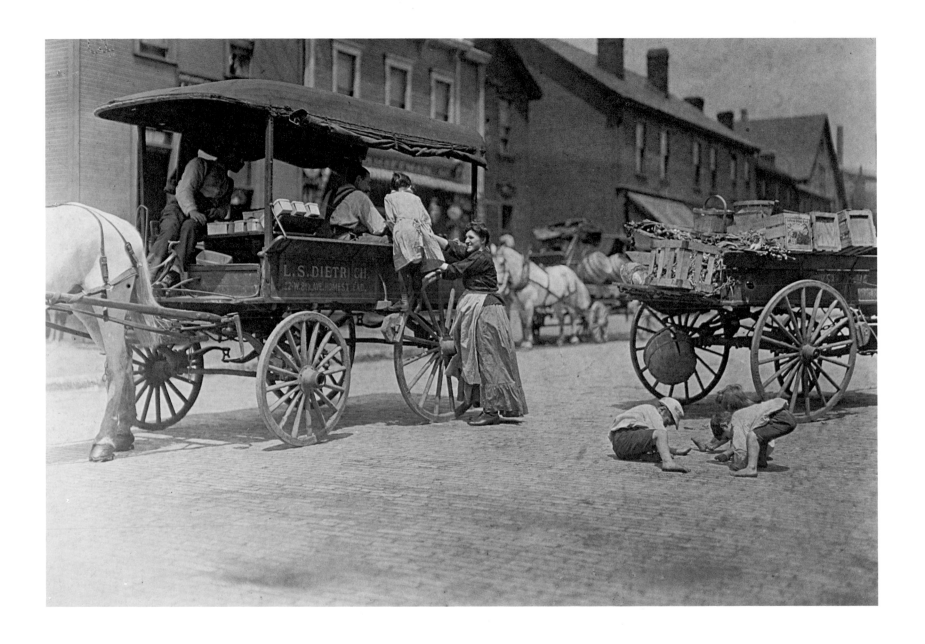

Street market, Homestead, Pennsylvania, 1907/08.

Two really significant aspects of my work have been recognized: The acceptance of the common man in contrast to the white collar stuff and the value of the realistic photography which has for some time been displaced by the fuzzy impressionism of the day. It has taken five years of hard work to make these two tiny dents in the armor of complacency but it it has been worth it. —Letter from Lewis Hine to Paul Kellogg, April 8, 1924

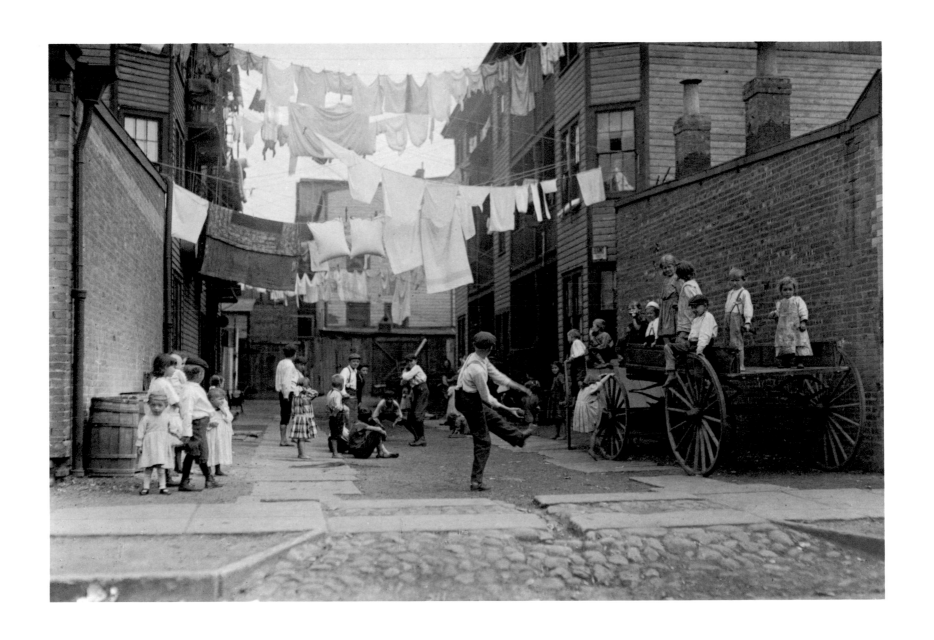

Playground in tenement alley, Boston, 1909.

Dannie Mercurio, Washington, D.C., 1912.

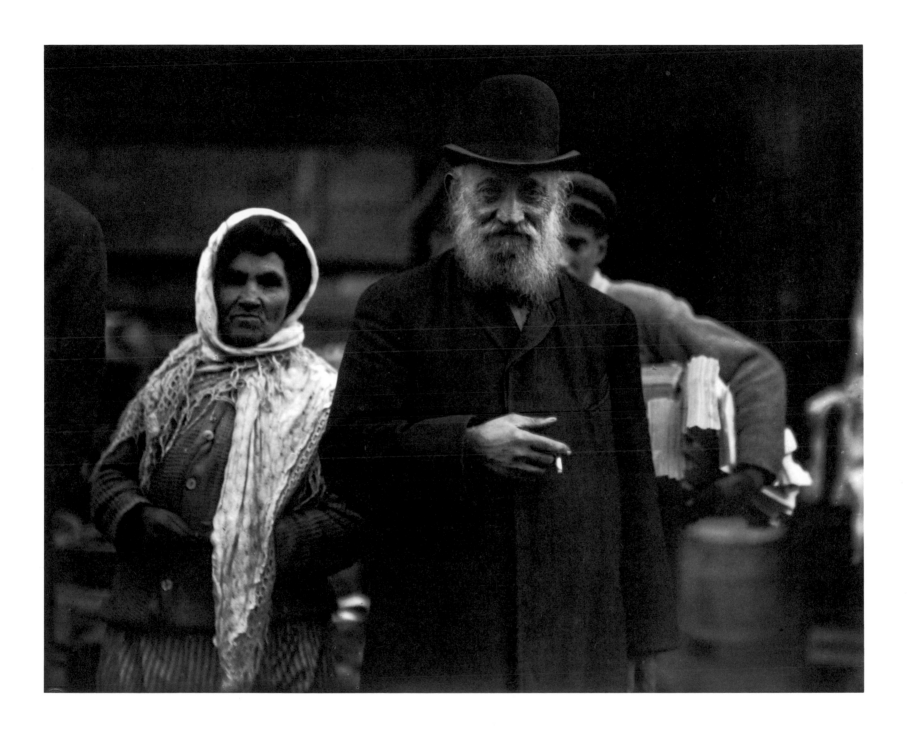

East Side, New York City, 1910.

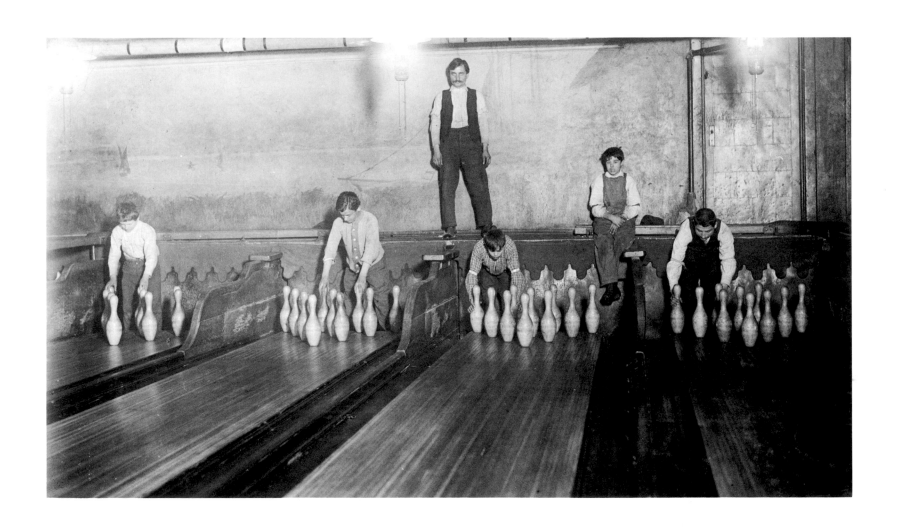

Pin boys in Subway Bowling Alley, New York City, 1909.

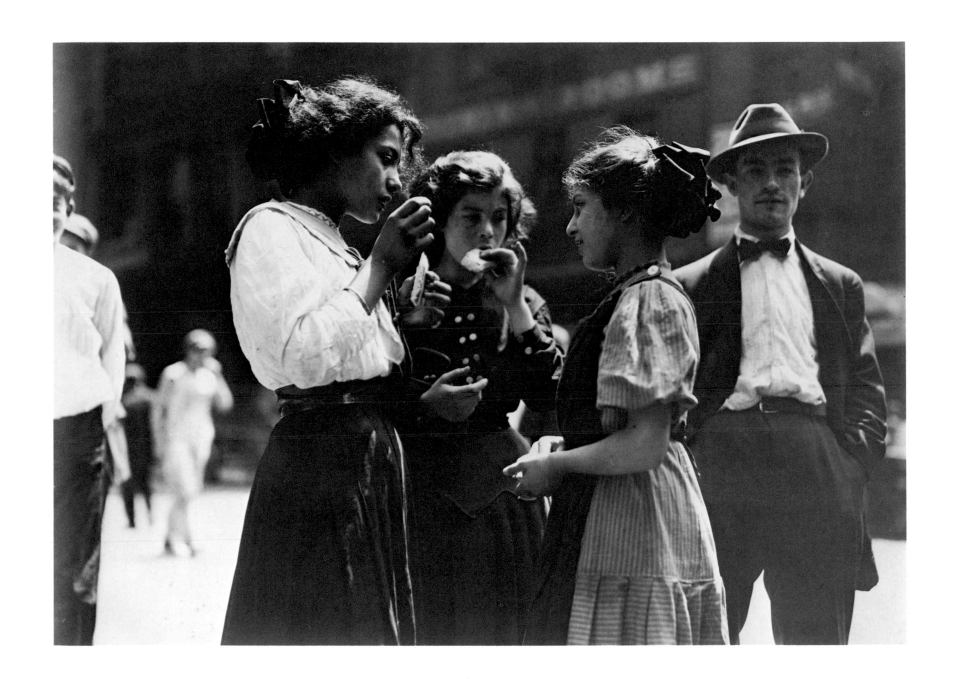

Lunchtime, 1915.

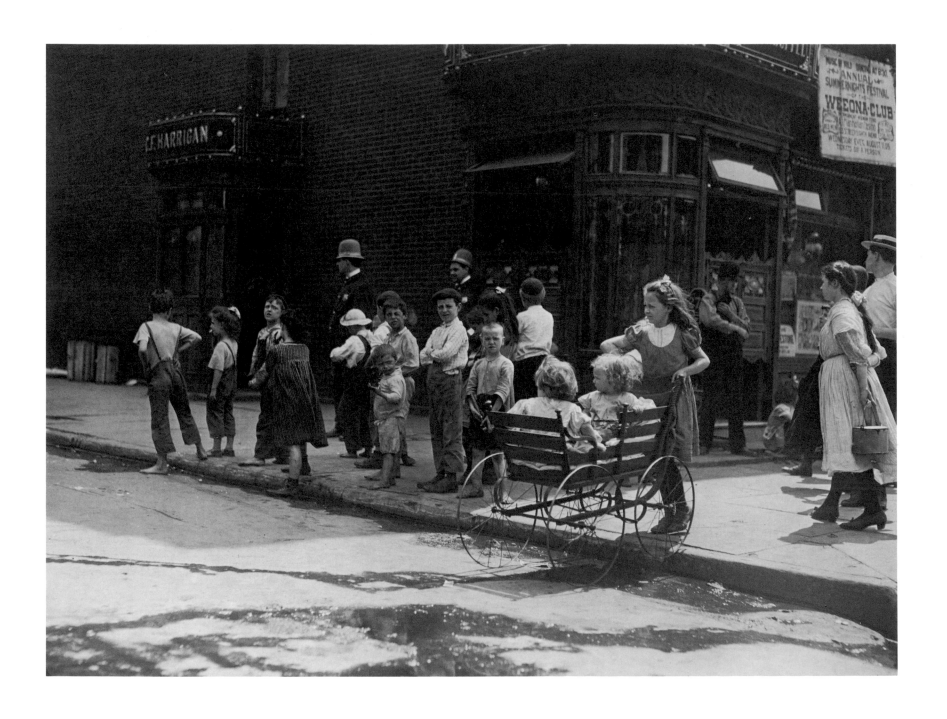

Street children, New York City, c. 1908.

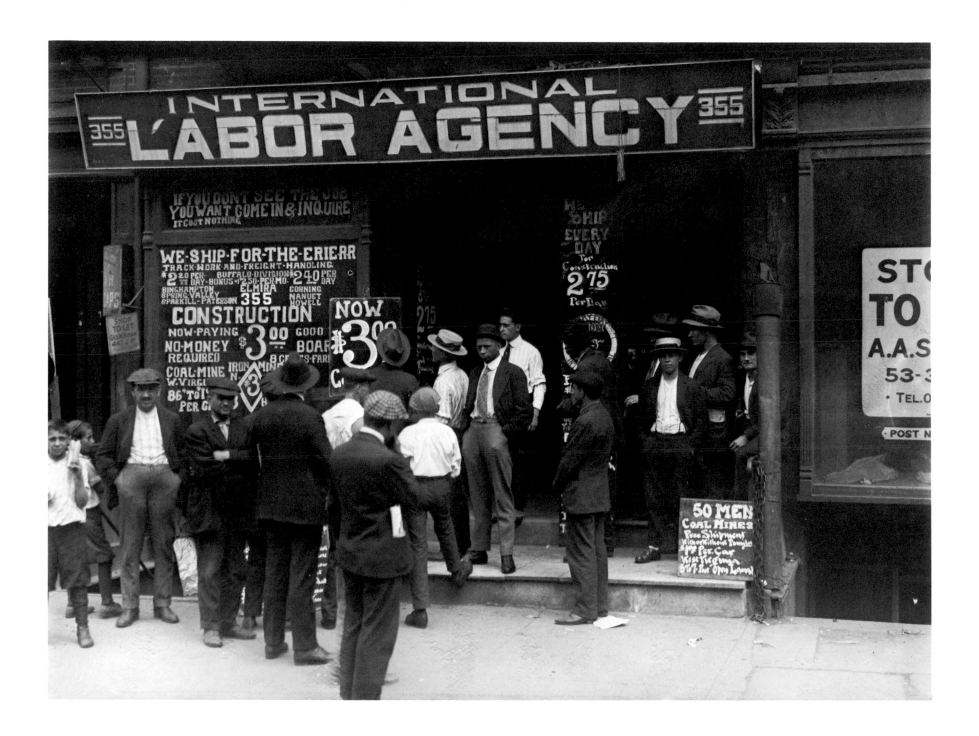

Labor Agency, New York City, 1910.

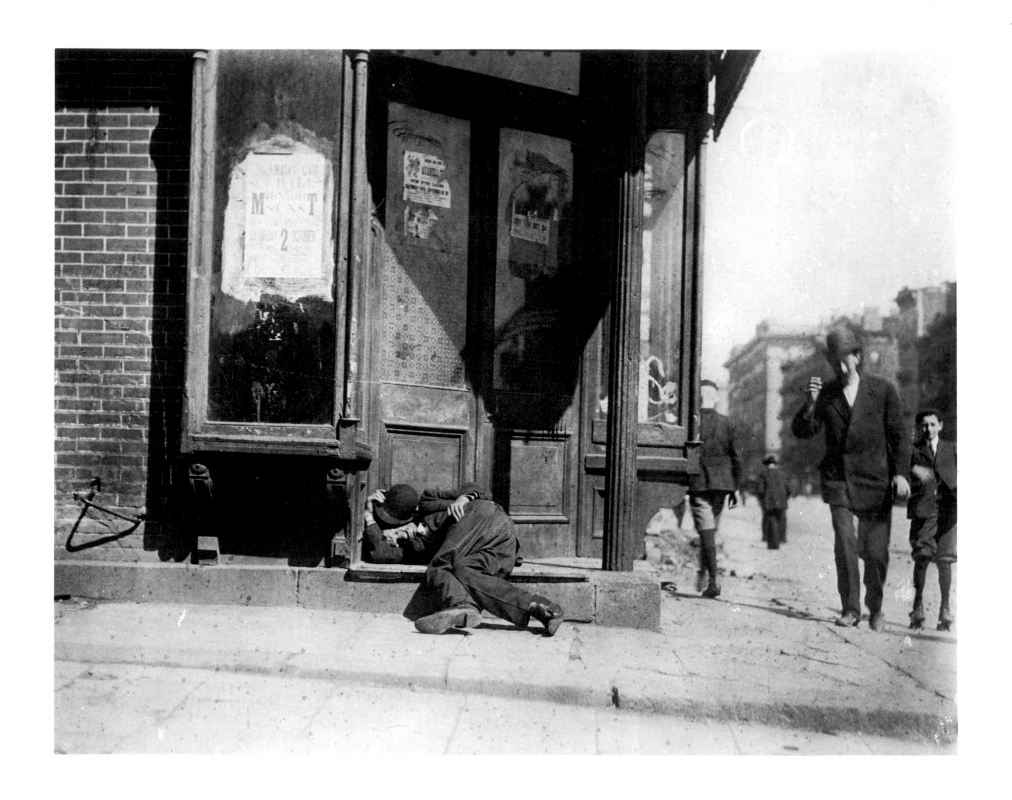

Man asleep in doorway, c. 1910.

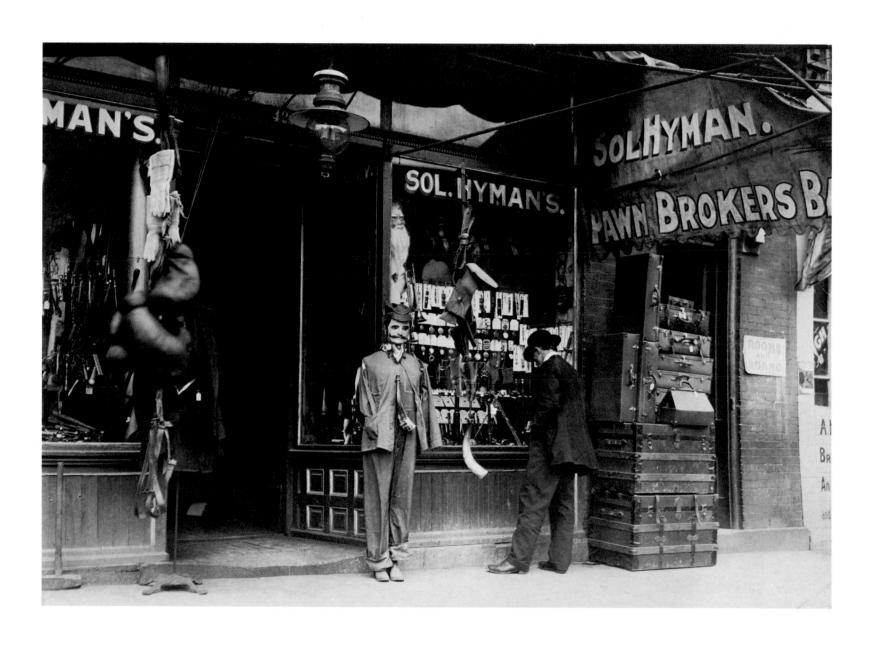

Pawnbroker's shop in disreputable district, Nashville, 1910.

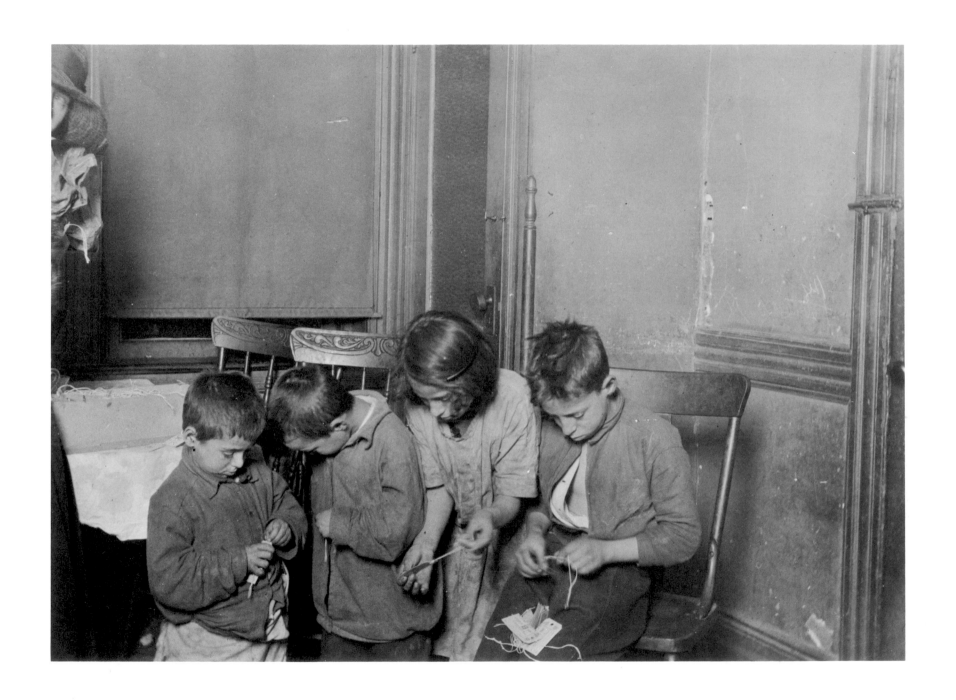

Children stringing milk tags, Newark, 1923.

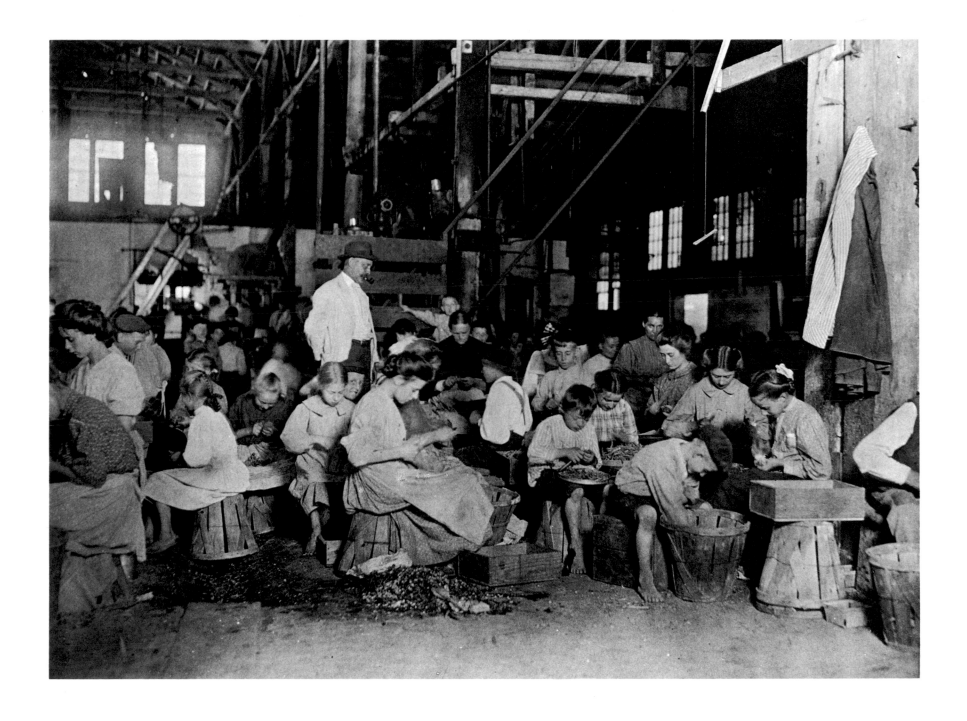

Cannery workers preparing beans, c. 1910.

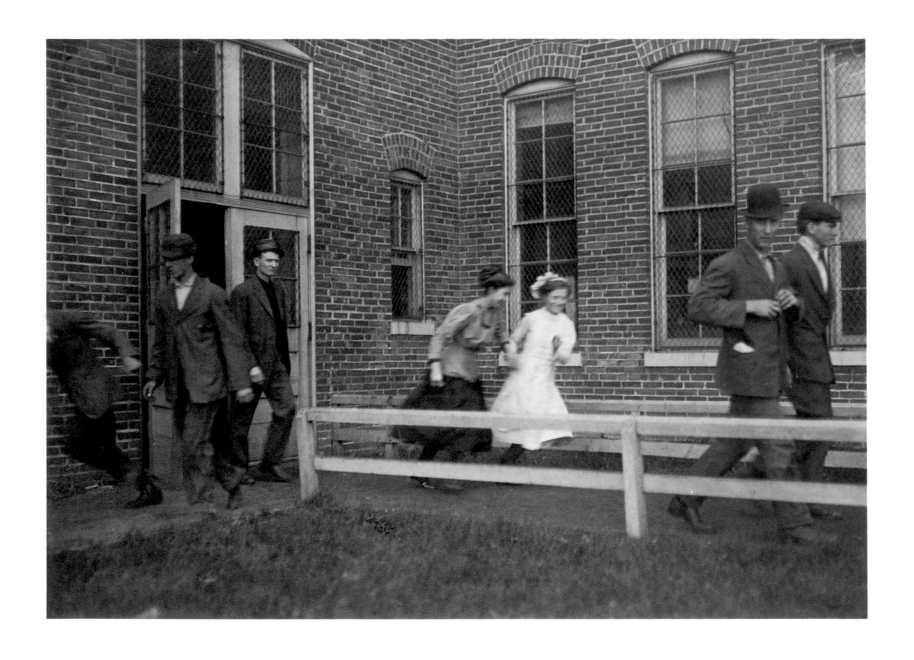

Workers leaving factory, 1910

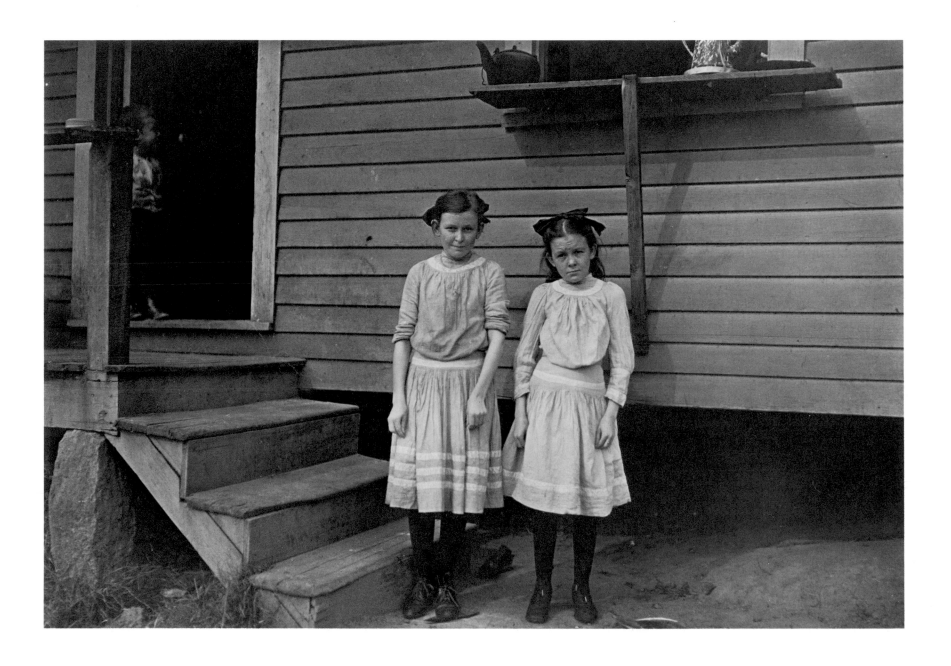

Lacy, twelve years old, and Savannah, eleven years old, Gastonia, North Carolina, November, 1908.

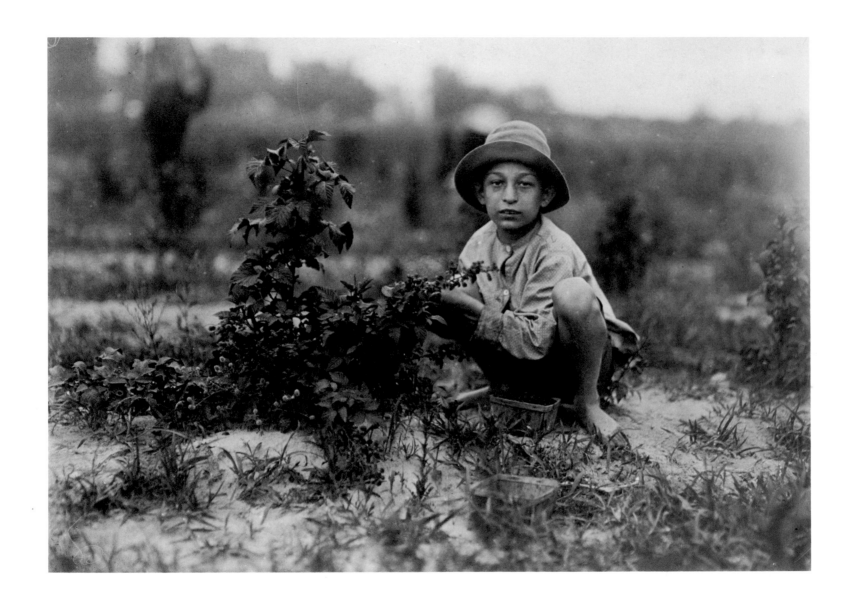

Boy picking berries, Baltimore, July, 1909

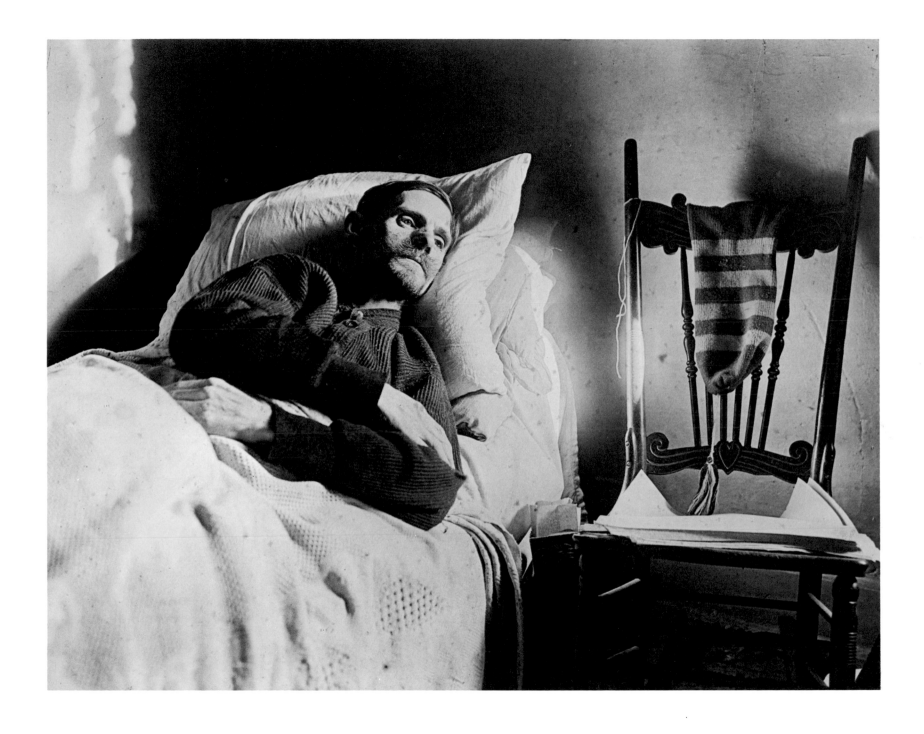

Man with tuberculosis, Chicago, 1910.

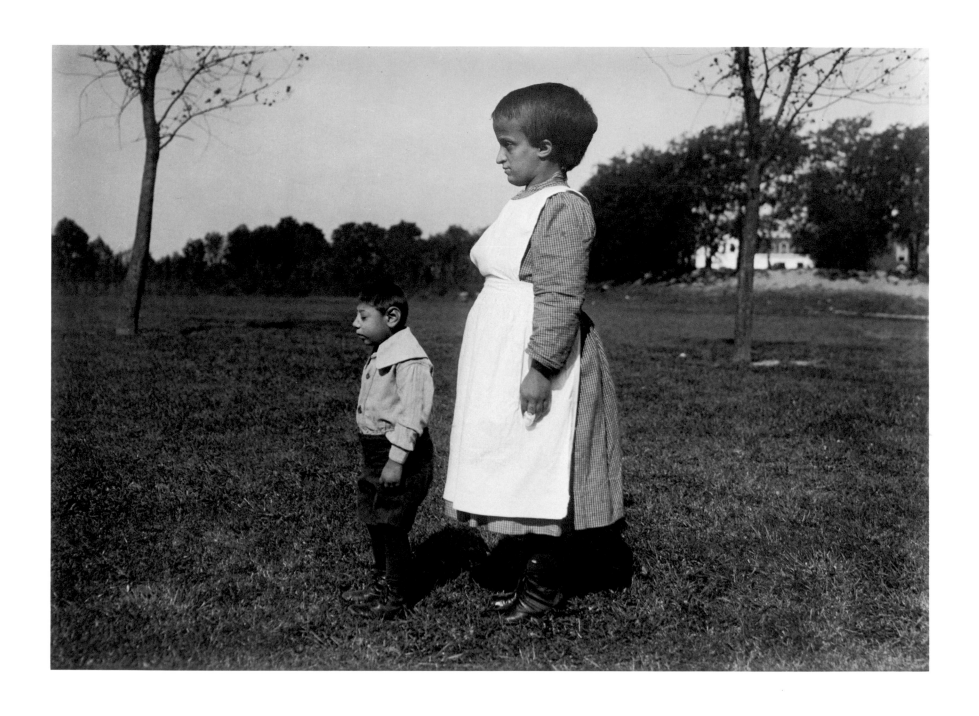

Retarded children, New Jersey, 1924.

I have to sit down often, ever so often, and give myself a spiritual antiseptic, as the surgeon before and after an operation. Sometimes I still have grave doubts about it all. There is a need for this kind of detective work and it is a good cause, but it is not always easy to be sure that it all is necessary.—Field note from Lewis Hine to Frank Manny, c. 1910.

All along I had to be double sure that my photo-data was 100% pure— no retouching or fakery of any kind. This had its influence on my continued use of straight photography which I preferred from the first.—Letter from Lewis Hine to Elizabeth McCausland, 1938.

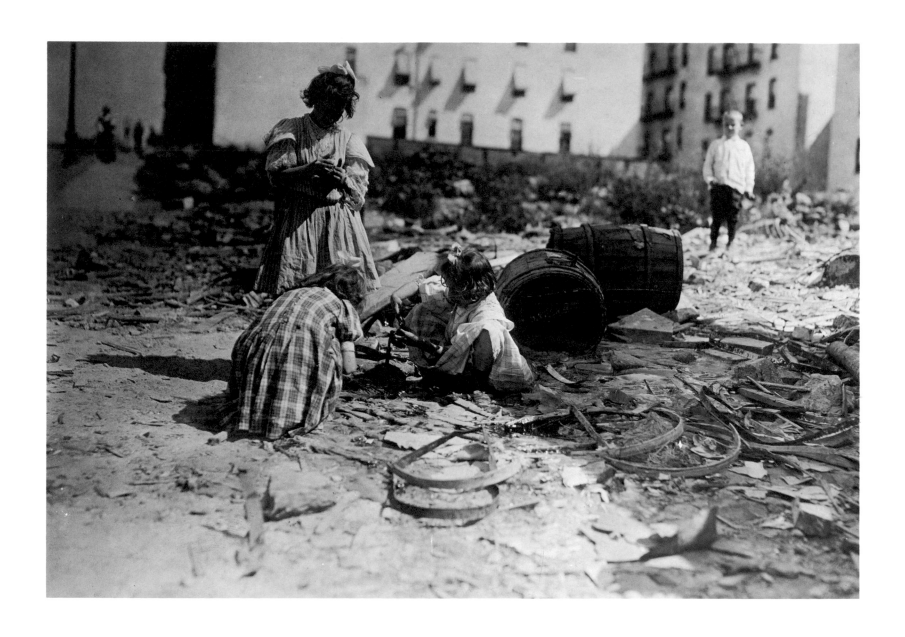

Vacant lot playground, New York City, c. 1910.

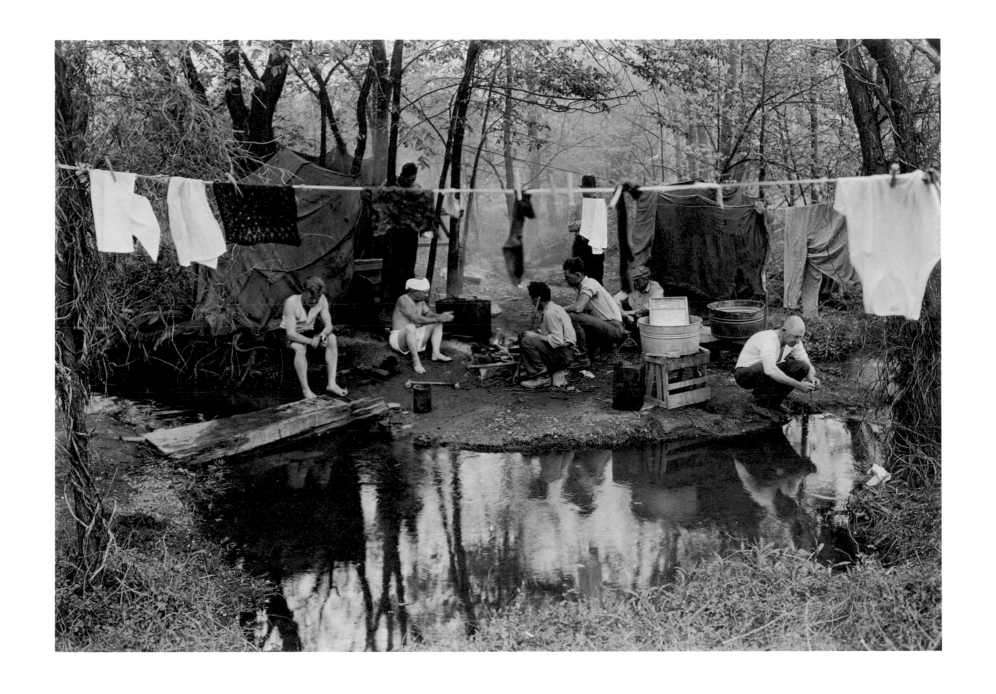

T.E.R.A. Camp Green Haven, New York State, 1936/37.

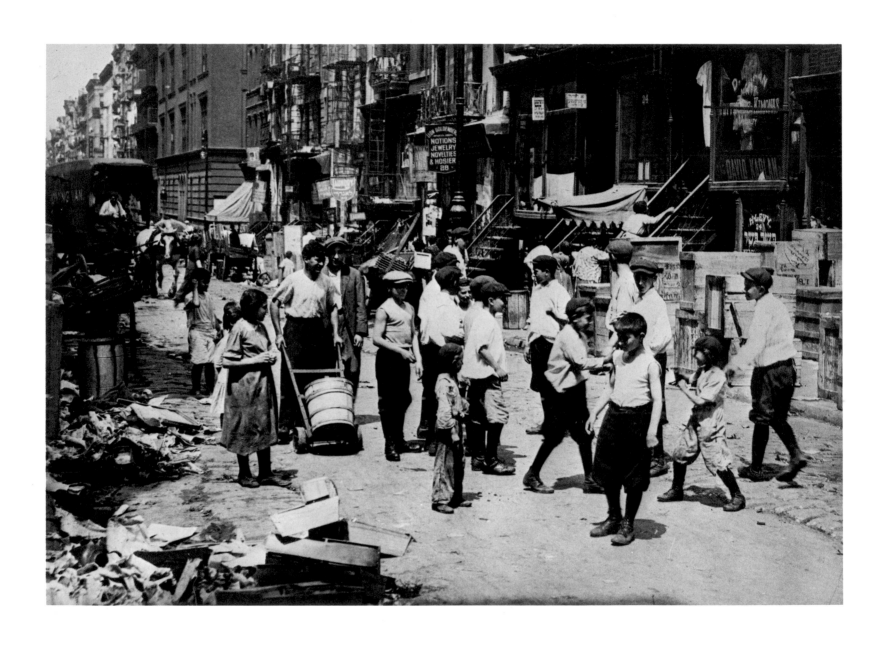

Children on street, Lower East Side, New York City.

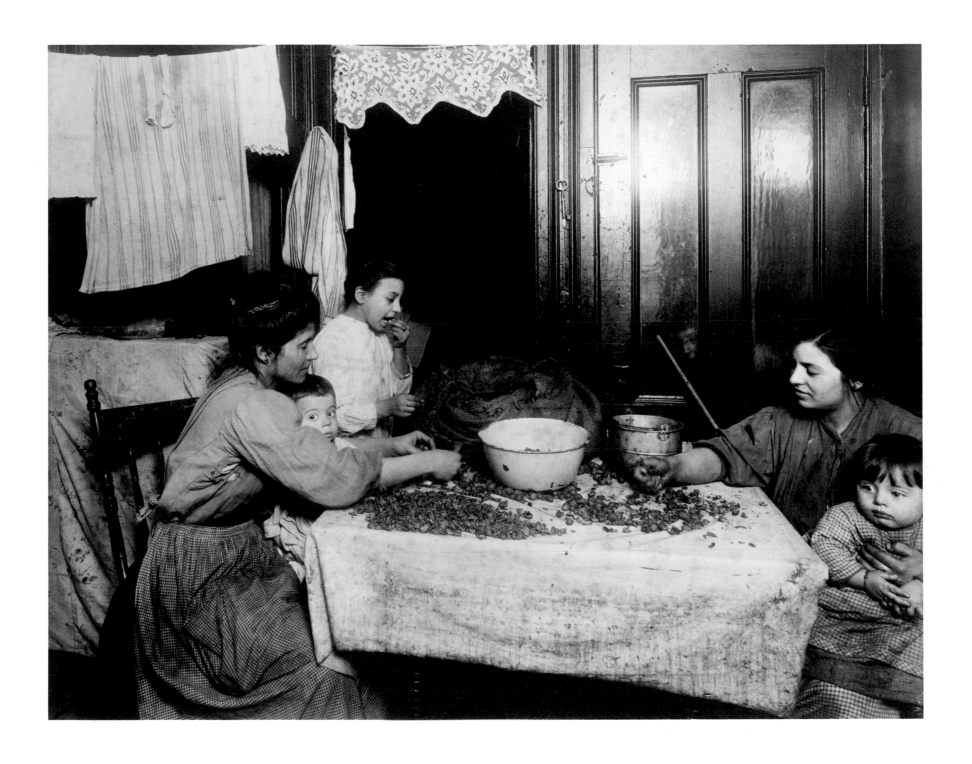

Tenement homework, Lower West Side, New York City, December, 1911.

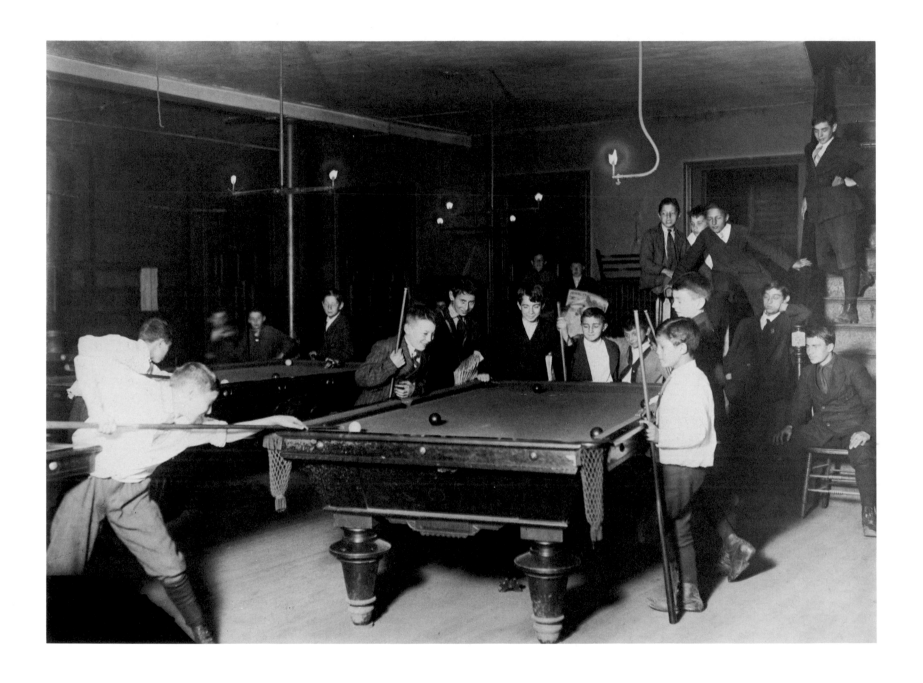

Pool hall interior, St. Louis, 1910.

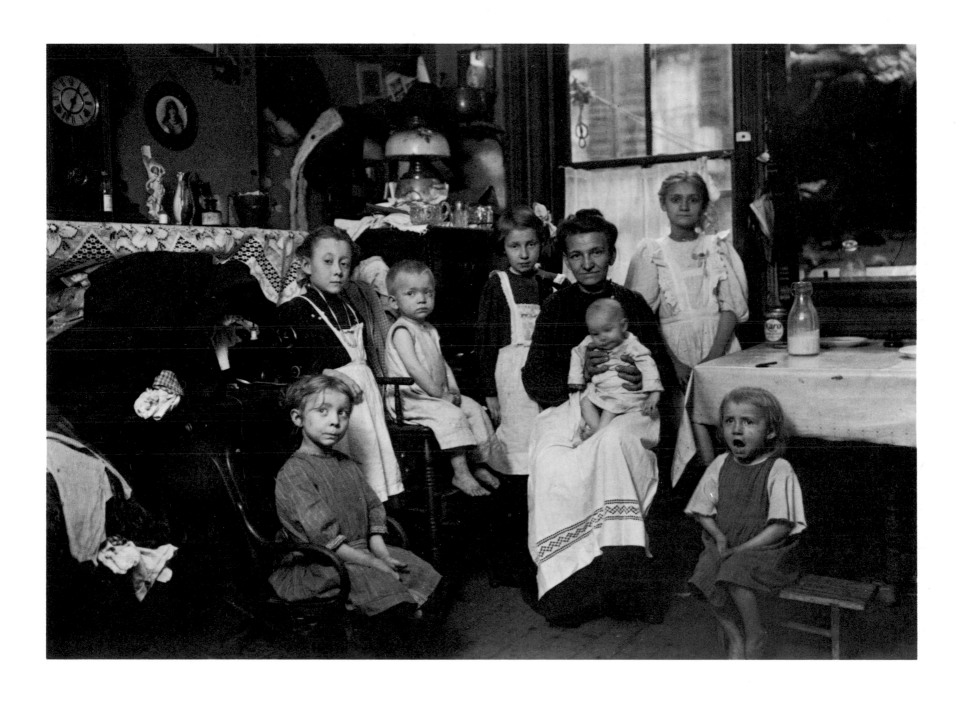

Family in tenement, New York City, 1910.

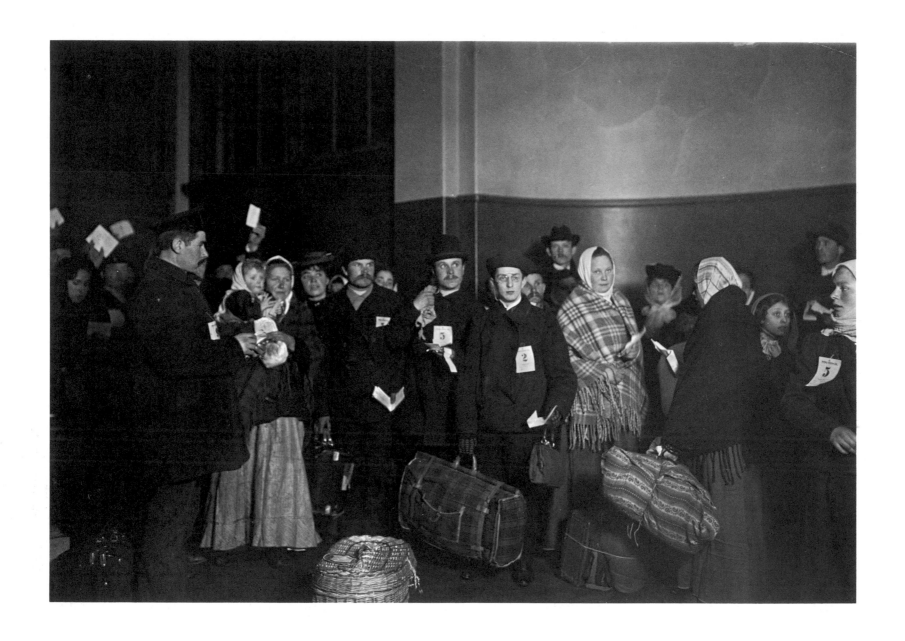

Slovak group, Ellis Island, 1906.

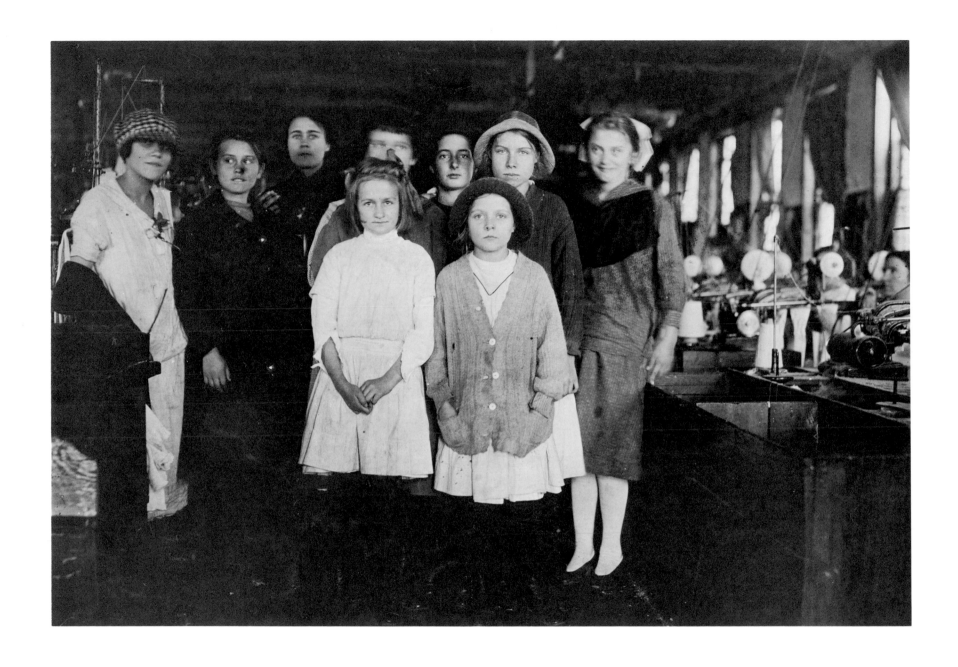

Young workers at cotton mill, Scotland Neck, North Carolina, November, 1914.

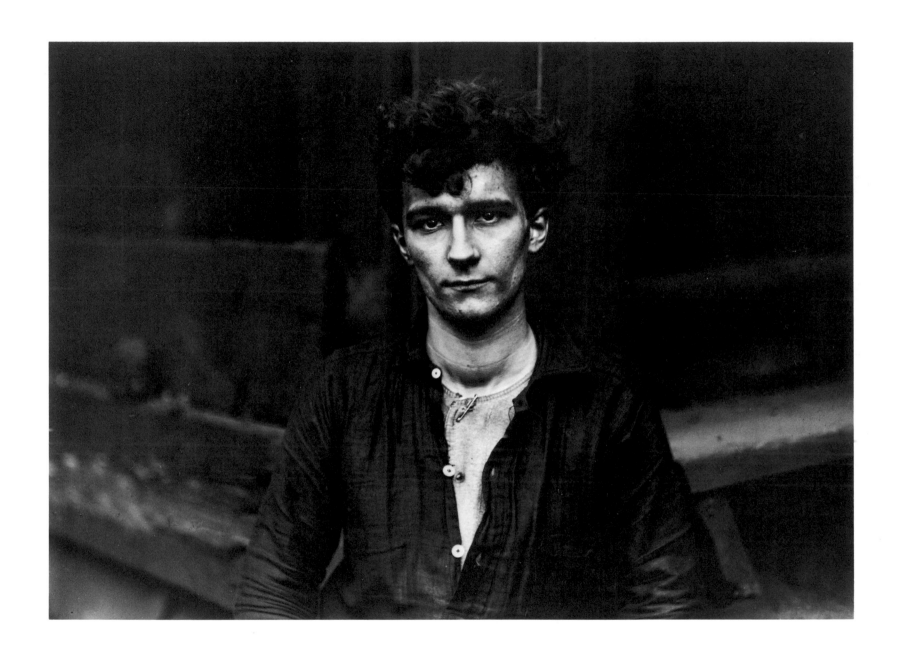

Young German steelworker, Pittsburgh, 1908.

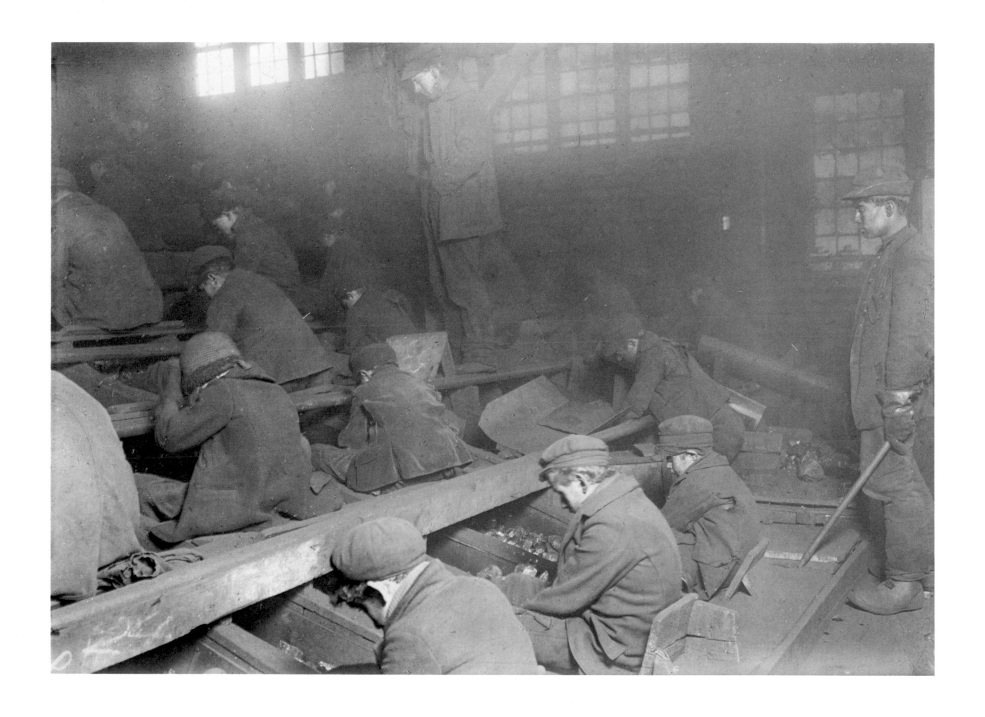

Coal breakers, Pennsylvania, 1910.

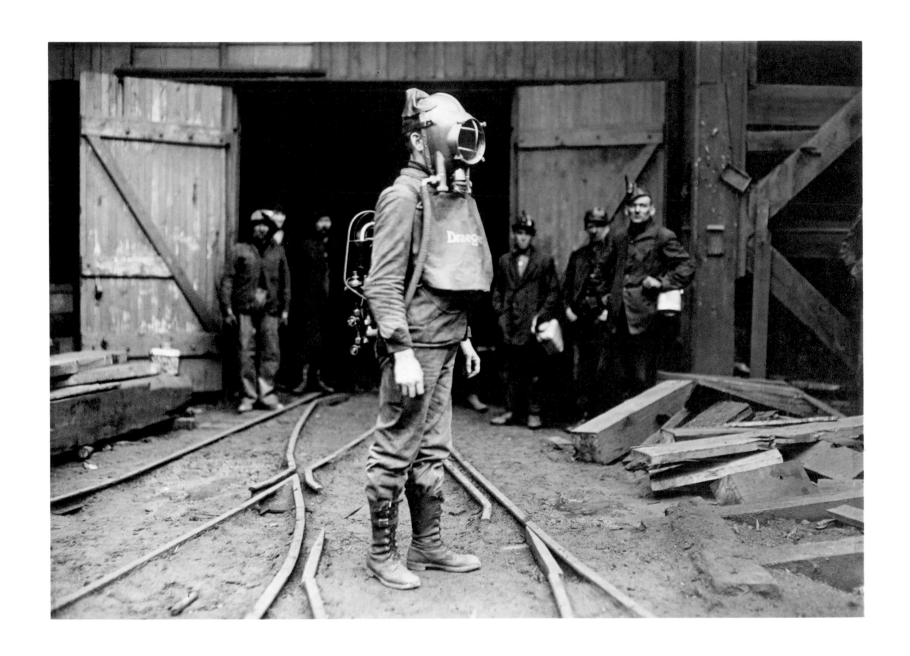

Miner in safety helmet, 1933.

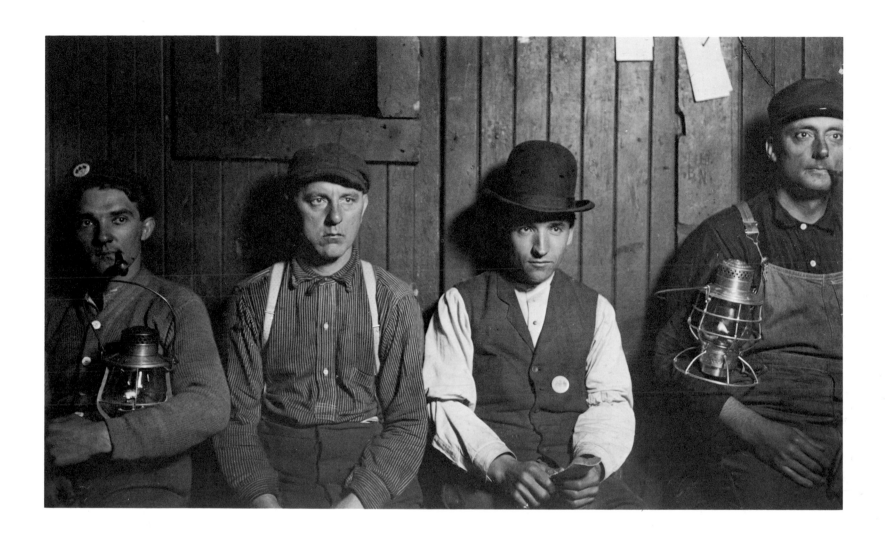

Switching crew, freight yard, Pennsylvania, 1907/08.

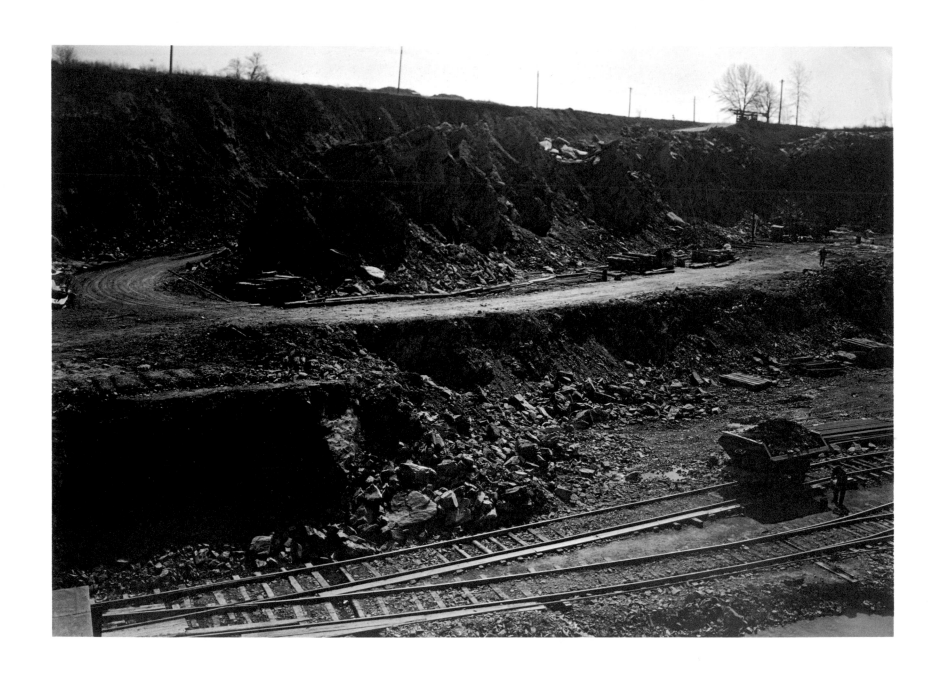

Tracks at coal mine, Scott's Run, West Virginia, 1936/37.

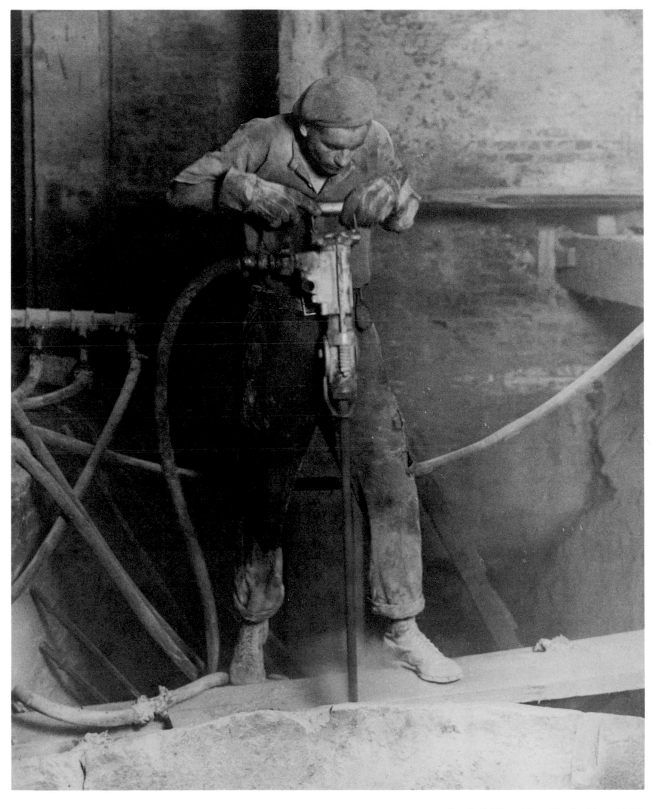

Rock driller, New York City, 1930.

My six months of skyscraping have culminated in a few extra thrills and finally achieving a record of the Highest Up when I was pushed and pulled up onto the **Peak** *of the Empire State, the highest point yet reached on a man-made structure.*

The day before, just before the high derrick was taken down, they swung me out in a box from the hundredth floor—a sheer drop of nearly a quarter of a mile—to get some shots of the tower. The Boss argued that it had never been done and could never be done again and that, anyway, it's safer than a ride on a Pullman or a walk in the city streets. So he prevailed. Growing up with a building this way is like the account of the strong boy (was it Hercules?) who began lifting a calf each day; and, when they had both reached maturity, he could shoulder the bull.—Letter from Lewis Hine to Paul Kellogg; November 25, 1930.

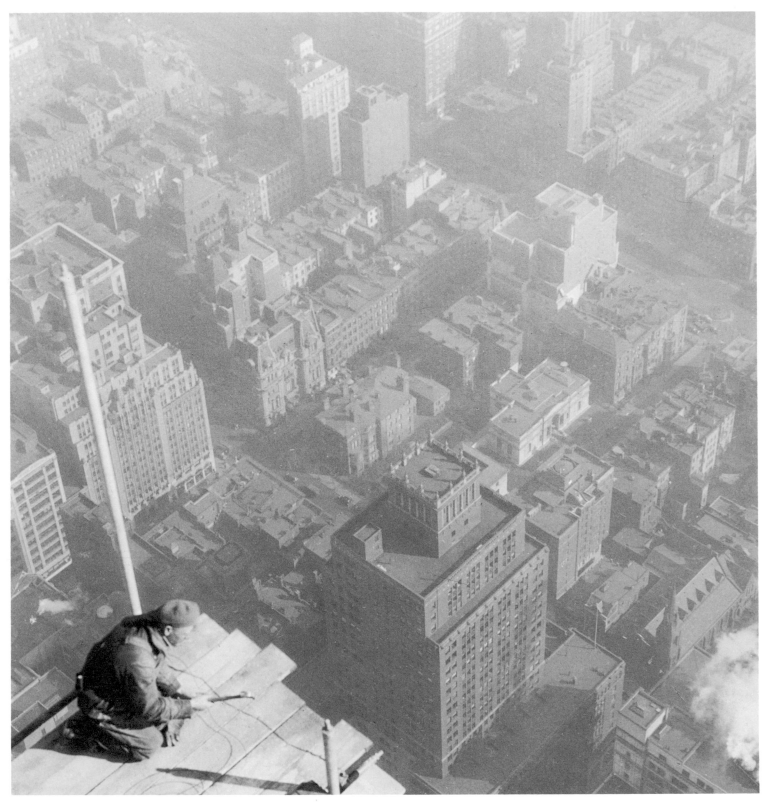

Empire State Building, New York City, 1930/31.

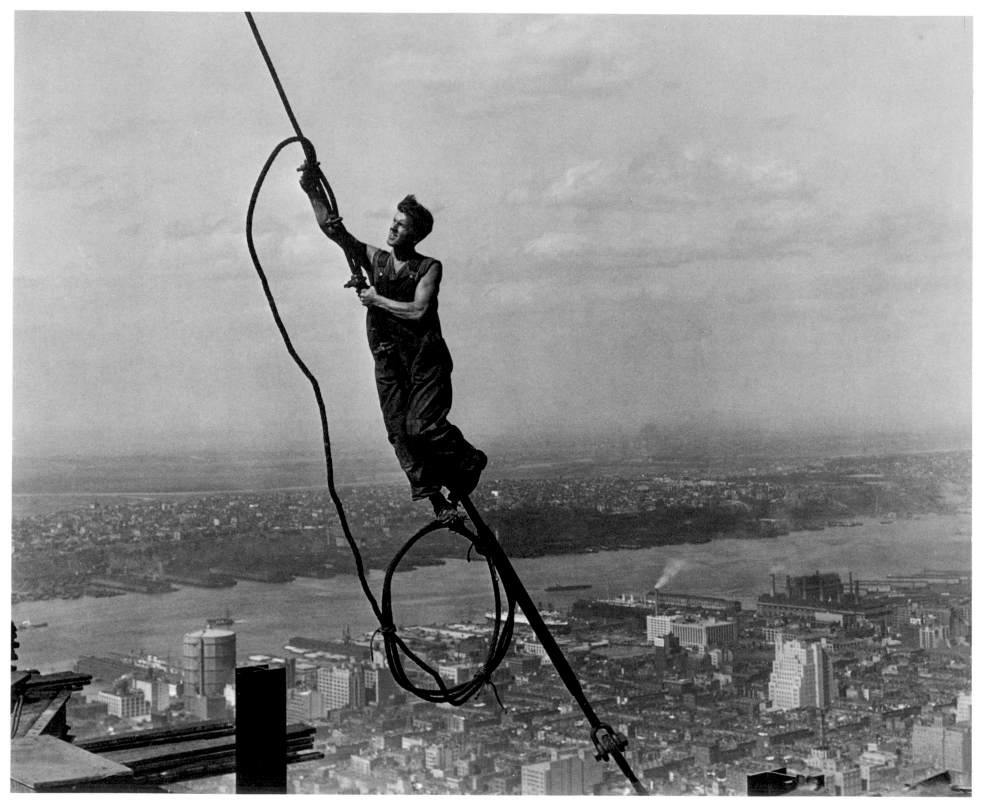

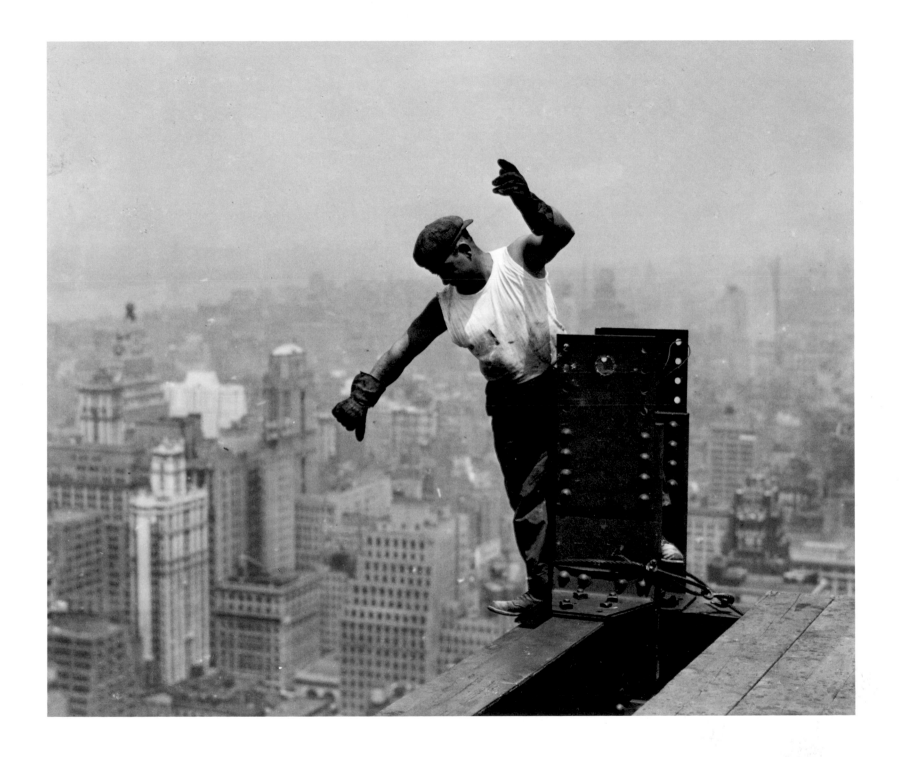

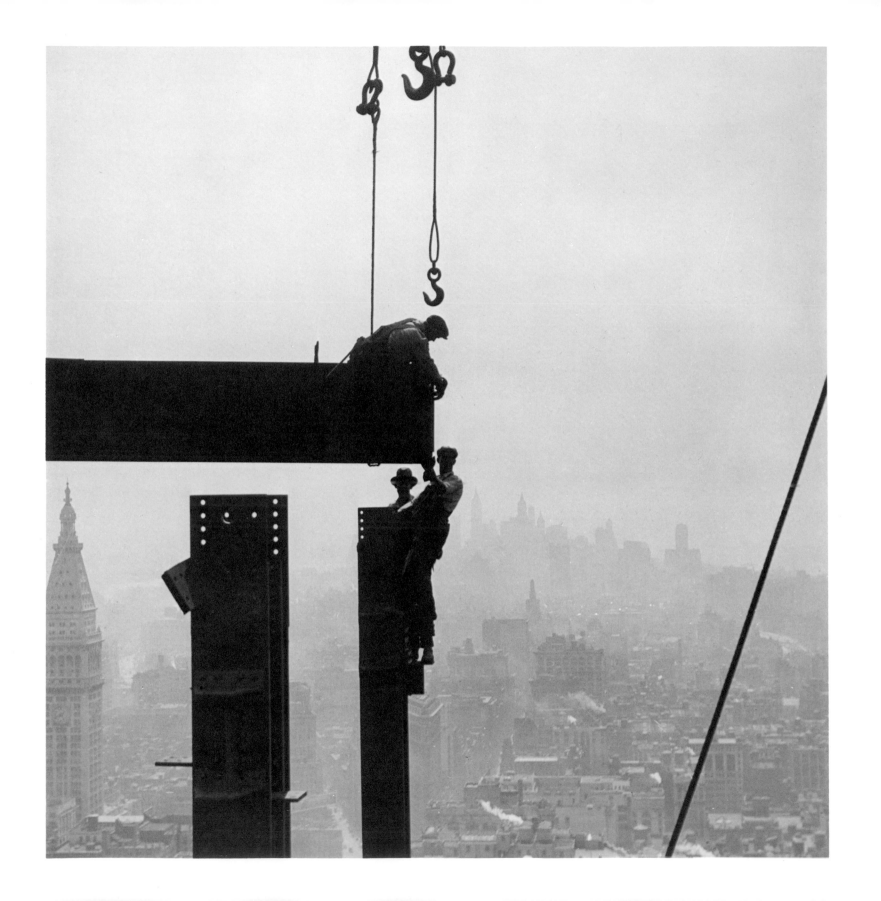

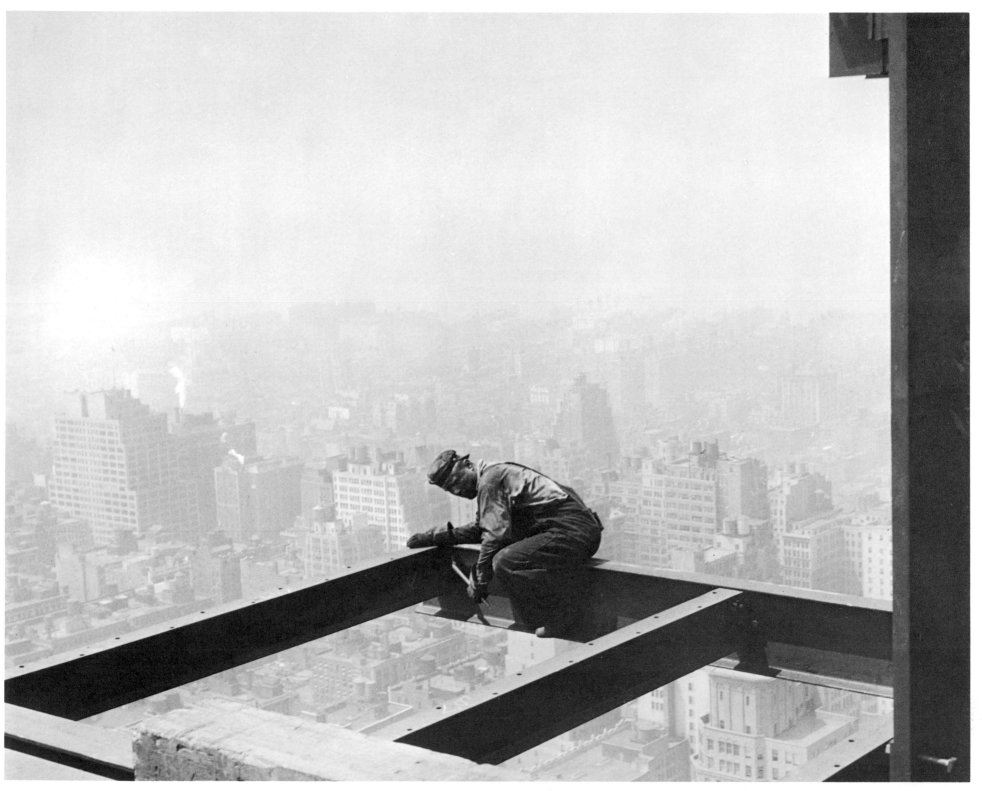

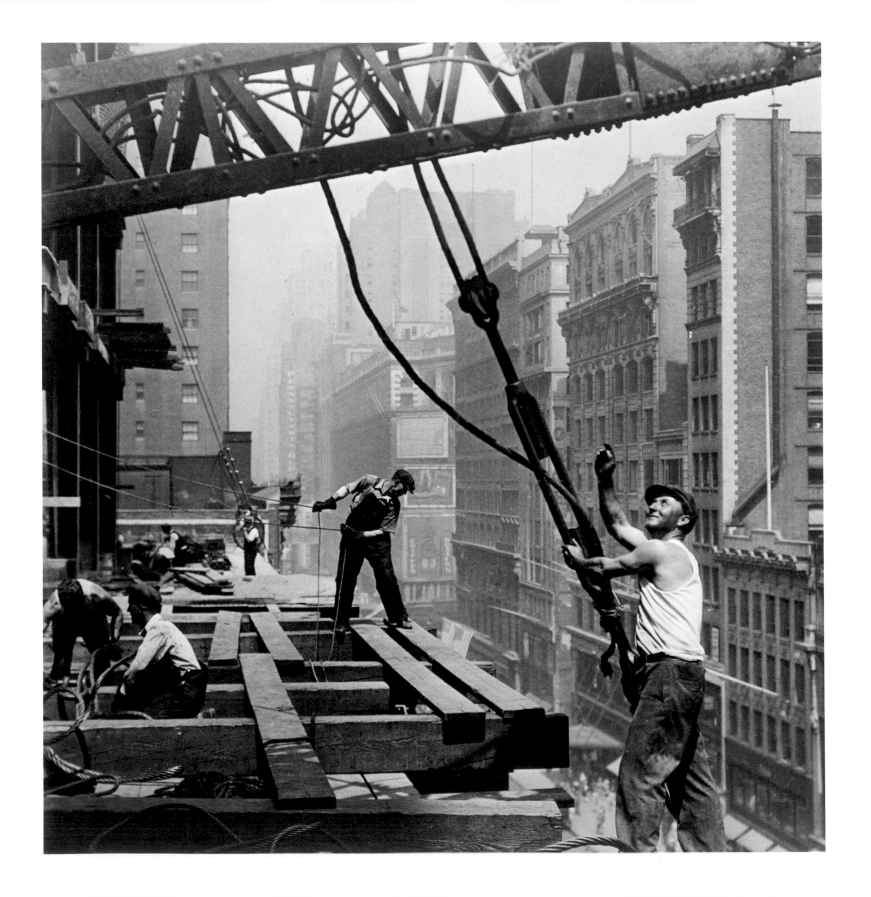

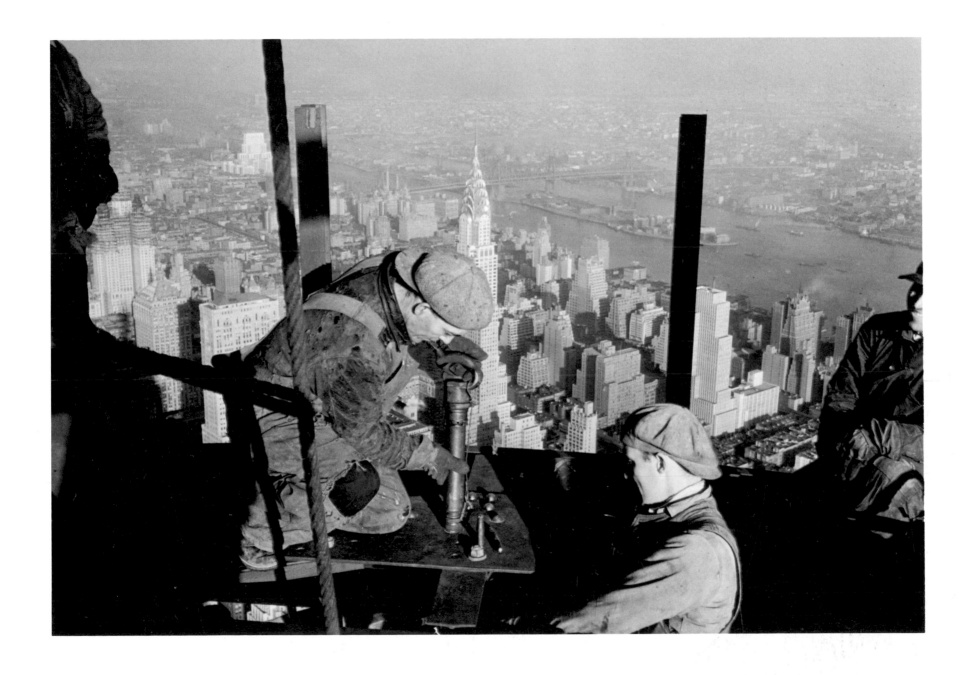

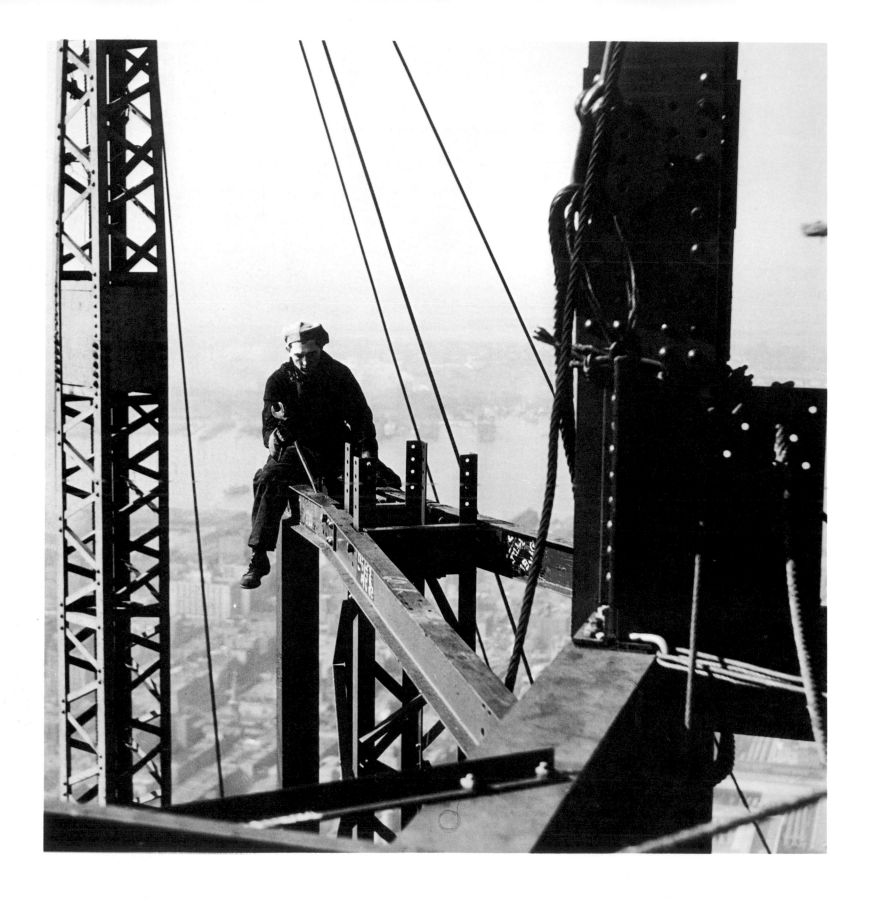

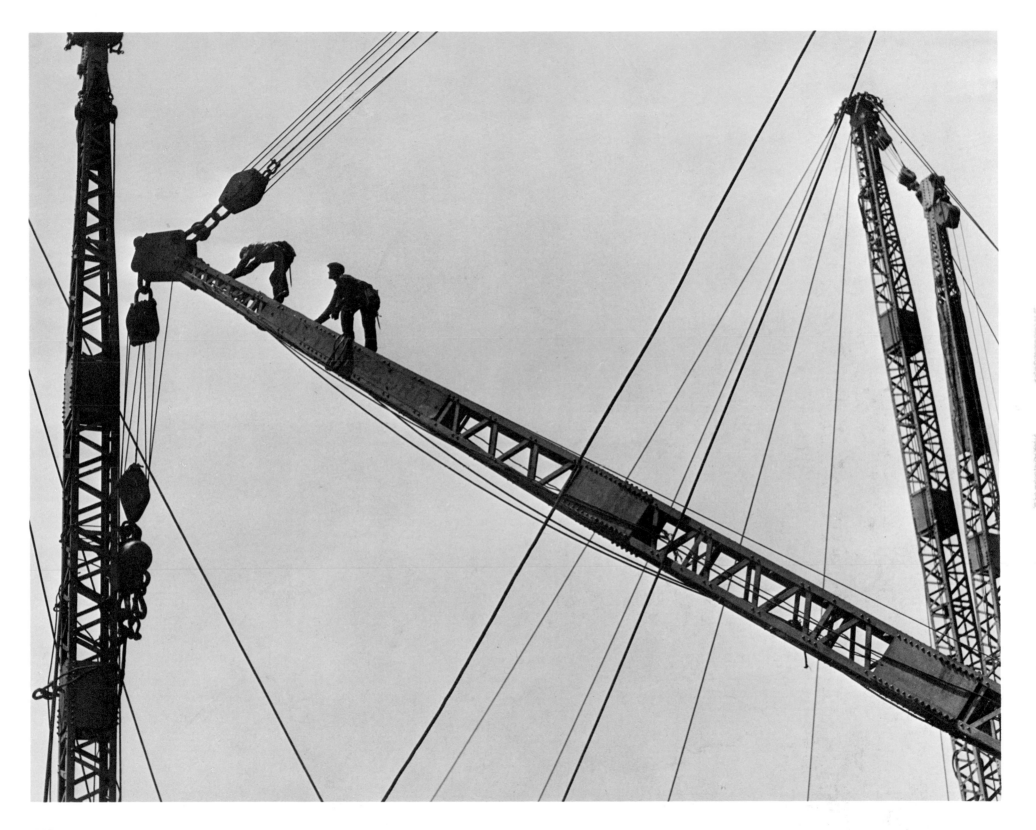

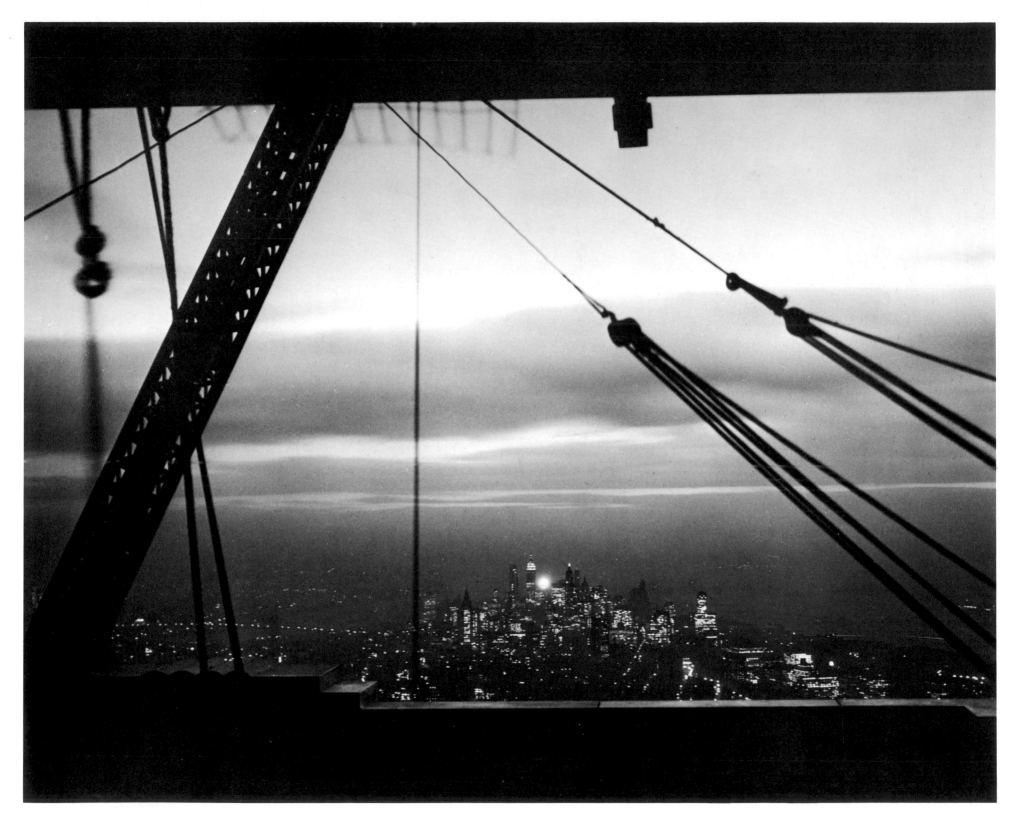

He, too, learned to be a spider, a watchful one, smuggling his camera to all kinds of dizzy perches. And thus he built up a unique album of the human side of tower construction. "A saga of the men who, outlined against the sky on dizzy heights, fuse the iron of their nerves with the steel of the girders they build into modern cities."—"Skyboys Who Rode the Ball," Literary Digest, *May 23, 1931*

(4) Ever—the Human Document

"Ever—the Human Document to keep the present and future in touch with the past."—Lewis W. Hine

Certain photographs seem the epitome of a time and a place: true facts as much as they are works of art. Think of Mathew Brady's Civil War, Eugene Atget's Paris, Walker Evans' 1930's: images so evocative of the spirit as well as the physical look of their subjects that they have become our very conception of that place at that time. Lewis Hine belongs among these true masters of the camera's power. His pictures make a history for us. They are also enthralling personal realities.

Hine belonged to the reality he photographed. And he knew perfectly where lay his power. Just before he died—in poverty and near-obscurity—Lewis Hine prepared his third application for a Guggenheim Fellowship. He proposed "a series of photo-studies dealing with the life of representative individuals of foreign extraction." As a "working base," he referred to his "collection of immigrant studies made at Ellis Island and elsewhere from 1905 to 1930." Now, thirty-five years later, he proposed to recapitulate his entire career. He would "follow" a selected group of foreign-born and record "their home-life, their work-life, community and recreational contacts and participation in fraternal, co-operative and trade union organizations." "The result," he promised, "would constitute an objective and factual document recording the significance, to the country, of the lives of many of our adopted citizens."[1]

It is probably rare in human experience for a career to seem in retrospect so continuous, so single-minded as Lewis Hine's likely appeared to him while composing his futile "Plans for Work." In 1905, when he traveled to Ellis Island with his burden of heavy equipment, and doubtless his anxieties, did he have intimations that this project would launch his imagination into a life-long enterprise? That this would be the opening scene of an action that would grow and change into an epic drama?

The unity that we can imagine Hine perceiving may well have been accidental, the result of early opportunities rather than deliberate choices, but the underlying instinct that directed him to seize certain opportunities was absolutely right. Beginning with his Ellis Island pictures, continuing through his Pittsburgh and child labor work, on into his Red Cross pictures and his "work portraits" in the 1920's, his documentation for the WPA, TVA, and other government agencies related to the "reconstruction" of the Depression years, Hine's work remained in touch with the history of his times.

Lewis Hine's subject was America in the first third of the twentieth century, the life of working people and the changing life of work itself. Throughout his career he was, in his own words, "looking at labor."[2] What he saw, we now take for granted as definitive realities of American life: the look of immigrants arriving at Ellis Island; of tenements and crowded streets in New York's Lower East Side; and, most indisputably, of early twentieth-century Amerian working children—thin, ragged, often wan, more often tough, in coal mines and cotton mills, in field and street and home.

Hine's pictures have etched themselves in the minds of three generations of Americans. We have seen them in history books and taken them as facts, unaware of the man who made them, the quiet, modest figure behind the camera who looked with passion, indignation—and with love and respect as well—upon workers and the conditions of work in industrial America. Much remains to be seen: these pictures are not illustrations but visions of a man for whom the camera was an instrument of truth. Hine was a working photographer, and his art—what makes his pictures fresh, living discoveries—is inseparable from his work in the fullest sense of the word.

As we shall see, Hine wrote often about his distinctive goals as an artist. It is perhaps unnecessary to add that these goals differed sharply from those promoted by the early defenders of photography as a medium with its own "high art" aesthetic. Hine clearly was not a Photo-Secessionist. He did not share with Alfred Stieglitz and his followers the belief that the fine print, the excellently made photograph that like a great painting could hang alone on a wall, was the critical mark of the true photographic picture. Hine had much different standards for what is valuable in a photograph. He was absorbed by social results, not technical perfection.

This difference was part of a larger contrast. "From their ivory tower," wrote Hine about the Photo-Secessionists in 1938, "how could they see way down to the substrata of it all?"[3] Broadly speaking, the Secessionists looked at the world and saw certain self-evident aesthetic themes: motherhood, as represented by women in flowing gowns attending to bright, happy children; labor, as represented by maidens plucking fruit in peaceful arbors. Their subjects were often beautiful women, artists, and well-appointed rooms adorned with paintings and other artworks. They tended to view the world itself as a work of art, free of poverty, real labor, and conflict. To be sure, Stieglitz included city scenes in his subject matter—"metropolitan scenes," in his own

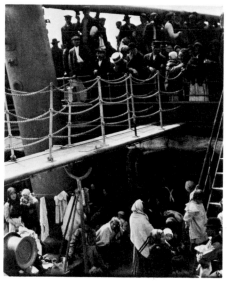
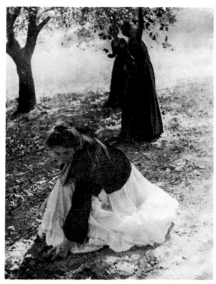

The Steerage, by Alfred Stieglitz *The Orchard, by Clarence H. White*

In 1902, Alfred Stieglitz—along with Edward Steichen and Clarence White—founded the Photo-Secession to promote photography as a medium of self-expression. In the course of its fifty issues, the organization's handsome quarterly, Camera Work, *edited by Stieglitz, became the forum for demonstrating his conviction that the camera could produce legitimate works of art. Three years later, Stieglitz and Steichen opened the photographic gallery "291," to which Lewis Hine brought his photography group from the Ethical Culture School in 1907. Seventeen-year-old Paul Strand, a member of the group, was entranced by his first vision of photography as poetic conception. For Stieglitz and the Secessionists, the expressive quality of a photograph derives from composition, tone, and texture, as well as from subject, an emphasis which Lewis Hine came to regard as too disinterested. In addition to expressive photography, "291," before it closed in 1917, introduced modern European and native art to America prior to the Armory Show of 1913.* Camera Work *also presented such innovative writers as Gertrude Stein, George Bernard Shaw, and Maurice Maeterlinck.*

words, "homely in themselves . . . presented in such a way as to impart to them a permanent value because of the poetic conception of the subject displayed in their rendering." But the references to "permanent value" and "poetic conception" suggest that these pictures were primarily aesthetic experiences, made at the expense of their intrinsic immediacy as subjects.

For Hine, the *art* of photography lay in its ability to interpret the everyday world, that of work, of poverty, of factory, street, household. He did not mean "humble" subjects; he did not mean "beauty" or "personal expression." He meant how people live. He wanted his pictures to make a difference in that world, to make living in it more bearable. He thought of his pictures as communications, and he guided his technique thereby. "All along," he wrote, "I had to be doubly sure that my photo-data was 100% pure—not retouching or fakery of any kind. This had its influence on my continued use of straight photography."[4] He, too, was a "straight" photographer, anticipating the direction taken by Stieglitz and Paul Strand after the demise of the Photo-Secession and soft-focus romanticism. To be "straight" for Hine meant more than purity of photographic means; it meant also a responsibility to the truth of his vision.

●

Hine's obsession with human labor had its roots in his working-class experiences as a youth. "After Grammar-school in Wisconsin's 'Sawdust City,' " he wrote about himself, "my education was transferred for seven years to the manual side of factory, store and bank. Here I lived behind the scenes in the life of the worker, gaining an understanding that increased through the years."[5] A down-to-earth sense of what lay "behind the scenes" remained with him and gave his work a key focus. "Cities do not build themselves," he wrote in his only published book, *Men at Work* (1932), "—machines cannot make machines,—unless, back of them all, are the brains and toil of Men." "Behind the scenes," "back of them all"—Hine's own work would be devoted to bringing forward the work of others, especially the industrial laborers responsible for the daily existence of modern society: to bringing forward, that is, what was invisible to the eyes which see only the products, the commodities, of labor. "Human values in photography," he wrote in 1933 to Florence Kellogg of *Survey Graphic,* could provide "a very important offset to some misconceptions about industry. One is that many of our national assets, fabrics, photographs, motors, airplanes and what-not,—'Just happen,' as

the products of a bunch of impersonal machines under the direction, perhaps, of a few human robots. You and I may know that it isn't so, but many are just plain ignorant of the sweat and service that go into all these products of the machine."[6] To show the "sweat and service"—to remove the mystery of how things get made, how resources get transformed into usable objects, was the persistent goal even of Hine's earliest photographs.

His concern with labor was not simply to celebrate it, to praise the humble worker; nor like his predecessor in social photography, Jacob Riis, did he wish only to expose the horrible living conditions of urban workers. Riis's mission—one which he performed with extraordinary success—was to arouse the middle-class public to the existence of an "other half" in the slums and the infested tenements of the Lower East Side. He took his camera into the slums as if invading a foreign territory and brought back trophies of human degradation which shocked the public into action. Only passingly was he concerned with work, with labor, with how and where the demoralized people who inhabit his pictures made their living. Like Hine, his goal was to make the invisible visible, but with a crucial if subtle difference. Riis was an evangelist who appealed to moral conscience; his subjects were victims who deserved their brothers' charity. "Behind the scenes," on the other hand, implies another kind of emphasis—less upon a moral code than upon moral intelligence. It implies a curiosity about how the world works, with a special value set upon knowing such truths as how the clothes we wear get made and where our electrical power comes from. A curiosity, that is, about the processes of labor.

The setting for Lewis Hine's work was the broad movement for social welfare that arose early in the century, in the Progressive Era, and proliferated into a number of channels, including separate organizations and journals. Hine's vision, both for society and for photography, owes a great deal to the hopeful atmosphere of social betterment within which he worked. We can watch, almost step by step, as he discovered opportunities for the camera and a vocation for himself.

The first significant setting was the Ethical Culture School in New York City, where he taught for several years after attending the University of Chicago to study "the new education." He joined the teaching staff of ECS in 1901—nature study and geography were his subjects—and it was here that he took up photography. ECS, from its beginnings as a "Workingman's School" in 1878, had pioneered in the teaching of handwork, craft skills, and industrial education. Although by the time Hine arrived the

Felix Adler

Ethical Culture School

Frank Manny

*New York City's Ethical Culture School (whose
faculty Lewis Hine joined in 1901 at the behest of Frank
Manny) was called the Workingman's School when it
was established in 1877. In pioneering industrial education
and manual training, the school reflected the social
concerns that animated Ethical Culture and its prime mover,
Felix Adler (1851–1933). Adler studied for the rabbinate
and taught Hebrew and Oriental literature at Cornell
before founding Ethical Culture in 1876, a humanist religion
stressing moral conduct, the betterment of human
life, the worth, dignity, and creativity of man. Free from
sectarian dogmas, Ethical Culture asserts that the
primary religious ideal is to improve the quality of human
relations: in short, "deed not creed," as Adler put it.
Grounded as it was in man's ethical and social experience,
the movement assumed leadership in civil rights and
social reform. It set up New York City's first free kindergarten
and sponsored legal aid, visiting nurses, and model
tenements. Adler organized the nation's first child study
group and from 1904 to 1921 was the chairman of the
National Child Labor Committee.*

school had lost much of its working-class clientele, it retained its
character as innovative, "progressive" in its values, and concerned
with the integration of knowing and doing.[7]

The school principal, Frank Manny, wanted to use the camera
for records; Hine assumed the task and soon developed a full-scale
photography program. In later years, Hine tended to denigrate
what he called "polishing brains at the Ethical Informary,"[8]
but several essays he published between 1906 and 1908 on the
program show the influence of the school's educational theory on
his developing concept of photography. His articles are also the
first serious discussion in print of the place of photography in
schools—not as a "hobby" but as a discipline in its own right.

Hine wrote that the camera served two classroom needs, "recording
for mutual benefit" and "appealing to the visual sense,"
and that both in turn served "to increase our efficiency." The
word *efficiency* appears often in his writings; it had a special
meaning for the followers of the philosopher John Dewey and for
Progressive reformers as a whole. The reformers felt that
waste—of human effort, of individual skills and talents—was a
conspicuous threat to happiness in the fast-changing industrial
society of modern America, and in Dewey's influential view one
way to overcome it was to bring into the school curriculum the
actual tasks children would face as working adults. Efficient
study and work, modeled upon the processes of science, would
result in personal fulfillment, satisfaction, and (another term
Hine shared with reformers) joy.

The educational value of photography, then, fit neatly into
the goals and methods of the progressive education movement.
The camera, he wrote, aided learning by sharpening perception.
On excursions—nature study outings or visits to factories—the
camera helped direct attention to "the salient features of the trip"
and encouraged students to make a "systematic attempt . . . to get
snapshot records of what they saw." Hine also stressed the *practical*
values of camera work: its working procedures, its discipline,
its concomitant experiences of cooperation. He did not ignore
the role of art in photography, but even here, practicality
provided the focus. Photography taught art appreciation, for, Hine
argued, "in the last analysis, good photography is a question of
art." Not art for its own sake, but art as a heightened awareness of
the world: "This sharpening of the vision to a better appreciation
of the beauties about one I consider the best fruit of the whole
work." As an example of such vision, he included in a 1908 essay
a picture titled "A Tenement Madonna. A Study in Composition,"
and described the work as "a study made by the instructor

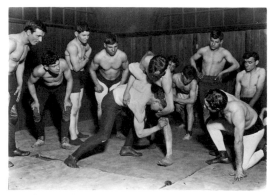

Jane Addams *Greek Wrestling Club, Hull-House, by Lewis Hine*

*The daughter of a prosperous Illinois merchant, Jane Addams
(1860–1935) was forced to abandon a medical career because
of poor health. It was while traveling abroad, after two
years of invalidism, that she visited London's Toynbee Hall,
recently set up as a combined social service center for
the poor and residence for those Oxford and Cambridge students
who were motivated by England's burgeoning reform
movement to live in an industrial area, collect social data,
develop adult education, and improve conditions. Jane
Addams ardently quoted Toynbee Hall's founder: "The things
which make men alike are finer and better than the
things that keep them apart." At twenty-nine, she and a college
classmate established Hull-House as a welfare center in
an immigrant neighborhood of Chicago's slums. Its goal: to
acclimate immigrants to America and humanize the
industrial city through educational, recreational, and cultural
activities. Lawyers, teachers, artists, businessmen, and
social workers all lived at Hull-House, which later covered half
a block and operated a playground across the street and
a large summer camp. One of the earliest and most influential
settlement houses in the United States, it became a
center of social reform, attracting visitors from all over the
world. Jane Addams allied herself with labor and other
reform groups to fight tenaciously and effectively for better
housing, parks and playgrounds, and a wide range of
welfare laws. In 1931, she was awarded the Nobel Peace Prize.*

to represent maternity among the poor, following the conception used by Raphael in his 'Madonna of the Chair.'"

Hine's ideas were still in flux, but what needs underlining among his thoughts at this stage is, first, his view of the practice of photography as an embodiment, or enactment, of progressive values: not merely as a way of making pictures, but as a way of practicing one's beliefs. Photography was a means of focusing activity in the world, a "scientific" means of heightening perception, sharing experiences, clarifying vision. The camera would shortly become Hine's own instrument for inserting himself into his times, his way of being-in-the-world.

A second important theme found throughout his early essays—more implicit than fully expressed—concerned the well-being of children, their happiness in creative activity, their preparation for later life. Here his ideas are in complete accord with those of Jane Addams, the notable reformer, writer, and founder of Hull-House in Chicago, who wrote in 1905: "A school which fails to give outlet and direction to the growing intelligence of the child 'to widen and organize his experience with reference to the world in which he lives' merely dresses his mind in antiquated precepts and gives him no clue to the life he must lead."[9] The fusion of learning with work—not the fragmented, regimented factory work of "child labor," but the healthy, creative, imaginative activity of children working in common on a project—was the heart of the "new pedagogy" she advocated. Hine agreed: children must learn to respect themselves, he wrote, and come to realize that they "amount to something." He proposed photography—camera work—as work that fit the need.

•

Hine had been led to Ellis Island, as he later quoted his wife's recollection of how the project began, by an "urge to capture and record some of the most picturesque of what many of our friends were talking about." "Our air was full of the new social spirit," Frank Manny remembered,"[10] and the "new immigration" suddenly loomed as a social problem of enormous proportions; the important social reform journal *Charities and the Commons* (later to be known as *The Survey*) devoted a series of articles in 1904 to the waves of newcomers from eastern and southern Europe and their often painful efforts to adjust to a new life. Reformers had been slow to awaken to the special needs and unique experiences of non–English-speaking immigrants. Sympathetic understanding was made no easier by a public opinion

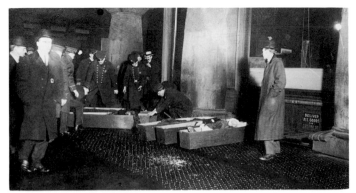

Aftermath of Triangle Fire

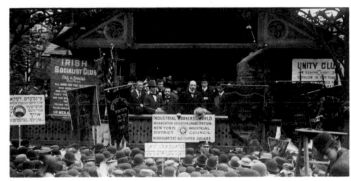

Rally, New York City

On March 25, 1911, a fire at the Triangle Waist Company near Washington Square in New York City resulted in the death of 146 workers—women and girls who either leaped to their death or were fatally burned. The event riveted public attention on the city's working conditions: the misery of filthy factories and the perils of sweatshops without proper ventilation or safety devices. Robert F. Wagner and Alfred E. Smith were appointed to the State Factory Commission, and, in time, urgently needed reforms were legislated. The Triangle Fire had other repercussions. During the first decade of this century, industry's counterattack against organized labor had been so successful that A.F.L. membership declined in 1905 and remained almost stationary for the next five years. It was during this period that the needle trades unions were attempting to organize such firms as the Triangle Waist Company. Many women workers refused to join for fear of being labeled "socialist," since it was A.F.L. socialists who led the International Garment Workers Union. Events such as the Triangle Fire propelled workers to join unions not only for economic gain but to express their solidarity with the exploited victims and survivors.

that invoked such racist stereotypes as "the hatchet-faced, pimply, sallow-cheeked, rat-eyed young men of the Russian-Jew colony" and editorials troubled by the "menace" of "foreign ideas," "festering" slums, and loose morals. It is typical that Riis's *How the Other Half Lives* (1889) is laced with many racial stereotypes. Even the usually cool and detached novelist Henry James, who visited Ellis Island in 1905, worried over the impact of "this visible act of ingurgitation" on the national identity of Americans: what would it mean, he wondered in *The American Scene* (1907), "to share the sanctity of his American consciousness . . . with the inconceivable alien."

Hine's urge to record the Ellis Island scene matched a new sensitivity among informed Americans toward the immigrant; at the same time, it put him in touch with a social experience that was destined literally to transform American life. Beginning in the 1880's, "pushed" by poverty, famine, and persecution at home, and "pulled" by tales of opportunity in the New World and by ardent campaigns of American industrialists looking for fresh supplies of labor, tens of millions of people from predominantly peasant societies of Europe undertook the hazardous adventure of founding a new life. The numbers were overwhelming: as many as five thousand people passed through the Ellis Island facilities on one day. What made the experience all the more poignant was its historical dimensions. The flood of immigrants fed directly into the two rushing forces that were rapidly altering the course of American life: the growth of cities and the spread of the machine. Immigrants swelled the cities—creating in New York's Lower East Side, for example, the highest population density known in any city outside of Asia—and filled the ranks of unskilled labor, at wages of $1.50 a day, demanded by the expanding industrial machine. By 1924, fully one-third of the country's population were immigrants or their children, and an even higher proportion made up the industrial work force.

Ellis Island represented the opening American act of one of the most remarkable dramas in all of history: the conversion of agricultural laborers, rural homemakers, and traditional craftsmen into urban industrial workers. This transformation, which occurred with such swiftness that we almost forget it happened (it took not much more than a generation in this country) was to become Lewis Hine's major theme.

There was also, for Hine, a personal drama at Ellis Island. Something happened to him in the course of photographing this experience. He went to Ellis Island as a school photographer; he left it a master. He learned his work there, not only technically

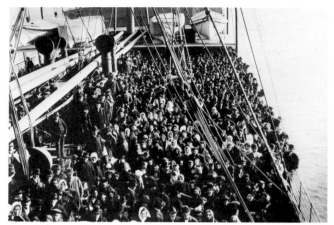

Immigrants arriving at Ellis Island

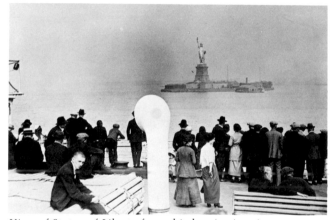

View of Statue of Liberty from ship bearing immigrants

Ellis Island, "The Gateway to the New World," located in New York Harbor less than half a mile from the Statue of Liberty, opened in 1892. On January 1 of that year, three large steamships, having made the voyage from Europe, waited in the harbor to deposit their steerage passengers. Once on the island, these immigrants would undergo a clearance process designed to determine whether they were eligible for entrance to the United States. Under the terms of the immigration laws, aliens could be turned back for reasons of illness, criminal record, or radical politics. By 1932, more than sixty million had passed through the island's three-story reception building. Other structures included dormitories for detainees, a small hospital, a restaurant, and a baggage station. Employees numbered between 500 and 850, depending on the flow of immigrants. Lewis Hine photographed here from 1904 to 1909, capturing the year 1907, when the waves of immigration peaked at more than one million.

(he later prided himself for his ability to deal with "difficult situations and light conditions"[11]) but aesthetically.

In his Ellis Island pictures, Hine sought, and captured, moments of small drama: an Italian family waiting for their luggage, a Hungarian mother embracing her child, a woman resting in fatigue on a bench against her bundles. His pictures are quick with the moment; they show figures in the act of experiencing Ellis Island—its long lines, its processing hall divided into sections by bars, its screened-off waiting room, its tedium, its stale air of officialdom.

Anyone visiting Ellis Island with an eye to making pictures—and there were many cameras there—would naturally be drawn to the exotic and picturesque native costumes, hair styles, and demeanor. Hine focused on and identified ethnic types, but he rarely allowed the typical to overwhelm individual traits. He did not impose on his subjects the habits of commercial studio photography—the stiff, formal pose and the artificial background. Instead, he always framed his pictures to include enough background detail to place his figures in their immediate settings.

It is true that most of his pictures are posed—his technical apparatus of stand-camera and flash tray required the subject's cooperation—but many are posed frontally, with unmistakable eye-contact between the subject and the camera lens. Such posing, which remained one of the hallmarks of Hine's photography, was a significant departure from the methods of conventional portraiture. It was a standing rule among pictorialists—and one of the stylistic devices they used to set apart their portraits, which they called "studies," from commercial work—to avoid direct eye-contact as if it were a plague. Otherwise, they felt, the print would look too much like a mere photograph. At Ellis Island, Hine apparently discovered for himself the unique power of frontality (as Stieglitz had done some years earlier in his famous open-air portraits).

He also discovered something else related to frontality, something that might be called "decorum." He learned how to achieve a certain physical distance, corresponding to a psychological distance, that allowed for a free interaction between the eyes of the subject and the camera eye. Put another way, he allowed his subjects room for *their* self-expression. This is something that cannot be taught, cannot be reduced to rules. As much as in any other aspect of his style, Hine's own character expresses itself in where he places himself *vis-à-vis* his subject. The camera set down before the subject opens a place, creates a scene in which

the subject can stand forth and the camera can do its work of recording. Typically in Hine's pictures, the place of the picture is a social space in which individuality is defined, related, and expressed through the encompassing detail.

Given the probability that Hine came to Ellis Island with no particular pictorial preconceptions but, we can assume, with a readiness to look sympathetically upon the "huddled masses" he would find there, perhaps the quality of decorum simply appeared naturally. He accepted the strangeness of these people—a far different matter from James's "inconceivable" alienness—and his own to them; he respected their distance, and allowed them to re-create themselves in the studied eye of his camera. Still, the spatial boundaries, the solicited pose, are signs of the photographer's gentlest of interventions, not an imposition but a subtle collaboration.

Lewis Hine entered swiftly upon his new vocation. The Ethical Culture School and the classes he took at New York and Columbia universities introduced him to a number of prominent reformers. He came to know such leaders as Florence Kelley, the young Francis Perkins, John Spargo, and the Kellogg brothers, Arthur and Paul, who worked at *Charities and the Commons*. The new social spirit caught him up and gave him a focus. In 1908, he quit teaching—"merely changing the educational efforts from the school-room to the world"—and enlisted as "social photographer" in the cause of reform. Shortly thereafter, he joined the staff of the National Child Labor Committee.

It is important to note that reform, not revolution, was the aim of Hine and his associates, even the Socialists among them. Their intent was to cure industrial capitalism of its ills, making it more equitable in the distribution of its fruits. The reformers believed in democracy and wanted it to work. Something less than the system itself was in the wrong: they stressed the environmental causes of slums, family breakdowns, crime, and undertook careful, detailed analyses of poverty, of poor housing, of working children. Investigation became their mode; Hine's photography, one of their principal instruments.

An early investigative opportunity of great consequence for Hine came in 1907, when Paul Kellogg, managing editor of *Charities and the Commons*, invited him to participate in the Pittsburgh Survey, which would be the largest and most intense effort yet made in America to study in detail a typical industrial city.

The fact that Pittsburgh had been selected for such a project signified an important shift in public awareness. It was a

The Survey Graphic

Paul Kellogg

As a teenager, Paul Kellogg (1879–1958) was a newspaper reporter and city editor in his native Michigan before coming to New York. While still a student at the New York School of Social Work and Columbia University, he began his life-long association with journals dedicated to social betterment. At twenty-eight, he became director and guiding spirit of the most ambitious study of an American industrial city yet undertaken, the Pittsburgh Survey. Prior to the publication of the survey, in six volumes, Charities and the Commons, of which he was managing editor, devoted three issues to this material, including Lewis Hine's photographs. Kellogg was clearly changing the emphasis of his journal from charities to socioeconomic reform. In 1909, he launched The Survey, a weekly magazine whose influence among community leaders far outdistanced its modest circulation. Kellogg was editor of The Survey for the more than forty years of its existence and, after 1921, of the monthly Survey Graphic. From the beginning, Arthur Kellogg, Paul's brother, played an active editorial role in all these journalistic enterprises, which were to sustain Lewis Hine as a photographer through many a lean year.

big city, run by the rulers of the steel industry and torn by labor violence—the bloody Homestead strike of the 1890's, which destroyed the fledgling steelworkers' union, was still a fresh memory. The city was divided between masses of immigrant, largely unskilled workers on one hand and a comfortable middle class of managers, executives, and politicians on the other. Pittsburgh was a classic example of absentee ownership in the new capitalist style: the new rulers were not individuals like Carnegie and Henry Frick of the previous generation, but corporations with large staffs of planners, engineers, and research scientists whose main offices were elsewhere. The selection of Pittsburgh signaled a recognition of where the power now lay in American society—in industrial capitalism—and where the major social problems occurred—in factories, in working-class homes and neighborhoods.

The Survey investigators—social workers and specialists in such fields as labor economics—combed the city to uncover facts about the ethnic composition of Pittsburgh's workers, their housing conditions and family life; about the cost of living, the quality of education and recreation, and working conditions; about wages, hours, and the workers' exposure to industrial accidents.[12] The investigators left nothing untouched, their findings eventually appearing in six thick volumes. The study exposed the rawest nerves of modern America, and following as it did for Hine on the Ellis Island project, confirmed the direction of his work: to depict working-class life in industrial America.

Hine's pictures appear in each of the Survey's six volumes. He worked in Pittsburgh for only three months (the entire investigation lasted a year and a half), but his achievement was enormous. His images contributed immeasurably to the success of the Survey, and helped make it even today a lively document. The effect of the experience on his own work was also immeasurable. The "survey" idea became his guiding principle. It provided both a form and an ideology, a way of working and a purpose.

"Survey" was a key item in the reform outlook. A survey, like a map, assumes that the world is comprehensible to rational understanding and that understanding can result in *social* action. It assumes, too, that once the plain facts, the map of the social terrain, are clear to everyone, then change or reform will naturally follow. Reasonable men and women, the Progressive ideology held, would behave in their collective self-interest once they saw the true shape of their affairs. To see was to know, and to know was to act. On just such a pristine formula was Progressive optimism—and Hine's—based.

The study vivified its map of the city with, in the words of Paul Kellogg, the chief architect of the Survey, "piled up actualities." "Instead of relying on abstract categories, such as death rates, or of telling pathetic stories of tragic individual figures such as novelists use, we . . . draw upon the common experience." The surveyors wished "to make the town real—to itself," and so they launched themselves "on the high seas" between the census at one extreme and "yellow journalism at the other." "With the chartings of such dauntless explorers as Jacob Riis and Lincoln Steffens," the members of the Survey collected many individual biographies, recounted their own personal experiences, and endeavored "to stamp the work with the creative personality of the responsible investigators." As its most adventuresome innovation, the Survey enlisted a photographer, Lewis Hine, and a painter, Joseph Stella, in its campaign to tell its findings "through the eye as well as through the written word."

Stella's charcoal and pastel drawings provide significant contrast with Hine's photographs, both in the way they were used and in their character. Where Stella's drawings, chiefly heads of immigrant steelworkers, showed an artist's *impressions* and were inserted singly within the text, the photographs were presented as facts, visual facts, in connection with the text. The captions typically referred back to the text, connecting the pictures to large specific themes of the Survey—as in the portraits of industrial accident victims captioned "An Arm Gone at Twenty" and "The Wounds of Work."

Stella, moreover, responded to the Pittsburgh experience with intense and romantic exuberance. In his journals, he wrote about "the spasm and the pathos of those workers condemned to a very strenuous life, exposed to the constant MENACE OF DEATH." Pittsburgh was a Dantean "revelation, a battlefield, ever-pulsating, throbbing with the innumerable explosions of its steel mills." He wrote that he "worked with fury" to get this feeling into his drawings, which, with their reds and blacks, their lined, grimed, and grimacing faces, convey a feeling of a living inferno.[13]

Hine's images could not be further from Stella's turbulent conceptions. The photographer had the mission of procuring irrefutable visual evidence, and he followed a practice similar to that of the Ellis Island pictures—arranging individuals and groups within their settings. The evidence adduced through his pictures was determined by the strategy of the Survey to propose simple, self-evident contrasts between what was thought to be true and what was discovered actually to be true. For example, the volume

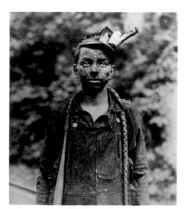
Miner, c. 1908, by Lewis Hine

Four miners, 1908, by Joseph Stella

Joseph Stella (1877–1946) was nineteen when he left Italy for New York, where he began his studies at the Art Students League. His magazine illustrations, including a 1905 series of Ellis Island immigrants, won him a reputation as a social artist and led to his assignment with the Pittsburgh Survey, for which he made powerful drawings of industrial works and workers. Stella's Pittsburgh images, which appeared with Hine's photographs in The Survey, *are expressive of his feelings, often ambivalent, about the "eloquent misery" of the steel and coal city. Even early in his career, as a painter of proletarian scenes, Stella was never formally allied with the Ashcan School, a group of artists, based in New York City, who depicted commonplace aspects of urban life.*

devoted to the steelworkers opens with a description of the "glamour" of the industry, of the "majestic and illimitable" power of steelmaking, and then raises against this positive image an antagonistic one: the insufferable "working life" of the men who labor in the mills. The camera had the specific task of disclosing the unseen and presenting it within a frame of reference that claimed the original image to be not so much false as incomplete. Thus Hine's pictures, like the Survey itself, do not aim to shock the viewer into rebellion, or to move him to a condemnation of a Dantean system, but to persuade the viewer that the full picture, the complete scene, includes contradictory evidence. Such facts as crippled workers, crowded one-room dwellings, dirty streets—and with it all, the strength and worthiness radiant in the faces of workers—prove that something is wrong. The challenge for the viewer is to reconcile the opposing images: industrial power and human waste.

Photographs presumably do not lie. Yet, presented differently, in a different frame of reference, they might lead to other interpretations. Indeed, several of the Pittsburgh pictures appeared in the September, 1912, issue of the *International Socialist Review*, in an article that called for open rebellion and urged workers to turn against both their industrial bosses and their conservative union leaders. To assure communication of the meaning intended by the photographer, the Survey recognized how important it was to key the pictures to a text, to establish a clearly articulated structure of presentation.

Finally, in Hine's Pittsburgh pictures, we witness the unfolding of a pedagogical purpose: the showing of the work place as central to human experience. His photographs do not break the rhythm of work but only interrupt it for a moment of reflection; they always allow the figure of the worker to dominate the instruments of his labor, the open hearths, the mine pits, the shovels and tongs and trolleys. Other photographers took their cameras into factories and workshops, but none developed the scene as fully as did Hine. The Pittsburgh Survey inaugurates his visual conception of industrial labor, a conception that would gather into a thundering critique and rebuke in the child labor pictures, and then into an affirmative summation in the "work portraits" and "men at work" series of the 1920's and 1930's.

●

"I'm sure I am right in my choice of work," Hine wrote to Frank Manny in 1910, two years after joining the staff of the National Child Labor Committee. "My child-labor photos have

already set the authorities to work to see 'if such things can be possible.' They try to get around them by crying 'Fake' but therein lies the value of the data and a witness. My 'sociological horizon' broadens hourly.''[14]

Written from the field, this statement provides a revealing slant on the photographs that have been hailed as Hine's greatest work. He would later comment that he thought his "work portraits" his best efforts, but there seems no doubt that his years with the NCLC were the most creative and inventive of his career. The aim of his photographs for the Committee was strictly functional; he wanted to move people to action. The photographs were evidence in the court of public opinion. And in gathering the evidence Hine learned the nature of the beast he was up against: not only the deadening effects of industrial labor on both children and adults, and its cruel effects on family life, but the connivance among employers, inspectors, and sometimes even parents and the working children themselves to pretend that all was well and natural. Thus his "sociological horizon" broadened to take in a complex social mechanism.

And step by step with his widening grasp of social conditions and the rationale behind them, he enlarged his photographic horizon. The point is sometimes made that in his child labor pictures, which covered the years 1908 to 1918 (during which he also undertook other assignments dealing with housing and settlement houses and adult workers), Hine was "a social agitator first and photographer second,"[15] that he gave "little thought to art other than to do his best to make accurate and convincing renderings of matters that deeply moved him."[16] Both these statements and the views they represent are meant as compliments, the implication being that "art" would interfere with the making of moving, effective pictures. But a more accurate view of Hine during this period is that his "sociological horizon" gave his photography a specific focus—not only a function but a form, a form derived from its function. The extraordinary and unprecedented body of thousands of child labor pictures not only records a vivid history of weary faces, exhausted and often crippled bodies, but also reflects a history of the artist's discoveries of the expressive range of his medium.

The two horizons, sociological and photographic, became one. Sociologically, Hine learned that not truth but self-interest moved "the authorities" and that only irrefutable truth, delivered in a package of photographic image and data (dates, places, names, ages, heights, hours of work, daily earnings), would appeal to the sole force capable of moving them: public opinion. Photographi-

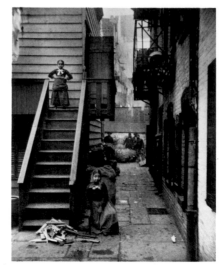

Baxter Street alley, by Jacob Riis

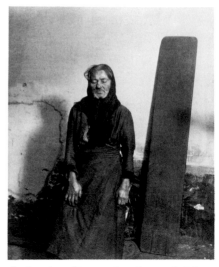

Lodger in police station, by Jacob Riis

Jacob Riis (1849–1914) went to the Lower East Side as if he were entering enemy territory. He carried on his battle against the slum on two fronts, using his camera as a weapon, recording atrocious conditions, and lecturing the public at gatherings in halls and churches. He combined these efforts with his work as an investigative newspaper reporter and with publishing such books as The Making of an American and How the Other Half Lives. Prior to Lewis Hine, Riis was the most prominent social photographer. A noted public figure, he was a frequent guest at the White House during the presidency of Theodore Roosevelt.

cally, he learned that the image which packed the most powerful social punch was that with the strongest aesthetic impact, because this was the image that most effectively made the public a witness to the scenes of degradation that filled his angry vision in these years.

Hine gathered verbal data along with his pictures, wrote copious reports, gave lectures and slide talks, and often published brief essays on his investigations. These writings, often moving and acute in their own right, deserve our attention; they express Hine's feelings about his labor in the cause of a better life for working people, as well as his ideas about the cause. But his true labor was photography, and this period of intense commitment and agitation resulted in a body of images that virtually revolutionized the medium.

The practical purpose of the NCLC in its early years was to survey and publicize the facts of child labor. There were about two million children under sixteen in the work force at the time, and the Committee's modest aim was to see that existing state laws were enacted. Investigation was conducted by region and industry, and Hine's itinerary followed the pattern of the larger campaign: in the Northeast, along the Atlantic and Gulf coasts, in the Deep South and the Midwest, he looked for illegal child labor in textile mills, glass factories, coal mines, sweatshops and tenements, canneries and fisheries, on city streets and in beet, berry, and cotton fields.

There was real heroism in this project that covered tens of thousands of miles, entailing as it did physical adventure and risk. The 1909 annual NCLC report described Hine as having made over 800 photographs the previous year, photographs that were "of great value in furnishing visual testimony in corroboration of evidence gathered in field investigation." The evidence was often hidden, kept out of sight. Bosses guarded their mills and cotton fields and sweatshops with a jealous eye. (They still do, as contemporary photographers chased from factory gates and migrant worker camps can testify.) Hine devised an ingenious bag of tricks to elude the barriers. He sometimes pretended he was after pictures of machines, not children, or he passed himself off as a salesman. Often, one hand in his pocket made notes on ages and sizes while the other worked the camera, the buttons on his coat serving as a measure of height. "Sneak" work was common, and so was physical threat: "I have a number of times been very near getting what has been coming to me from those who do not agree with me on child labor matters," he once wrote.[17]

The camera made visible what unrecognized social bound-

aries and, often enough, plain ignorance and myopia kept invisible. "In a city of this size," Hine wrote about Hartford, "35 newsgirls are not very noticeable to the passerby."[18] Indeed, myopic or indifferent adults often appear in his street photographs. In many of his writings, he called upon his audience to cross a geographical social boundary: "Come out with me to one of these canneries at 3 o'clock in the morning. Here is the crude, shedlike building, with a long dock at which the oyster boats unload their cargoes. Near the dock is the ever-present shell pile, a monument of mute testimony to the patient toil of little fingers. It is cold, damp, dark."[19] The prose itself is photographic in its concreteness and vivid detail. But the moral point of view is unmistakable, as it is in the photographs: not only outrage at the conditions ("the subject always makes me see red") but impatience with those who refuse to recognize that "such things can be possible."

In Hine's day, workshops, which used to be mixed in with residential and commercial neighborhoods, were fast becoming secret and secretive places, buried in dark corners of tenements, hidden behind imposing brick walls of factories. There seemed to be a correlation: as work became more mechanized, more fragmented into simple-minded physical acts even a child could perform, the work place became less visible, less open to public scrutiny. This secrecy, Hine learned, hid shameful sights (later in his career, he would stress the evidence of workers' creativity and intelligence kept out of view), and he came to define his task as that of showing the world of consumers exactly what the world of makers was like. This task became a ripping aside of the veil that disguised and mystified the brutal system of production.

A similar implicit *disclosing* effect governs his writings. The rhetoric is sometimes flat understatement: "There have been several accidents in this mill lately. A little twelve-year-old spinner recently had her leg broken by a doffer boy who ran into her with his doffing box. On the same day a woman had her finger taken off by her machine."[20] Sometimes it is rage suppressed into irony: "We read with perfect composure that a fifteen-year-old breaker boy was smothered to death in a Pennsylvania coal chute; we forget to count the cost to a girl of long hours of work over a machine that is always calling for more, making her 'wish she could be a machine too.' "[21] The prose is as exhaustive in its recital of details, of photographic facts, as the pictures: "The dreary cars are ready for them with their loads of dirty, rough clusters of shells, and as these shells accumulate under foot in irregular piles, they soon make the question of mere standing one of extreme physical strain. Note the uncertain footing and dilapi-

dated foot-wear of that little girl." The parade of detail, the out-pouring of a sympathy that must make an appropriate language for itself, is unrelenting:

"What is your name, little girl?" "Dunno." "How old are you?" "Dunno." "How many pots do you shuck in a day?" "Dunno." And the pity of it is that they do not know. What then do they know? Enough to stand patiently with the rest, picking up the hard, dirty clusters of shells, deftly prying them open, dropping the meat into the pot, and then to go through this process with another and another and another, until after many minutes the pot is full; a relief—she can carry it over to the weigher and rest, doing nothing, a min-ute, and walk back,—such a change from the dreary stand-ing, reaching, prying and dropping—minute upon minute, hour upon hour, day upon day, month after month. Or per-chance, for variety, the catch might have been shrimp, and then the hours of work are shorter; but the shrimp are icy and cold, and the blood in one's fingers congeals, and the fingers become so sore that they welcome the oysters again.[22]

Always the effort is to bring into view what cannot be seen, or, as in Dreiser's writings, the rationalizations that prevent people from seeing clearly. On the face of it, "toting dinners to fathers in the Georgia cotton mills" is harmless enough but "appearances are deceitful." Some children are recruited into making a trade of toting dinners. It breaks up their school day; it lets them work in the mill under the legal age. "We cannot sanction it as harmless."[23]

Wherever possible, Hine tried to photograph the work place itself, showing the details of labor. Where this was not feasible, he waited at factory gates to catch his damning images and followed children to their homes. But the work place was—and became again in his pictures of the 1920's and 1930's—his quarry. It was there that he made one of the exciting discoveries in the history of photography, equal to Brady's on the battlefield: that the work site could become the site of powerful pictures, rich in a special human content. In a significant sense, Hine can be said to have created his own subject matter. His camera is no mere recording device; others looked at the same scene, but Hine *saw* what he looked at. One might surmise that the reason he saw it so clearly was that he recognized how much his own seeing participated in the act he photographed. Insofar as his camera became part of the scene, the work place became his own place of work, the place where his particular photographic art came into its own. It is

appropriate, and significant, that his pictures frequently showed signs, such as his own shadow, of the process that produced them.

But the task of revealing what he saw was a multiple one. It could not depend on single images. The nature of his assignments and the function to which his pictures would be put served to diminish the independent value of any single image in favor of an amassing of images: so many accumulated details, so much truth, meant all the more irrefutable evidence. While each picture, then, had its own backing of data, its own internal story, it took its meaning ultimately from the larger story. This is the task that perhaps requires the most strenuous act of imagination on the part of Hine's audience today—to see his individual images in the context of their companions. As much as possible, his work should be seen in its original form, in the myriad of reports and pamphlets of the NCLC and on the pages of *The Survey* and other journals: single pictures with captions (one can guess that Hine himself wrote most of these); groups of pictures dealing with specific industries; pictures sequenced parallel to actual narra-tives, stories written for schoolchildren (again presumably writ-ten by him) to teach them about the labor represented by their cotton dresses, their medicine bottles, their coal heat; and fre-quent montages of images (an early use of this device) in exhibi-tion posters and especially in the brilliant form, which he un-doubtedly invented, called "Time Exposures by Lewis Hine."

The mass of photographs—either each particular group pub-lished as a sequence, or all the child labor pictures in their entirety—represents an unfolding of a cumulative meaning; each image takes its force from within a continuing chain of signifi-cance. It becomes more than itself and is transformed into a sign charged with special meaning.

The montage posters are perhaps the most controlled se-quences Hine developed in the sense of being tightly organized, and here the interplay between the single image and overall ideology, or social "map," is clearest. The message cannot be misconstrued: child labor, the photographs *show* us, is "making human junk." Yet the situation is not hopeless: "What Are We Going to Do About It?" depicts several solutions. Hine saw child labor as a process, a "vicious circle," in which everyone suffered. The photographed children are not simply victims tugging at our hearts for charity; they are signs of a collective predicament, a concrete and systematic social process. "You all know how the circle goes," Hine wrote; "child labor, illiteracy, industrial ineffi-ciency, low wages, long hours, low standards of living, bad hous-ing, poor food, unemployment, intemperance, disease, poverty,

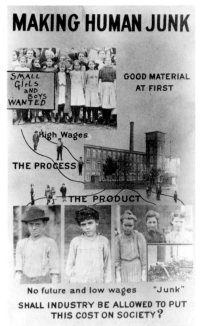

NCLC poster by Lewis Hine

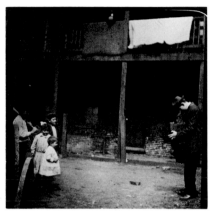

Lewis Hine photographing in a slum

The National Child Labor Committee, which assigned Lewis Hine one of his first photographic projects, began in 1904 as a broad coalition of social workers (among them, Jane Addams, Lillian Wald, and Florence Kelley), educators, labor leaders, and prominent politicians. The cause of saving children had wide public support, but in their day-to-day work the field investigators and staff members came up against stubborn resistance. Ultimately, even their campaign for a federal child labor bill proved to be a losing battle; there is still none on the books.

child labor, illiteracy, industrial inefficiency, low wages—but we are repeating." The consequences were inevitable; the cycle, unbreakable. "A little child working at the manufacturer's machine is the one who becomes industrially inefficient. As an adult he works for the lowest wage. He is the first to be unemployed when business is slack and the last to be taken on when business picks up. He is the one who lives in the two-room tenement. His children in turn, are the first to be employed. . . ."[24]

Thus Hine describes the making of a chronically underprivileged, unskilled working class, a systematic destruction of morale and human resources. And the blame, at bottom, is simply profit. Not work by itself, which can be healthy for children, but work dictated by the economic needs of the capitalist. "There is work which profits the children, and there is work that brings profit only to employers. . . . The object of employing children is not to train them, but to get high profits from their work."[25] And not only from *their* work: ". . . the employer of children forces all wages down to the level of the child's wage."[26]

Hine's posters, as well as his articles, were not simply exposés; they were polemics. And the antagonist was an irrational, self-destructive social system which he described with Dickensian sarcasm: "Industry, with its usual unselfish, altruistic spirit, has been demonstrating for years how we may utilize waste. . . . The master minds of industry have been greatly disturbed over the forces and activities in the home that, like the mighty Niagara, are sweeping onward and accomplishing nothing. They see mothers spending whole days at housework, children at play, neighbors visiting with each other. But what does it all amount to? If these golden moments could be harnessed to the wheels of Industry—Ah, what a millennium! If each of our 25,000,000 children, for example, could knit for three hours a day . . . we could keep the world in socks."[27]

But if Hine's pictures take their full force from their context, we can still see his particular social vision, his own humanity, in single images. Unlike the subjects in Jacob Riis's pictures, who are usually downtrodden, passive, and objects of pity or horror, Hine's people are alive and tough. His children have savvy—*savoir-faire*, a worldly air. They have not succumbed. Their spirit is at odds with their surroundings. And this contradiction fills the pictures with an air of tension—not between such abstractions as "suffering, helpless children" and "a brutal system" but between living creatures and a very particular fate.

●

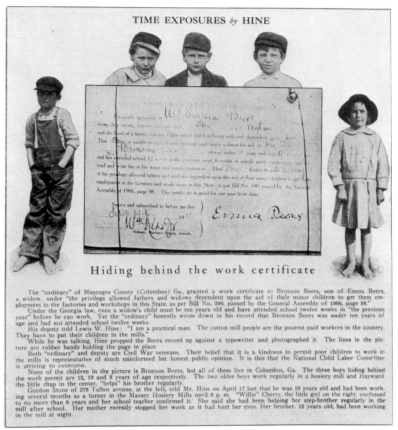

TIME EXPOSURES by HINE

Hiding behind the work certificate

The "ordinary" of Muscogee County (Columbus) Ga., granted a work certificate to Bronson Beers, son of Emma Beers, a widow, under "the privilege allowed fathers and widows dependent upon the aid of their minor children to get them employment in the factories and workshops in this State, as per Bill No. 390, passed by the General Assembly of 1906, page 98."

Under the Georgia law, even a widow's child must be ten years old and have attended school twelve weeks in "the previous year" before he can work. Yet the "ordinary" honestly wrote down in his record that Bronson Beers was *under* ten years of age and had *not* attended school twelve weeks.

His deputy told Lewis W. Hine: "I am a practical man. The cotton mill people are the poorest paid workers in the country. They have to put their children in the mills."

While he was talking, Hine propped the Beers record up against a typewriter and photographed it. The lines in the picture are rubber bands holding the page in place.

Both "ordinary" and deputy are Civil War veterans. Their belief that it is a kindness to permit poor children to work in the mills is representative of much uninformed but honest public opinion. It is this that the National Child Labor Committee is striving to overcome.

None of the children in the picture is Bronson Beers, but all of them live in Columbus, Ga. The three boys hiding behind the work permit are 12, 10 and 8 years of age respectively. The two older boys work regularly in a hosiery mill and Hayward the little chap in the center, "helps" his brother regularly.

Gordon Stone of 278 Talbot avenue, at the left, told Mr. Hine on April 17 last that he was 10 years old and had been working several months as a turner in the Massey Hosiery Mills until 8 p. m. "Willie" Cherry, the little girl on the right, confessed to no more than 6 years and her school teacher confirmed it. She said she had been helping her step-brother regularly in the mill after school. Her mother recently stopped her work as it had hurt her eyes. Her brother, 12 years old, had been working in the mill at night.

Time Exposures *feature in* The Survey

Time Exposures by Lewis Hine *were published in* The Survey *in 1914 and 1915 as the magazine experimented with varieties of presentation to best communicate its message. Hine was one of the first Americans to experiment with photomontage, a graphic process of juxtaposing several images to achieve new depth of meaning. To complete his statement, he combined the image with a documentary text. Hine also wrote investigative field reports which often appeared in the magazine but not always with illustrations. These articles movingly depicted in words the conditions he found as he traveled.*

"For many years," Hine wrote, "I have followed the procession of child workers winding through a thousand industrial communities, from the canneries of Maine to the fields of Texas. I have heard their tragic stories, watched their cramped lives and seen their fruitless struggles in the industrial game where the odds are all against them. I wish I could give you a bird's-eye view of my varied experiences."[28] Hine's work sets a special value upon firsthand experience in grander terms, upon the artist's role as *witness*. He held with Whitman that "the true use for the imaginative faculty of modern times is to give ultimate vivifications to facts, to science, and to common lives." With other artists of his time, Hine shared a focus on the everyday: in the social reporting of Lincoln Steffens and Jack London; in the fiction of Stephen Crane, Theodore Dreiser, and, later, John Dos Passos; and in the new subject matter of city streets painted by the Ashcan group, especially Robert Henri and John Sloan.

That he was entirely conscious of this role is clear from an essay he wrote in 1909, early in his work for the NCLC, which he delivered as a lecture with slides. "Social Photography: How the Camera May Help in the Social Uplift" is a personal manifesto. It laid the basis for a certain *art* of photography to which he remained true for the rest of his life.

He delivered the paper at a session of an annual meeting of the National Conference of Charities and Correction. The meeting was devoted to "Press and Publicity," and in the paper Hine argued that "Servants of the Common Good" must, above all others, be inventive and imaginative in their publicity. Winning the trust of the "great public" was their foremost goal; photography, an essential instrument. When "the great social peril is darkness and ignorance," he declared, quoting Victor Hugo, " 'What then . . . is required? Light! Light in floods!' " "Let there be light" is the dictum of the social worker, "and in this campaign for light we have for our advance agent the light writer—the photograph."[29]

It may seem familiar now, but the conception of the photograph as a kind of writing was, in 1909, an advanced notion. Some years later, the avant-garde artist Lazlo Moholy-Nagy wrote, in a famous aphorism, "a knowledge of photography is just as important as that of the alphabet" and "the illiterates of the future will be ignorant of the use of camera and pen alike." In his essay, Hine makes clear that he gave serious thought to the aesthetic issues involved in photography as a medium of communication.

"Where lies the power in a picture?" he asked as he flashed on the screen an image of newsies huddled under the Brooklyn

Bridge at 3 A.M., waiting for customers. The picture, he explained, "is a symbol that brings one immediately into close touch with reality"; it tells "a story packed into the most condensed and vital form." Indeed, it is even "more effective than the reality would have been, because, in the picture, the non-essential and conflicting interests have been eliminated." A picture, then, is the product of a specific understanding, and to communicate its story it must be clear about its own message. Its vital form depends upon the maker's deliberate elimination of the nonessential.

So much is equally true of all pictures—paintings, engravings, or photographs. But, Hine added, "the photograph has an added realism of its own"—an "inherent attraction" that engenders the common belief that "the photograph cannot falsify." Because "this unbounded faith in the integrity of photography is often rudely shaken" (for "while photographs may not lie, liars may photograph"), it is doubly important, "in our revelation of the truth, to see to it that the camera we depend upon contracts no bad habits." Because of its inherent "realism" or literalism, the photograph might be used as a powerful weapon of deception. For the same reasons, its power as a "lever . . . for the social uplift" is equally impressive. But how to draw upon this power? Here Hine takes a step toward a coherent and advanced theory of photography by placing the power for "uplift" in the effect that a verbal caption can have upon a photograph. He dramatized this effect by reading a passage from Hugo on the "dismal servitude" of children against a picture "of a tiny spinner in a Carolina cotton-mill." "With a picture thus sympathetically interpreted, what a lever we have for the social uplift."

Commenting on Moholy-Nagy's aphorism, the German critic Walter Benjamin wrote in the early 1930's: "But must we not also count as illiterate the photographer who cannot read his own pictures? Will not the caption become the most important component of the shot?" Benjamin refers to Bertolt Brecht's remark that by itself a photograph of a Krupp plant would tell us nothing about the social reality behind the image—would remain "stuck in the approximate." Citing Atget's photographs of empty streets in Paris, Benjamin expands Brecht's point by saying that they "have been compared with those of a scene of action. But is not every corner of our cities a scene of action? Is not every passerby an actor? Is it not the task of the photographer—descendant of the augurs and the haruspices—to uncover guilt and name the guilty?"[30]

The naming of the guilty is precisely the work of Lewis Hine in his child labor pictures, and the caption is central to his en-

deavor, to his *art*. He understood this perfectly. "With several hundred photos like those which I have shown, backed with records of observations, conversations, names and addresses, are we not better able to refute those who, either optimistically or hypocritically, spread the news that there is no child labor?"

One other aspect of Hine's work demands comment: its *democratic* element. Hine was determined to share not only his firsthand experiences in the form of images but also his experiences in the craft and technique of his art. "The greatest advance in social work," he wrote in his 1909 essay, "is to be made by the popularizing of camera work, so these records can be made by those who are in the thick of the battle." He wished to share, to democratize, the apparatus of picture-making, to dispel the aura of the arcane from the camera. "Fight it out for yourselves," he urged his audience, "for better little technique and much sympathy than the reverse."

"I have had all along, as you know," he wrote to a friend in 1910, "a conviction that my demonstration of the value of the photographic appeal can find its real fruition best if it helps the workers to realize that they themselves can use it as a lever even tho it may not be the mainspring of the works."[31]

●

If the camera might become the worker's ally, his lever for change, often enough it stood against him as a foe. To see as clearly as possible what Lewis Hine was up to in the next phase of his work, that of *affirmative* photography, mention must be made of the critical role played by the camera in the hands of engineers who were shaping the worker's life at his work place. The new character of industrial labor became Hine's major theme after World War I, and it is noteworthy that in pursuing that theme he in effect set his camera against that of management— against the camera of the time-study man.

After a period in Europe during the war, photographing refugees and relief activities for the American Red Cross, Hine made a turn that has generally been interpreted as a drastic and unfortunate shift from social criticism to affirmation. Between the child labor pictures and the so-called "work portraits" lies a gulf, many believe, of both social and aesthetic values. Hine's eye was weakened, according to one critic, by an "exaggerated desire to glorify the working class."[32]

In fact, the "work portraits" are the most troubling, the most problematic of Hine's pictures. Still, they have a significant place within his entire work. They seem contradictory to his earlier

pictures, yet they are not. If one recognizes the battle of cameras that they represent—Hine's against management's—one can see that they are still consistent with his enterprise as a polemical social photographer.

"In Paris, after the Armistice," Hine recalled in 1938, "I thought I had done my share of *negative* documentation. I wanted to do something *positive.* So I said to myself, 'Why not do the worker at work? The man on the job.' At that time, he was as underprivileged as the kid in the mill."[33] The aim was to show not industry in a positive light but the worker—to show the importance of *human* labor at a time in the 1920's when public attention was obsessed with the *machine* as the genius of American prosperity and power.

Thus Hine's project takes on at least notable social significance once its context is identified. The "underprivileged" status Hine had in mind derived from the increasingly potent myth that the worker was merely a cog in a machine, a replaceable part. Indeed, this notion had some foundation in reality, for the thrust in industry was toward ever-refined mechanization—a breaking-up of the labor process into minute steps that required a diminishing amount of training and skill to perform. Coupling the time-study procedures of Frederick Winslow Taylor ("Taylorism") and the motion studies of Frank B. Gilbreth (who named the units of movement after his own name spelled backwards: *therbligs*), industrial capitalism was rapidly transforming the nature of work itself. If Taylor's instrument was the stop watch, Gilbreth's was the camera, a motion-recording device he called the "cyclograph." The camera, then, played a role, albeit a relatively minor one, in depriving workers of their crafts, their skills, their expertise, their power of self-determination at work—and, ultimately, their dignity as people.

The dignity of work, its pleasures and satisfactions: this theme had belonged to Hine's vision from the very beginning, and it is the theme he pursued in his work portraits. As early as in his 1909 lecture on social photography, Hine had remarked: "Apart from the charitable or pathological phases of social work, what a field for photographic art lies untouched in the industrial world. There is urgent need," he added, "for intelligent interpretation of the world's workers, not only for the people of today, but for future ages." Conceptually speaking, the project was more daring, more complex, than his earlier investigations of child labor. And it is not surprising that the results are less uniformly successful—at least, less appealing to our present taste for the dynamic excitement of the early pictures.

In evaluating the work portraits, one also must take into account Hine's personal situation. After resigning from the NCLC in 1918, he never again held a long-term assignment that brought in a steady income. He remained close to Paul Kellogg and the renamed *Charities, The Survey*—which went on to introduce a monthly number, called *Survey Graphic,* devoted to feature articles of general interest and many illustrations—and found in this publication a welcome outlet for most of his pictures and his new interests. Early in the 1920's, he was approaching the age of fifty, and his career, especially recognition of his earlier work, was much on his mind. He held several exhibitions, won a prize offered by an advertising organization, and seemed to think more and more of the appropriateness of the word "artist" attached to his name, though he refused to accept the tag "art photographer." The work portraits are part of this shifting situation.

Hine was as articulate about the portraits as he was about his former projects. In 1920, the journal *Literary Digest* reviewed a recent Hine show under the title "Treating Labor Artistically." The writer compared a picture of Hine showing an open hearth—the picture identified by the "commonplace title" "Handling Hot Metal in a Pennsylvania Shop"—with the famous Stieglitz picture "The Hand of Man." The picture by Stieglitz, the reviewer wrote, "was an adoption of principles employed by Whistler. . . . The subject is comparatively nothing [the image shows a railroad yard, dark and smoky, from a distance], and the treatment all." Hine did not aim at such "artistic" results, the reviewer pointed out, but often achieved just as compelling an artistry. Then, with a quote from Hine himself, the article explained the real and primary purpose of Hine's industrial pictures: "to show the meaning of the worker's task, its effects upon him, and the character of his relation to the industry by which he earns a living." Photographing workers on the job, Hine told the reviewer, was "a new development in the movement to study the human problem of men and women in modern industry." The article cited Hine's plan to do a series of such studies for presentation "both to the workers and the managers, a picture record of the significance of industrial processes and of the people engaged in them."[34]

The functional use of photographs within the social process of the factory—the working out of relations between labor and management—was foremost in Hine's mind. "The great problem of industry," he said in another interview in 1926, "is to go a step beyond merely having the employer and employee 'get along.'

The Hand of Man, *New York, 1902, by Alfred Stieglitz*

Handling Hot Metal in a Pennsylvania Shop, *by Lewis Hine*

Ten years after Stieglitz's interpretation of the machine age, The Hand of Man, *Lewis Hine photographed the process of* Handling Hot Metal in a Pennsylvania Shop. *According to a 1920 review in the journal* Literary Digest, *which compared the two photographs, each presented a different view of industrial America: Stieglitz, a romantic vision from a transcendent perspective; Hine, a human document of social reality.*

The employee must be induced to feel a pride in his work." "But," asked the interviewer, "do the workers you deal with understand what you are doing?" "Not all of them, naturally," Hine replied. "Yet I have found many so-called 'human machines' who had a genuine interest in the finer things of life. It is perfectly possible to direct that interest to their jobs—to make them see those jobs as 'finer things' too."[35] To see work as art, and themselves as artists in their work: an extraordinary goal Hine set for his audience of workers, and for himself.

Such a project had no precedent in the United States, although similar efforts were being undertaken in Europe at the same time and Hine might have known of them. In any case, as in his NCLC days, he was trying to fashion a role for himself as a particular kind of artist, and the fact that he failed to make any headway in getting industries to accept his project might be taken as a sign of its utopian aspect.

We are left with the pictures themselves, in the form of portfolios in *The Survey* and elsewhere, and eventually in a small selection of them in a book aimed at schoolchildren, *Men at Work* (1932). While discussing them as pictures, we should do Hine the honor of at least remembering his largest plans for these images. They were meant as very specific communications—and a very specific kind of resistance to the continuing degradation of work, one of the most potent social forces of his day and ours.

Taken as pictures alone, and as a group, the work portraits *look* different from the earlier efforts. Hine devotes great attention here to textures—of metal, cloth, and flesh—and to lighting. Many have qualities of lighting that suggest studio conditions, although all were made on site. If "craftsmanship" is itself a theme here, so the pictures themselves seem products of a photographic craft more prominent than was the case earlier. Then, too, individual images seem more overtly endowed with a symbolic import than before: instead of the backing of data, Hine now titles the prints by type of craft—brakeman, printer, assistant master mechanic, furnace repair foreman. The individual is to this extent submerged in the type, which itself is a way to affirm the persistence of namable *crafts* in industry. Captions for the pictures in *Survey Graphic* often linked the new industrial and factory laborer to earlier, preindustrial forms of work. The "skilled machinist" is like a blacksmith shoeing a horse; "powermakers" are "of the ancient life of grooms, and hostlers, and veterinarians."

To our present taste, the message of the pictures may be too transparent, too preconceived, too much a theme superimposed

on an otherwise interesting subject. True, the enterprise is of interest for its sociological ambitions. Of interest, too, is the fact that Hine would later return to the theme of crafts, "the passing crafts and the present activities that are carrying over the essentials of the old crafts for the benefit of the present generation," in a proposal for a foundation grant in 1937.[36] But the pictures suffer. We miss the visual excitement, the spontaneity, the brilliant improvisations of the earlier work. Most of these pictures seem seriously out of touch with the lives they portray.

Yet many are marvelous, vivid portraits, sensitive to the nuances of individual faces. "I have a conviction," Hine wrote in 1933, "that the design registered in the human face through years of life and work, is more vital for purposes of permanent record, (tho it is more subtle perhaps) than the geometric pattern of lights and shadows that passes in the taking, and serves (so often) as mere photographic jazz."[37] And enough of the work portraits confirm this conviction for us to respect the series and take it as serious work.

The work series took one final and glorious turn. In 1930, Hine accepted the job of documenting the construction of the Empire State Building. The resulting photographs are, in a sense, his crowning work, a surmounting triumph of his vision—and, though in a much different mode, comparable as a statement to Joseph Stella's Futurist portrayal of skyscrapers in "The Voice of the City" (which had appeared in an issue of *Survey Graphic* along with Hine's portfolio on "powermakers") and to Hart Crane's celebration of the Brooklyn Bridge, *The Bridge* (1930).

The drama of the project was breathtaking. Hine climbed with the "sky boys" floor by floor, balancing his equipment on girder after girder, swinging out in a basket at the hundredth floor for views from the top. The pictures are astonishing performances; they restore to his work the spontaneity, the visual energy, the plasticity of the child labor images. Moreover, this project gave Hine just the focus he needed. These are not "portraits." They are pictures of work itself. We *see* that human labor counts. The site of the building is a work place made entirely by labor, an open space shaped, filled in, given form by workers in charge of machines. Foundation men, derrick men, riveters, sky-jacks: the trades and crafts can be named and depicted in the process of making something—the tallest building in the world.

Here Hine could follow with his camera a process that culminated in a tangible product: not "power," something abstract, metaphysical, beyond sight, but a *building*, a tower, an unmistakable presence. In this series, the subject matched the ideology—the creative contribution of labor—and the camera is thus freed from imposing a message. Sheer graphic execution becomes its goal. In the best sense of his functionalist idea of education, Hine shows us the building as it appears, step by step: nothing mysterious, nothing ominous (as in Stieglitz's skyscraper studies in the same years)—only something *made*, with skill and daring and courage.

And pictures themselves are something made. The camera enters the work place, dead center, and makes of it a work place of its own. Taking his lead from his mighty subject, Hine participates in the making of the tower by serving as its faithful reflection—its self-consciousness, one might say. It is as if the making of the tower, an epitome of the constructive potential of labor, photographs itself.

•

When Lewis Hine glanced back over his career in October, 1940, he caught the essence of a unifying thread: "Ever—the Human Document to keep the present and future in touch with the past." He died a month later in poverty and neglect. Since then, Americans have known of Hine, if at all, as a man who long ago made pictures of children in factories and of immigrants at Ellis Island. He seemed to belong to the past, to the memory of an earlier America.

But Hine's pictures are very much alive. In his NCLC days, his vision made a real difference, and it can once more. Allow his images to mingle with our own evidence of the quality of work and life today, and we learn about our common history as Americans. More than this, Hine was not simply a chronicler of social conditions. He brought to the role of "Servant of the Public Good" the intensity of a visionary. He saw the world from the point of view of the neglected, the sufferers, the victims of callousness, greed, and violence; and he was filled with a passion to share his vision, to show it to others, to win respect and compassionate regard for the dignity of working people and for himself. Photography was his labor. He identified with working people because he was one of them, and he remained so to the end.

The material of art, wrote John Dewey, the great American teacher of Hine's generation, is always social. Art is a form of communication, Dewey realized, and not an absolute essence. Like Hine, he stressed the continuity between "the intensified forms of experience that are works of art and the everyday events, doings, and sufferings that are universally recognized to constitute experience." Art is always a *practical* effect. "Esthetic ex-

perience," Dewey pointed out, "is always more than esthetic. In it a body of matters and meanings, not in themselves esthetic, become esthetic as they enter into an ordered rhythmic movement toward consummation. The material itself is widely human."

Dewey might well have been speaking of Hine's photographs: their intensity, their rhythms, their vibrant energy—the mark of their art. As art they connect us, ground us once more, in the fluid movements of our own everyday lives, of history, the present and the future. "Artists have always been the real purveyors of news," Dewey tells us, "for it is not the outward happening in itself which is new, but the kindling by it of emotion, perception and appreciation." Dewey envisioned "a subtle, delicate, vivid and responsive art of communication" that would be the basis of a revived American "great community." With such an art, it was his high hope, "democracy will come into its own, for democracy is a name for a life of free and enriching communion. It had its seer in Walt Whitman." And in Lewis Hine.

<div align="right">—Alan Trachtenberg</div>

Lewis Hine at his home in Hastings-on-Hudson, New York, c. 1935, Berenice Abbott

NOTES 1. "Plans for Work." Guggenheim application, Oct., 1940. 2. "Looking at Labor." Enclosed in letter to Paul Kellogg, July 6, 1939. Hine described the enclosure (a three-paragraph statement) as a "home-made publicity statement." University of Minnesota Social Welfare History Archives Center. 3. Letter to Elizabeth McCausland, Sept. 7, 1938. Elizabeth McCausland Papers, Archives of the American Institute of Art. 4. "Notes on Early Influence," 1938. Elizabeth McCausland Papers. 5. "Fifty Years of Preparation." Attached to Guggenheim application, Oct., 1940. Enclosed in letter to Roy E. Stryker, Oct. 17, 1940. Stryker Papers, National Archives. 6. Feb. 17, 1933. Elizabeth McCausland Papers. 7. Howard B. Radest, *Toward Common Ground: The Story of the Ethical Societies in the United States* (New York, 1969), pp. 16–17, 27–30, 42–44. 8. Letter to Arthur and Paul Kellogg, Feb. 7, 1931. 9. "Child Labor Legislation: A Requisite for industrial Efficiency." In *Child Labor* (New York, 1905), p. 130. 10. "Notes on Early Influence," *loc. cit.* 11. *Ibid.* 12. Paul Kellogg, "The Pittsburgh Survey," *Charities and the Commons,* 19 (Jan., 1909), 524. 13. "Notes About Stella." Quoted in Irma Jaffe, *Joseph Stella* (Cambridge, Mass., 1970), p. 20. See Helen Cooper, "Stella's *Miners,*" *Yale University Art Gallery Bulletin,* 35 (Fall, 1975), 12. On at least two occasions, *The Survey* expressed some discomfort with the darker sides of Stella's images: see Cooper, 12, and Jaffe, 54. 14. "Notes on Early Influence," *loc. cit.* 15. George Cruger, "Lewis Hine." *Arts in Virginia,* 16, 1 (Fall, 1975), 18. 16. Robert H. Bremner, *From the Depths: The Discovery of Poverty in the United States* (New York, 1956), p. 197. 17. "Tasks in the Tenements, *Child Labor Bulletin,* 3 (1914–15), 95. 18. "Street Trades in Hartford." National Child Labor Committee Papers, Library of Congress. 19. "The Child's Burden in Oyster and Shrimp Canneries," *Child Labor Bulletin,* 2 (1913), 106. 20. "Present Conditions in the South, *Child Labor Bulletin,* 2 (1913), 64. 21. "The High Cost of Child Labor," *Child Labor Bulletin,* 3 (1914–15), 63. 22. "The Child's Burden in Oyster and Shrimp Canneries," *loc. cit.,* 109. 23. "The High Cost of Child Labor," *loc. cit.,* 65. 24. "The High Cost of Child Labor" (reprint of Exhibit Handbook), *Child Labor Bulletin,* 3 (1914–15), 34. The words are quoted from a lecture by John Kingsbury delivered at the 9th annual conference of the NCLC. 25. "The High Cost of Child Labor," *loc. cit.,* 66. 26. "The High Cost of Child Labor" (Exhibit Handbook), *loc. cit.,* 30. 27. "Tasks in the Tenements," *loc. cit.,* 95–96. 28. "The High Cost of Child Labor," *loc. cit.,* 63. 29. Quotations in this and following paragraphs are from "Social Photography: How the Camera May Help in the Social Uplift," *Proceedings,* National Conference of Charities and Correction (June, 1909), 50–54. 30. "A Short History of Photography," *Screen* (Spring, 1972), 25. 31. "Notes on Early Influence," *loc. cit.* 32. Cruger, *op. cit.* 33. Elizabeth McCausland, "Portrait of a Photographer," *Survey Graphic* (Oct., 1938), 503. 34. *Literary Digest,* 67 (Dec., 1920), 32. 35. "A Camera Interpretation of Labor," *The Mentor,* 14 (Sept., 1926), 43. 36. Paul Kellogg, Aug. 14, 1937. 37. Letter to Florence Kellogg, Feb. 17, 1933.

(5) Bibliography

SELECTED BIBLIOGRAPHY The National Child Labor Committee issued a variety of publications beginning in 1907. These consisted of small-format leaflets, titled and numbered, and larger-format pamphlets with more pages, similarly titled and differently numbered. Hine's photographs, and occasionally his articles, appeared in over forty-one different leaflets and pamphlets; in addition, they were used consistently in *The Child Labor Bulletin*, which began as a quarterly in 1912 and became a monthly, *The American Child*, in 1919. His images of Southern subjects particularly were made available for reproduction to a broad spectrum of periodicals. The NCLC publications are too numerous to list, and the same photographs often appeared in *The Survey*. As a result, only the *Survey* references appear.

BY LEWIS W. HINE[*]

1906 ARTICLES: "The School Camera," *The Elementary School Teacher*, 6 (Mar.), 343–47. "The School in the Park," *Outlook*, 83 (July 28), 712–18. "An Indian Summer," *Outlook*, 84 (Oct. 27), 502–06. "The Silhouette in Photography," *The Photographic Times*, 38 (Nov.), 488–90.

1907 "The Newsboy at Night in Philadelphia," *Charities and the Commons*, 17 (Feb. 2), 778–84 (uncredited). "How Combat Crap Shooting," *Charities and the Commons*, 17 (Mar. 9), 1044–46 (uncredited). ARTICLE: "Charity on a Business Basis," *The World Today*, 13 (Dec.), 1254–60.

1908 *Charities and the Commons:* "What Bad Housing Means to Pittsburgh," 19 (Mar. 7), 1683–98 (uncredited); "Ellis Island Portrait," 20 (June 6), cover; "Kids Shooting Crap," 20 (Aug. 1), cover; "Pittsburgh Steam Laundry Workers," 20 (Aug. 1), 549–63; "As They Came to Ellis Island," 20 (Sept. 5), 645–47; "Pittsburgh Women in the Metal Trades," 21 (Oct. 3), 36, 42 (uncredited); "Child with Teddy Bear," 21 (Dec. 5), cover. "People Who Make Your Christmas." *The Designer*, 29 (Dec.), 106–07 (double-page picture spread, uncredited). ARTICLES: "Industrial Training for Deaf Mutes," *Craftsman*, 13 (Jan.), 400–08. "A Novel School for Housewives," *The Designer*, 28 (May), 64–66, 79. "Photography in the School, *The Photographic Times*, 40 (Aug.), 227–32. "Question of the School Excursion," *Education*, 29 (Oct.), 84–91.

1909 *Charities and the Commons/The Survey:*[**] "The Working Women of Pittsburgh," 21 (Jan. 2), 570–80 (uncredited); "Immigrant Types in the Steel-District—Photographs by Louis [*sic*] Hine," 21 (Jan. 2), 581–89; "Homestead: A Steel Town and Its People," 21 (Jan. 2), 612–28 (uncredited); "Child Labor in the Carolinas," 21 (Jan. 30), cover and 743–57; "The Housing Situation in Pittsburgh," 21 (Feb. 6), 870–81; "Skunk Hollow: A Pocket of Civic Neglect," 21 (Feb. 6), 890–96; "Painters' Row: The Study of a Group of Company Houses and Their Tenants," 21 (Feb. 6), 898–910; "The Mill Town Courts and Their

[*]Except where articles are specified, all references are to the publication of photographs in periodicals and books.

[**]The Jan. 2, Feb. 6, and Mar. 6 issues were devoted to the Pittsburgh Survey. Beginning with Vol. 22 (Apr.), *Charities and the Commons* became *The Survey*.

Lodgers," 21 (Feb. 6), 913–16; "Wage Earners of Pittsburgh," 21 (Mar. 6), 1051–57; "The Industrial Environment of Pittsburgh's Working Women," 21 (Mar. 6), 1117–29; "Climbing into America," 22 (Apr. 3), 111–14; "The Irregularity of Employment of Women Factory Workers," 22 (May 1), 196–210; "The Way of the Girl," 22 (July 3), 486–97; "Southerners of Tomorrow—Photographs by Lewis W. Hine for the NCLC," 23 (Oct. 2), 2ff; "Our Untrained Citizens—Photographs by Lewis W. Hine for the NCLC," 23 (Oct. 2), 21–35. "The Social Engineer in Pittsburgh," *Outlook,* 93 (Sept. 25), 155–157. "Day Laborers Before Their Time," *Outlook,* 93 (Oct. 23), 434–43. "The Woman's Invasion," Part II, with Emmett V. O'Neill, *Everybody's,* 19 (Dec.), 798–810. (Part I, 19 [Nov.], uncredited, possibly by Hine and O'Neill.) *Neglected Neighbors in the National Capital,* Charles F. Weller. Philadelphia: John C. Wonston. *Women and the Trades,* Elizabeth Beardsley Butler. New York: Charities Publication Committee.

1910 *The Survey:* "The Construction Camps of the People," 23 (Jan. 1), 448ff; "Roving Children," 23 (Jan. 1), 480ff; "Backyards and Alleys in South Chicago," 24 (Apr. 2), 18–24; "Delivering Easter Bonnets," 24 (Apr. 16), cover; "How Girls Learn the Millinery Trade," 24 (Apr. 16), 105–13; "Hine's Children of the Tenements—So. Chicago," 24 (Apr. 23), cover; "In the Babies' Ward," 24 (May 28), cover; "City Neighbors at Play," 24 (July 2), 548–59; "Neighbor at Hull House," 24 (July 30), cover; "Bohemian Woman at Ellis Island," 24 (Aug. 6), 672; "Of the New New Englanders," 24 (Aug. 20), cover; "The Next Generation: Charleston," 24 (Aug. 27), cover; "Southern Cotton Mill Boy," 24 (Sept. 10), cover; "Life in Harlem Is a Serious Business," 24 (Sept. 24), cover. *International Socialist Review:* "The Bakers Strike vs the Bread Trust," 11 (July); "Slaves of Steel," 11 (Aug.), 75–79; "A Union Seaman," 11 (Sept.), cover; "Boy Scabs on the Great Lakes," 11 (Sept.), 155–60; "The Cloakmakers' Strike," 11 (Sept.), 168–71. "Autobiographical Notes upon Twenty Years at Hull House," illustrated with photographs specially taken by Lewis W. Hine, *American Magazine,* 69, 70 (6 installments, 4 with Hine photographs). "Unto the Least of These," *Everybody's,* 21 (July), 75–87. "Toilers of the Tenements," *McClure's,* 35 (July), 231–40. "Working Girls' Budgets," *McClure's,* 35 (Oct.), 595–607. *Homestead: The Households of a Mill Town,* Margaret F. Byington. New York: Charities Publication Committee (illus. by Hine and J. Stella). *Our Slavic Fellow Citizens,* Emily Greene Balch. New York: Russell Sage Foundation. (Three volumes of *The Pittsburgh Survey.*) *The Steel Workers,* John A. Fitch. New York: Charities Publication Committee. *Work Accidents and the Law,* Crystal Eastman. New York: Charities Publication Committee. ARTICLE: "Communication," *The Survey,* 24 (Apr. 30), 187.

1911 *The Survey:* "Old Worlds in New," 25 (Jan. 7), 570; "The Findings of the Immigration Commission," 25 (Jan. 7), 571–78; "The Cost of Cranberry Sauce," 25 (Jan. 7), 605–10; "Housing Awakening," 25 (Feb. 4), 768ff; "Homework in the Tenements," 25 (Feb. 4), 772–79; "Millinery Shop," 26 (Apr. 8), 86; "A Madonna of the Tenements," 26 (July 8), cover; "A Madonna of Ellis Island," 26 (Aug. 12), cover; "Her First Day in America," 26 (Sept. 16), cover; "A Young Miner," 26 (Sept. 23), cover; "Newsboy," 27 (Dec. 2), 1275; "The Cost of Cranberry Sauce," 27 (Dec. 2), 1281–84; "Old Bethlehem and the New," 27 (Dec. 2), 1286ff. *International Socialist Review:* "The Fighting Garment Workers," 11 (Jan.), 386; "Homeworkers in New York," 11 (Jan.), 395–401; "The Passing of the Bottle Blower," 11 (Feb.), 449–57; "Child Slaves in the Cotton Mills," 11 (Mar.), 521–24; "Justice in Pittsburgh," 12 (Sept.), 158; "The Steel Trusts Private City—Gary," 12 (Dec.), 327–33. "Old Age at Forty," *American Magazine,* 71 (Mar.). ARTICLE: Child Labor in Gulf Coast Canneries," *American Academy of Social Science Annals* (July), 118–122.

1912 *The Survey:* "Conservation of Childhood," 27 (Jan. 6), 1515–26; "A New Exhibit of Homework," 28 (Apr. 6), 8–10, 22–23; "The Human Side of Large Outputs—Steel and Steel Workers in Six American States," 28 (Apr. 6), 17ff; "Lillian: An Eleven Year Old Spinner," 28 (June 29), cover; "Hull House Woman," 28 (Aug. 24), cover; "Yarn Inspector," 28 (Aug. 31), cover; "Father Neptune," 28 (Sept. 14), cover; "Old Mill Hand/Young Steel Worker," 29 (Oct. 5), 6–7; "Girl on Playground," 29 (Nov. 2), cover. "Women Toilers Look into Their Lives Through Photographic Windows," *The Delineator,* 79 (May), 376–77. "Old World Madonnas," *The Delineator,* 79 (June), 490. "Over a Volcano," *International Socialist Review,* 13 (Sept.), 217–21. "At the Bottom," *Everybody's,* 27 (Nov.), 536–43.

1913 *The Survey:* "Box Factory Worker," 29 (Jan. 4), cover; "Baltimore to Biloxi and Back—The Children's Burden in Oyster and Shrimp Canneries," 30 (May 3), 167–72; "The Vocational Counselor in Action," 30 (May 3), 183–88 (uncredited); "Thanksgiving Cranberries," 31 (Nov. 22), cover; "Mother and Child," 31 (Dec. 6), cover, 245. "Big Brothers and Little," *Everybody's,* 29 (Aug.), 246–55. "The Call of the Steel Worker," *International Socialist Review,* 14 (Aug.), 77–84 (photos reused). *Artificial Flower Makers,* Mary Van Kleeck. New York: Survey Associates (Russell Sage Foundation). *Women in the Bookbinding Trade,* Mary Van Kleeck. New York: Survey Associates (Russell Sage Foundation).

1914 *The Survey:* "Newsboy—Child Labor Day," 31 (Jan. 17), 455; "Flowers of the Tenement Child," 31 (Jan. 24), 500; "Edith: A Five Year Old Picker," 31 (Feb. 7), cover; "Children or Cotton," 31 (Feb. 7), 589; "Still They Come," 31 (Feb. 7), 542 (uncredited); "Home Hospital Experiment," 31 (Feb. 7), 583–88; "On the Ferry from Ellis Island," 31 (Mar. 14), 738; "The High Cost of Child Labor" (poster), 32 (Apr. 11), 49; "Boyhood and Lawlessness on the West Side," 32 (Apr. 18), 80; "Opening the Canal," 32 (May 9), cover; "A Child's Creed," 32 (Aug. 8), 475; "The Girls They Leave Behind Them," 32 (Aug. 22), 217; "180 Bushels of Wheat," 33 (Dec. 5), 226; "Community Contrasts in Housing Millworkers: A Soho Hillside," 33 (Dec. 12), 293, 295. "Time Exposure by Hine": *Survey,* 31 (Feb. 21), 637; (Feb. 28), 663; (Mar. 7), 691; (Mar. 14), 737; (Mar. 21), 765; 32 (Apr. 4), 5; (Apr. 18), 69; (May 2), 111; (May 9), 171; (May 16), 192; (May 23), 212; (July 11), 388; (Aug. 1), 446; (Sept. 5), 556. *The Old World in the New,* Edward Alsworth Ross. New York: The Century Co. *The Pittsburgh District Frontage,* Lattimore, Devine, Woods et al. New York: Survey Associates. *Wage Earning in Pittsburgh,* Paul U. Kellogg, ed. New York: Survey As-

sociates. *West Side Studies: Boyhood and Lawlessness*, under direction of Pauline Goldmark. New York: Survey Associates. *Working Girls in Evening Schools*, Mary Van Kleeck. New York: Survey Associates (Russell Sage Foundation).

1915 *The Survey:* "Child Scavengers," 33 (Jan. 23), 435; "Social Legislation in the Keystone State," 33 (Feb. 6), 481–86; "Spare the Wage and Spoil the Child," 33 (Feb. 6), 488; "Child Workers in North Carolina Cotton Mills," 33 (Feb. 27), 573; "Immigrants on the New Trails," 34 (May 1), 115; "Little Brother," 34 (May 8), 134; "For All the Children," 34 (June 12), 241; "Vacation Time Never Comes in the School of a City Street," 34 (Aug. 21), cover; "Hassan Ben Ali," 35 (Nov. 13), cover; "Entertainment in the Joy Zone, San Francisco Exposition," 35 (Nov. 13), 164–65. "Time Exposure by Hine": *Survey*, 33 (Feb. 20), 553; 34 (May 15), 157. "Machines That Have Made History," *International Socialist Review*, 15 (Mar.), 530–36 (photographs credited to NCLC). *Street Land: Its Little People and Big Problems*, Philip Davis, assisted by Grace Kroll. Boston: Small, Maynard.

1916 *The Survey:* "War Time," 35 (Jan. 29), cover; "Beeters," 35 (Mar. 4), 655–60; "June in the Beet Fields," 36 (July 1), 374; "October in the Beet Fields," 37 (Oct. 14), 39; "November in the Beet Fields," 37 (Nov. 25), 203; "Night Breadline in the Bowery Mission," 37 (Dec. 9), 269.

1917 *The Survey:* "Beyond the Reach of the Law," 37 (Jan. 6), 396–97; "Out to Win," 37 (Jan. 20), 463; "A Plan to Safeguard Children in Farm Work," 38 (Apr. 28), 86; "Our New Cities," 39 (Oct. 27), 92–93. "The American Gamin," *Outlook*, 16 (June 6), 224–27. *A Seasonal Industry: A Study of the Millinery Trade in New York*, Mary Van Kleeck. New York: Russell Sage Foundation.

1918 *The Survey:* "Few Are Their Belongings," 40 (Aug. 10), cover; "How the American Red Cross Workers Served as the Social Police," 40 (Aug. 10), 532–33; "The Merciful Invasion of St. Etienne," 41 (Oct. 12), 38; "A Brotherhood of Misericordia," 41 (Nov. 9), 148–49. *Everybody's:* "Playtime at the Training Camp—The Soldiers' Life Is Not All Work," 39 (July), 66–67; "The Stuff That Makes Our Fighting Force," 39 (Sept.), 40–41; "The Yankee Stew," 39 (Oct.), 52–53.

1919 *The Survey:* "Refugees—In the Turkish Quarter," 42 (May 31), 373; "The Pull of the Home Tie," 42 (July 5), 523–28; "They Departed into Their Own Country," 42 (Aug. 2), 661–65; "The Child's Burden in the Balkans," 42 (Sept. 6), cover, 813–17; "Let It Be That Peace Shall Rule," 43 (Oct. 4), 19; "The War and the Children," 43 (Nov. 8), 79–85; "Christmas in Serbia," 43 (Dec. 20), 254. "Our All American Army," *The Red Cross Magazine*, 14 (Feb.), 41–44. "The Right to Youth," *The Red Cross Magazine*, 14 (May), 76–78 (uncredited). "Peace Time Pioneers," *World's Work*, 38 (Oct.), 641–48.

1920 "Helping Children to Health," *The Red Cross Magazine*, 15 (Aug.), 66. "Human Emotion Recorded by Photography," *The National Geographic*, 38 (Oct.), 284, I, VIII. *The Human Costs of the War*, Homer Folks. New York, London: Harper Bros. *Our Foreigners—A Chronicle of Americans in the Making*, Samuel P. Orth. New Haven: Yale University Press.

1921 *The Survey:* "Child Labor Day," 45 (Jan. 15), 559; "The Long Day—

Wear and Tear of a Twelve Hour Day," 45 (Mar. 5), 788–94; "Three Shifts," 45 (Mar. 5), 815, 818. *Survey Graphic* (illustrated monthly issue of *The Survey*, commencing Oct. 29): "The Railroaders: Work Portraits," 47 (Oct. 29), 159–66; "The Powermakers: Work Portraits," 47 (Dec. 31), 511–18.

1922 *Survey Graphic:* "The Sonny (sic) Side of Life in West Virginia," 47 (Jan. 21), 628–29; "Harbor Workers: Work Portraits," 47 (Feb. 25), 851–58; "Coal, Mines, Miners and the Public," 47 (Mar. 25), cover; "The Man on the Job: Work Portraits," 47 (Mar. 25), 976, 991–96; "The Man-Trip," 47 (Mar. 25), 1014–15; "Economic Aspects of the Anthracite Industry," 47 (Mar. 25), 1016, 1020, 1025–27; "Postal Service in the Big City," 48 (July 1), 455–62; "Truckman, Truck Workers," 48 (Sept. 1), cover, 669–76. *Rural Child Welfare*, under direction of Edward Clopper. New York: Macmillan.

1923 *Survey Graphic:* "Joy in Work," 49 (Feb. 1), cover; "Hands: Work Portraits," 49 (Feb. 1), 559–65; "Mother and Child," 51 (Oct. 1), 4; "The Homes of the Free," 51 (Nov. 1), 155. "Makers of the Nation's Telephones," *Western Electric News*, 12, 1 (Mar.), 1; 12, 2 (Apr.), 1, 18; 12, 3 (May), 1, 4, 26; 12, 4 (June), 1, 10, 23; 12, 5 (July), 22; 12, 6 (Aug.), 23. "An Open Letter to Jackie Coogan," *Collier's Weekly* (Mar. 31), 11. "Work Photographs," *International Studio*, 77 (Aug.), 375–79.

1924 *Survey Graphic:* "A Railroad Shopman," 51 (Jan. 1), 310; "Medieval Industry in the 20th Century," 51 (Feb. 1), 456–61; "Cast of Characters in the New Drama of the Power Makers," 51 (Mar. 1), 593–99; "Man in Hoisting Machine," 51 (Mar. 1), 602; "Some Tools of the Trade," 51 (Mar. 1), 629–32; "Portrait of Arthur Gleason," 52 (July 1), 419; "Going to School in a Textile Mill," 52 (Sept. 1), cover, 571–75; "Heart Disease and the Job," 53 (Nov. 1), 119–22, 126–28, 130, 133, 137. "Makers of the Nation's Telephones," *Western Electric News*, 13, 1 (Mar.), 24, 28, 29; 13, 2 (Apr.), 2; 13, 3 (May), 8, 9; 13, 4 (June), 29; 13, 5 (July), 1; 13, 6 (Aug.), 1; 13, 7 (Sept.), 1; 13, 8 (Oct.), 2, 7; 13, 9 (Nov.), 1.

1925 *Survey Graphic:* "On the Rural Health Front," 53 (Jan. 11), 383–86, 388–89 (text and photographs by Hine); "Portrait of a Man," 53 (Mar. 1), 644; "Can We Survive in Crowds in Our Cities?" 55 (Nov. 1), 120; "Guardians of City Health—Portrait Studies," 55 (Nov. 1), 129, 133. "Weavers of the Wires of Communications," *Western Electric News*, 13, 11 (Jan.), 4. "Makers of the Nation's Telephones," *Western Electric News*, 14, 1 (Mar.), 1; 14, 2 (Apr.), 4, 24; 14, 4 (June), 1; 14, 5 (July), 1; 14, 6 (Aug.), 1; 14, 7 (Sept.), 24; 14, 8 (Oct.), 1. *American Economic Life and the Means of Its Improvement*, Tugwell, Munro, and Stryker. New York: Harcourt, Brace.

1926 *Vacuum Oil News:* "Mr. Thomas J. McGrath," 2, 1 (May), cover; "Mr. Gustav Shweizer," 2, 4 (Aug.), cover; "Mr. Martin McGrath," 2, 7 (Nov.), inside back cover. "Domesday for Diphtheria," *Survey Graphic*, 56 (Apr. 1), 14–17. "Makers of the Nation's Telephones," *Western Electric News*, 14, 12 (Feb.), 2; 15, 2 (Apr.), 2; 15, 3 (May), 2; 15, 7 (Sept.), 30; 15, 10 (Dec.), 6.

1927 "Mr. John F. Flynn," *Vacuum Oil News*, 2, 9 (Jan.), cover. "Makers of the Nation's Telephones," *Western Electric News*, 15, 11 (Jan.), 2; 15, 12 (Feb.), 2; 16, 2 (Apr.), 2; 16, 3 (May), 17.

1928 None other than *The American Child* (NCLC).

1929 *Survey Graphic:* "Trade Union Insurance—Promise and Realities," 62 (Apr. 1), 54–56; "Good Scouts," 62 (Aug. 1), 473–75; "Styles in Strikes," 63 (Dec. 1), 262–64; "Young Sheperdess [*sic*]," 63 (Dec. 1), 282.

1930 "Straightening Young Twigs," *Survey Graphic,* 64 (May 1), 120–22.

1931 *Survey Graphic:* "Up from City Streets," 65 (Jan. 1), 361–65; "The Job Line," 65 (Feb. 1), 4, 6–9; "Carrying Health to the Country," 65 (Mar. 1), 610–13. "The Steel Aviators," *World's Work,* 60 (Mar.), 69–77. "Lest Those Who Feed Us Starve," *World's Work,* 60 (Apr.), 68–73. "Skyboys Who 'Rode the Ball' on Empire State," *The Literary Digest,* 109 (May 23), 30–32. "Man and the Skyscraper," *The Commercial Photographer,* 6 (Aug.), 634–36. *Health on Farm and Village,* C. E. A. Winslow. New York: Macmillan. *Empire State: A History.* New York: Empire State, Inc. *Empire Statements,* Vols. 1, 2, 3, 4, 5, 6, 7 (back cover, no credit). New York: Empire State, Inc.

1932 *Survey Graphic:* "Scientific Management's Bigger Job," 67 (Mar. 1), 578; "Walden School Portrait," 68 (June 1), cover; "Warden Brown," 68 (Aug. 1), 351. "Empire State Building," *Young Wings* (Feb.), cover. *Men at Work,* Lewis W. Hine. New York: Macmillan.

1933 "Old Woman" (reversed), *Better Times,* 14 (Mar. 6), 12 (credited to United Hospital Fund). "Through the Threads," *Survey Graphic,** 22 (Apr.), 210–11. "Child Labor's End Foreseen," New York *Times* (Aug. 13), viii, 2:1. "A Fourteen Year Old Worker," *Survey Graphic,* 22 (Sept.), 446. *Through the Threads of the Shelton Looms.* New York: Sidney Blumenthal & Co., Inc. (20 photographs with text).

1934 *Survey Graphic:* "Yielding Place to the New," 23 (Jan.), 4; "Bench Marks in the Tennessee Valley," 23 (Jan.), 6–7, 9, 10; "Bench Marks in the Tennessee Valley," 23 (Mar.), 106–07; "Montclair Public Library," 23 (Aug.), 389; "Men off the Road," 23 (Sept.), 421–27; "Arthur Kellogg Portrait," 23 (Sept.), 435; "Bench Marks in the Tennessee Valley," 23 (Nov.), 549–51 (uncredited); "Here We Are," 23 (Dec.), 608–09. ARTICLES: "Up Goes the Skyscraper," *Young Wings* (Feb.), 4–5. "Photographing a Skyscraper," *Young Wings* (Feb.), 8.

1935 "Bench Marks in the Tennessee Valley," *Survey Graphic,* 24 (Mar.), 112–15 (uncredited). "Park Benches and Park Projects," *Survey Graphic,* 24 (June), 89–92. *Back Woods America,* Charles Morrow Wilson. Chapel Hill: University of North Carolina. *Job Satisfaction,* Robert Hoppock. A publication of the National Occupational Conference. New York, London: Harper and Bros. *Metropolis: An American City in Photographs,* Agnes Rogers. New York: Harper and Bros.

1936 *Survey Graphic:* "The American Bent for Planning," 25 (Apr.), 238–39 (uncredited, one possibly by Hine); "Can We Afford to Read Books?" 25 (May), 328; "Rural America," 25 (Dec.), 669–71. *Development of the Tennessee Valley.* Washington, D.C.: Government Printing Office. *Log of the TVA,* Arthur E. Morgan. New York: Survey Associates.

1937 *Survey Graphic:* "Children Wanted," 26 (Jan.), 10–16; "Manpower

*Now numbered separately from *The Survey.*

Skills," 26 (May), 275–79; "Work Portraits," 26 (Dec.), 639–42; "Some Pages from *The Survey* Scrapbook," 26 (Dec.), 677. *Technological Change,* David Weintraub and Lewis W. Hine. Philadelphia: National Research Projects, WPA.

1938 "Worker," *Survey Graphic,* 27 (Oct.), 484.

1939 *Survey Graphic:* "Americans Ship Out," 28 (Jan.), 13–17; "Maritime Labor Grows Up," 28 (Jan.), 18–20; "Crossroads School," 28 (Oct.), 604. "A Railroad Fireman," *Fortune,* 19 (June), 78–84. "Ellis Island Madonna," *Life,* 6 (June 5), 39. "The Melting Pot," *Fortune,* 20 (July), 72. "Good Americans Are Good Neighbors," *Hartford-Courant* (Nov. 5), 4–5.

1940 "We Are All Immigrants," *Friday,* 1 (Apr. 26), 15. "Photography," *PM's Weekly* (Aug. 25), 48.

ABOUT LEWIS W. HINE

1913 "Editorial Grist—Child Labor and Poverty," *The Survey,* 30 (Apr. 12), 61.

1915 "On the High Cost of Child Labor," *The Survey,* 33 (Jan. 16), 414.

1920 "A Boy and a Caption," *The Survey,* 44 (July 3), 492. "Two Notable Exhibits of Photographic Art," New York *Post* (Oct. 23), 5. "Lewis Hine's Photographs at the Civic Club," *Evening World* (Nov. 1), 24. "Treating Labor Artistically," *Literary Digest,* 67 (Dec. 4), 33–34. Review, Hastings *Press* (Dec. 10).

1924 "He Photo Interprets Big Labor," *Mentor,* 14 (Sept.), 41–47.

1928 "In Various Galleries—Interpretive Photography," New York *Times* (Dec. 30), 10, 13.

1929 "Hail to Hine," *Survey Graphic,* 63 (Nov. 15), 236. Announcement of Hine's exhibition at Russell Sage Foundation, Hastings *News* (Nov.); Brooklyn *Eagle* (Nov.).

1931 "Hine Exhibit," Yonkers *Herald* (Apr. 6). "Lewis Hine and the Empire State," *Better Times,* 13 (Apr. 11), 6. "The Modern Photograph," *The Studio,* Special Autumn Number (London), 92.

1932 Reviews of *Men at Work, Survey Graphic,* 69 (Oct. 1), 485; *Christian Science Monitor* (Oct. 22), 12, 1; New York *Herald Tribune* (Oct. 23), 10, 9; *The American Child,* 14, 8 (Nov.), 4; *Better Times,* 14 (Nov.), 23–24; *News Bulletin* (Social Work Publicity Council) (Dec. 3); New York *Daily News* (Dec. 5), 31, 2; Hastings *News* (Dec. 16).

1938 "A Generation Rediscovered Through Camera Shots," Elizabeth McCausland. Springfield *Sunday Union and Republican* (Sept. 11). "Portrait of a Photographer," Elizabeth McCausland. *Survey Graphic,* 27 (Oct.), 502–05. "Lewis Hine," Beaumont Newhall. *Magazine of Art,* 31 (Nov.), 636–37. "A Famous Camera Does Thirty Years of Case Work," *Better Times,* 20 (Dec. 9), 18.

1939 "Boswell of Ellis Island," Elizabeth McCausland. *U.S. Camera* (Jan.–Feb.), 58–62. "Portrait of Lewis Hine," Robert Marks. *Coronet,* 5 (Feb.), 147–57. Reviews of Hine Retrospective Exhibition, Riverside Museum, Hastings *News* (Jan. 5, 12); Springfield *Republican* (Jan. 8);

New York *Times* (Jan. 15); New York *World Telegram* (Jan. 21, June 10); *New Masses* (Jan. 31); Des Moines (Iowa) *Register* (Mar. 5).

1940 "Hine's Photo-Documents," Elizabeth McCausland. *Photo-Notes* (Sept.), 3–6.

The following appeared after Hine's death:
"Photos by Hine," *Bulletin Index* (Pittsburgh), 117, 24 (Dec. 12, 1940). "Child Labor Victory Comes Too Late," *PM* (Feb. 5, 1941), 21. "A Tribute to Lewis Hine," *The American Child*, 28, 8 (Dec., 1946), 1. "Early Photographs by Lewis Hine," *American Photography* (Oct., 1950), 35–37. "Broadening Realism," Jack Deschin. New York *Times* (July 1, 1951). "The Interpretive Photography of Lewis W. Hine," Robert Doty. *Image*, 51 (May, 1957), 112–19. "Lewis Hine," Elizabeth McCausland. In *The Complete Photographer*. New York: Morgan and Morgan, 1963. "They Led Child Labor Crusade," Milwaukee *Journal* (Sept. 21, 1966). *Lewis W. Hine and the American Social Conscience*, Judith Mara Gutman. New York: Walker and Co., 1967. "Through the Lens of Social Vision," Alan Trachtenberg. *The Nation* (June 10, 1968), 766–68. "Work or Starve, Photographs by Lewis W. Hine," *Trans-Action*, 8, 7 (May, 1971), 33, 35. "Lewis W. Hine," *Camera*, 6 (June, 1971), 16–25. *Lewis W. Hine, 1874–1940: Two Perspectives*, Judith Mara Gutman. New York: Grossman Publishers, 1974. "The Invention of Photographic Meaning," Alan Sekula. *Artforum* (Jan., 1975), 27–45. "Lewis Hine," George Cruger. *Arts in Virginia*, Virginia Museum Quarterly, 16, 1 (Fall, 1975), 16–40. "Lewis Hine, 1874–1940," Lionel Suntop. *Creative Camera Annual*, London (1976). "Speaking Out: Homage to Hine," Lou Stettner. *Camera 35*, 20, 4 (June, 1976), 21, 62.

•

PUBLIC COLLECTIONS *International Museum of Photography—George Eastman House*, Rochester, N.Y. The former Photo League Collection. Nearly 4,000 original Hine negatives, more than 6,000 prints.

Library of Congress, Washington, D.C. *Prints and Photographs Division:* 5,000 prints made for the NCLC. About 1,000 prints and negatives made for the ARC overseas and in West Virginia and Arkansas are filed separately with American Red Cross photographs. *Manuscript Division:* An assortment of prints included in the papers of the National Child Labor Committee.

University of Maryland Baltimore County. Library: Collection of 5,200 negatives and prints made for the National Child Labor Committee.

American Red Cross, Headquarters Building, Washington, D.C. 500 negatives and prints of work done for the ARC after 1930.

National Archives, Washington, D.C. *Prints and Photographs Division:* 500 prints made by Hine for the National Research Project on Re-Employment Opportunities, WPA, 1936–37.

Columbia University, New York City. *Avery Library:* About 350 enlargements of the Empire State Building. *Rare Book and Manuscript Division:* Photographs of the Red Cross Balkan Mission included in the Homer Folks Papers.

New York Public Library, New York City. *Local History and Genealogy Division:* 208 enlargements, made for the Russell Sage Foundation.

The Tennessee Valley Authority, Knoxville, Tenn. *Graphics Department:* 150 negatives and prints made in 1935.

University of Georgia Libraries, Athens, Ga. 126 prints of Georgia textile mill laborers, originally made for the NCLC.

Museum of Modern Art, New York City. *Department of Photography.*

University of Minnesota Social Welfare History Archives Center, Minneapolis, Minn.

Metropolitan Museum of Art, New York City.

National Child Labor Committee, New York City.

New York University, New York City. *Tamiment Library.*

Chicago Historical Society, Chicago, Ill.

SOURCES FOR PLATES Collection of Walter and Naomi Rosenblum: Pages 2, 27, 29–36, 38–39, 43–44, 47, 49, 51–56, 59–60, 62–63, 66, 69–70, 72–73, 75–77, 81–83, 89, 94, 98, 101, 103–104, 109, 112; The International Museum of Photography–George Eastman House: Pages 28, 37, 48, 61, 64–65, 67, 79–80, 85, 90, 93, 97, 100; Avery Library, Columbia University, New York City: Pages 105, 107–108, 110–111, 113–116; Helios Gallery, New York City: Pages 46, 50, 84, 87–88, 99; The Library of Congress, Washington, D.C.: Pages 40, 45, 68, 96; Lunn Gallery/International Graphics, Ltd., Washington, D.C.: Pages 71, 102; National Archives, Washington, D.C.: Page 57; Chicago Historical Society: Page 92; University of Maryland, Baltimore County Library: Page 41; National Child Labor Committee: Page 95; Private Collection: Page 86.

PICTURE CREDITS Page 8: The International Museum of Photography—George Eastman House, Rochester, N.Y.; Page 119: Top and bottom left, The Ethical Culture School, New York City; bottom right, courtesy of Paul S. Harris, Marlborough, N.H.; Page 120: Right, Jane Addams' Hull-House, University of Illinois, Chicago, Ill.; left, Collection of Walter and Naomi Rosenblum; Page 121: Culver Pictures, Inc., New York City; Page 122: Culver Pictures, Inc., New York City; Page 123: Left, courtesy Yale University Library, New Haven, Conn.; right, Social Welfare History Archives, University of Minnesota, Minneapolis, Minn.; Page 125: Top, Collection of Walter and Naomi Rosenblum; bottom, Collection of Caesar P. Kimmel; Page 129: Courtesy Yale University Library, New Haven, Conn.; Page 130; Left, The Library of Congress, Washington, D.C.; right, International Museum of Photography—George Eastman House, Rochester, N.Y.; Page 133: Bottom, Yale University Library, New Haven, Conn.; Page 143: Courtesy Marlborough Gallery, New York City. Text excerpts, pages 42, 91, from the Elizabeth McCausland Papers, courtesy Archives of American Art, New York City.